MW01046718

HERALDRY

A Pictorial Archive for Artists and Designers

ARTHUR CHARLES FOX-DAVIES

SELECTED AND ARRANGED BY
CAROL BELANGER GRAFTON

RECTE · OMNIA · DUCE · DEO

DOVER PUBLICATIONS, INC., New York

Copyright © 1991 by Dover Publications, Inc.
All rights reserved under Pan American and International Copyright Conventions.

Published in Canada by General Publishing Company, Ltd., 30 Lesmill Road, Don Mills, Toronto, Ontario.

Published in the United Kingdom by Constable and Company, Ltd., 3 The Lanchesters, 162–164 Fulham Palace Road, London W6 9ER.

Heraldry: A Pictorial Archive for Artists and Designers, first published in 1991, is a new selection of illustrations from *The Art of Heraldry: An Encyclopaedia of Armory*, originally published by T. C. & E. C. Jack, London, 1904. The Publisher's Note and the captions have been written specially for the present edition.

DOVER *Pictorial Archive* SERIES

This book belongs to the Dover Pictorial Archive Series. You may use the designs and illustrations for graphics and crafts applications, free and without special permission, provided that you include no more than ten in the same publication or project. (For permission for additional use, please write to Dover Publications, Inc., 31 East 2nd Street, Mineola, N.Y. 11501.)

However, republication or reproduction of any illustration by any other graphic service whether it be in a book or in any other design resource is strictly prohibited.

Manufactured in the United States of America
Dover Publications, Inc., 31 East 2nd Street, Mineola, N.Y. 11501

Library of Congress Cataloging-in-Publication Data

Fox-Davies, Arthur Charles, 1871–1928.
 [Art of heraldry. Selections]
 Heraldry : a pictorial archive for artists and designers / Arthur Charles Fox-Davies ; selected and arranged by Carol Belanger Grafton.
 p. cm. — (Dover pictorial archive series)
 Selections from The art of heraldry.
 ISBN 0-486-26906-X
 1. Heraldry. I. Grafton, Carol Belanger. II. Title. III. Series.
CR21.F725 1991
929.6—dc20 91-22730
 CIP

Publisher's Note

THE ART OF HERALDRY involves the devising, the description (or blazoning) and the regulation of hereditary symbols used to distinguish not only individuals, but also institutions of all kinds, from colleges and churches to guilds and corporations. Heralds were originally messengers wearing the livery of their lord; later their duties extended to the announcing of contenders at tournaments and, in time, they became the foremost authorities on all aspects of heraldry and genealogy. Heraldic symbolism is generally thought to have developed out of the confluence of two medieval design practices: the identificatory markings borne by a warrior on his shield and surcoat in battle, and the insignia on seals used to authenticate documents. By the middle of the twelfth century in Western Europe, heraldic devices were already playing an important role at state functions. The earliest extant work on heraldry is the *Tractatus de insigniis et armis* [Treatise on Insignia and Arms], which was written ca. 1356 by Bartolo da Sassoferrato. The English College of Arms was founded in 1484. Rolls of arms, which listed, often with illustrations, the arms of participants at tournaments and other important social occasions, date from the middle of the thirteenth century in England. Painted books of arms were first produced in Germany, and, during the medieval period, arms were increasingly depicted on wood, stone and glass. By the sixteenth century, however, with the introduction of gunpowder into Western Europe, and the consequent development of new weaponry and new forms of warfare, armor was rapidly becoming obsolete. Coats of arms survived these changes by acquiring a new function. Since arms had always been the possession of the higher feudal castes they had indirectly served as marks of social distinction for the bearer, and this secondary role now came to predominate. This shift was to a great extent responsible for the remarkable change that took place in the style of heraldic design. Simplicity is the primary stylistic characteristic of medieval arms: a warrior, when fully clad in armor, depended upon his arms being easily recognizable by his own comrades. When heraldry began to flourish away from the battlefield, designs soon became far more elaborate. By the eighteenth century they had reached a period of considerable sophistication.

Armorial bearings are a development of the basic idea of the coat of arms, and usually consist of the following elements: (1) the shield itself, which is the essential part of the entire design, displaying the arms of the bearer; (2) the helmet, which is positioned above the shield; (3) the crest, which is set above the helmet and is bound to it by a wreath matching the colors of the shield; (4) the mantling or lambrequin, which, also matching the principal colors of the shield, hangs from the helmet; (5) the crown, coronet or chapeau, designating the bearer's rank; (6) the motto, which, except on Scottish arms (where it is placed above the arms), appears on a scroll beneath the shield; (7) the supporters, which are the figures appearing on either side of the shield; and (8) the compartment, which is the foundation upon which the supporters stand.

The shield itself consists of the "field" and the "charges" that are placed on it. There are three kinds of heraldic field: (1) colours or tinctures, of which there are five: azure (blue), gules (red), sable (black), vert (green) and purpure (purple); (2) metals, of which there are two: or (gold) and argent (silver); and (3) furs, of which there are five: ermine (a white field with black spots), ermines (a black field with white spots), erminois (a gold field with black spots), pean (a black field with gold spots) and vair (blue and white). It is a general, though often neglected, rule of heraldic design that the same kind of field should not be repeated on a coat of arms (i.e., metal should not be superimposed on metal).

The heraldic field is charged with an object. The history of heraldic design testifies to an ever-increasing variety of heraldic charges; these can be divided into two major kinds: ordinaries and other charges. On pages 30 and 31 of the present volume are displayed the various ordinaries. The most easily recognizable of these are the chief (which covers the top third of the shield), the pale (which covers a perpendicular third in the center of the shield), the bend (which covers a diagonal third) and the chevron (an inverted "V"). The other heraldic charges range widely, from animals (lions, tigers, antelope) and mythical creatures (dragons, wyverns, griffins, unicorns) to aircraft, household and industrial objects, weapons and religious symbols.

There is a sophisticated vocabulary for blazoning (describing verbally) the various ways in which heraldic charges are represented. An animal such as a lion is blazoned in the following ways: rampant (when on its hind legs); passant (when walking); statant (when standing); guardant (when in a full-faced posture); regardant (when looking back over its shoulder); sejant (when sitting); and dormant (when sleeping).

One of the most important functions of heraldic symbolism is to represent the relationship between an individual bearer of a coat of arms and his or her family. Marks of cadency, which include the label, the crescent, the mullet (a five-pointed star) and the fleur-de-lis, are used to designate such familial relations. An eldest son, for example, would bear the same arms as his father, but with the addition of a label.

The marshalling of arms, which includes impalement and quartering, is the means by which two coats of arms are conjoined onto a single shield on the occasion of a marriage. The present volume contains many examples of such conjoining of arms.

Heraldry: A Pictorial Archive for Artists and Designers offers a selection that covers the entire history of heraldic art, from the armorial shields of the thirteenth to the armorial bearings of the nineteenth century. Among the individuals whose arms are depicted here are Edward the Black Prince, the great German minnesingers Walter von der Vogelweide and Hartmann von Aue, the German printer Erhard Ratdolt and the English poet John Milton. In addition to the arms of individuals, the reader will also find those of tradesmen's guilds, societies, universities and cities. The captions at the bottom of each page identify the bearer of the arms, when known, or the manuscript from which the arms have been taken.

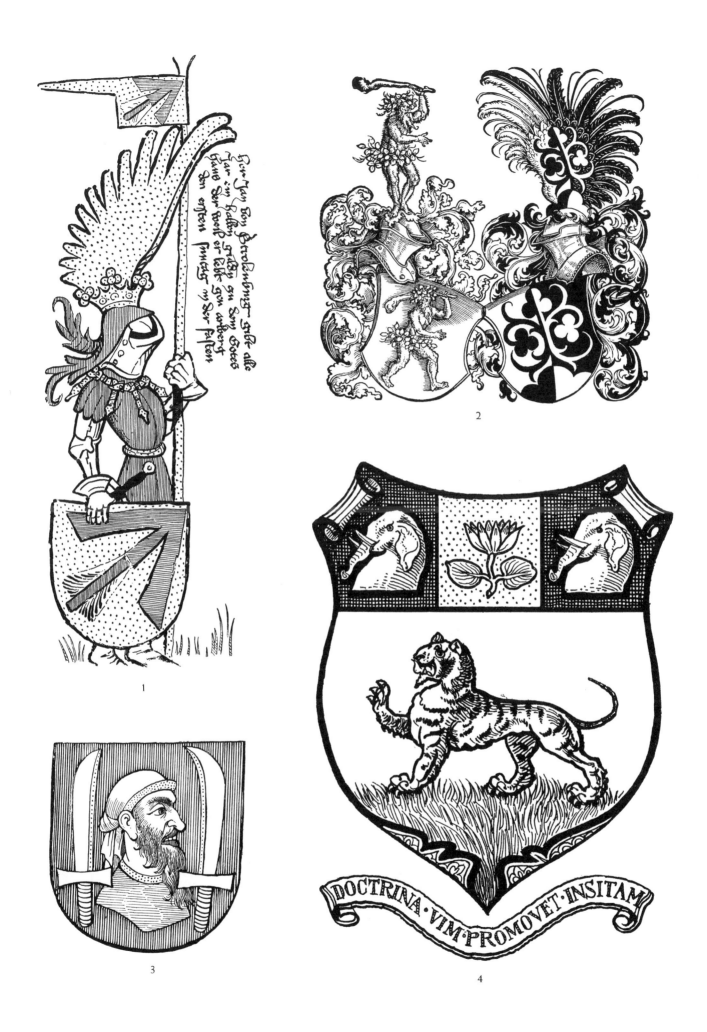

1. Johann von Strolenburg. 2. LEFT: Sigismund Grimm; RIGHT: Markus Würsing. 3. Michael Mohorai Vid. 4. The University of Madras.

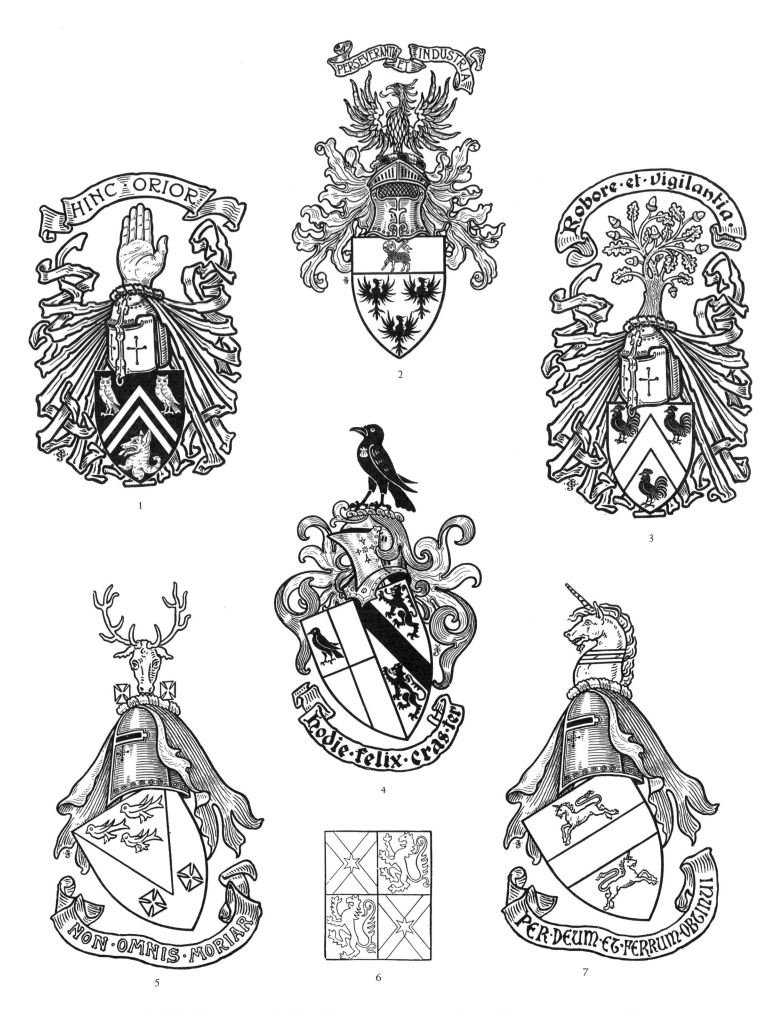

1. Charles Howatson. 2. Sir Robert Pullar. 3. James Aitken. 4. Thomas W. Craster. 5. Bertram
C. Windle. 6. William Nevill, Earl of Kent. 7. Thomas E. Swanzy.

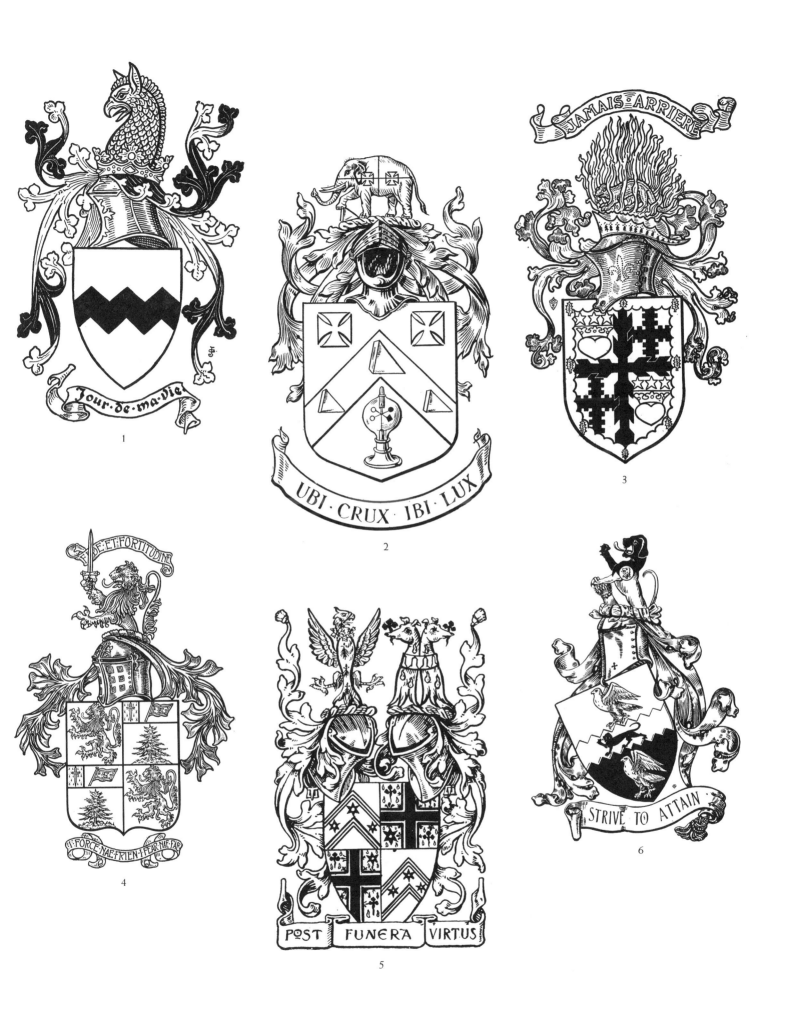

1. William C. Cornwallis-West. 2. Sir William Crookes. 3. William C. Douglas. 4. George Farquharson. 5. John R. Atkin-Roberts. 6. Frederic B. George.

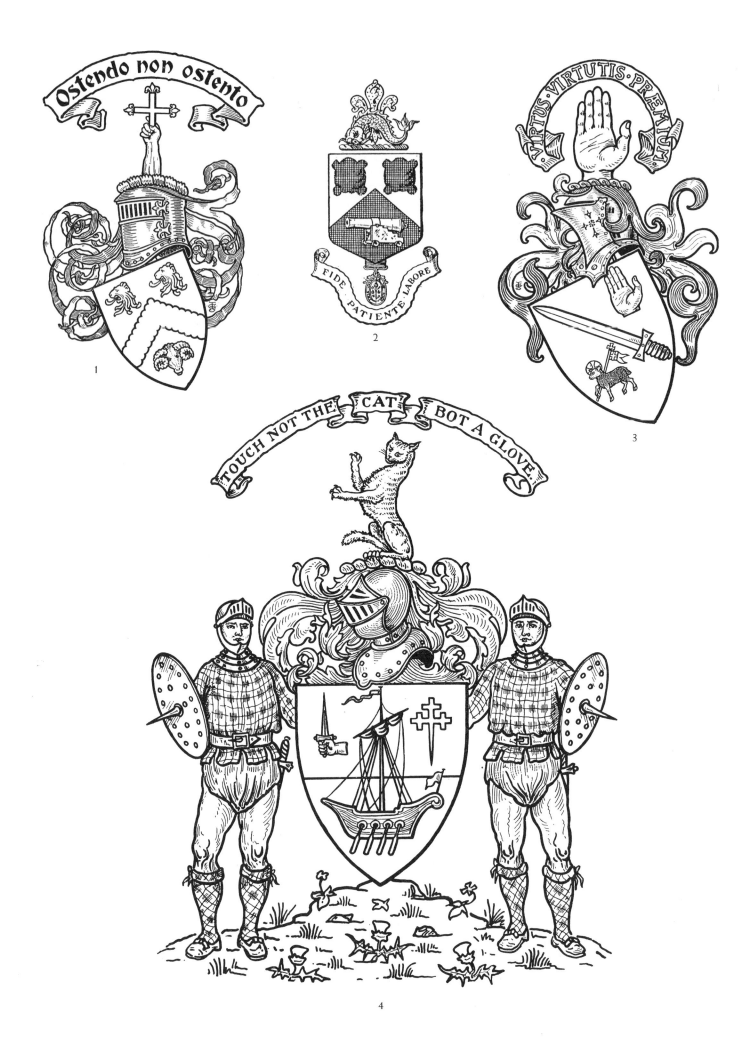

Ostendo non ostento

FIDE PATIENTE LABORE

VIRTUS · VIRTUTIS · PREMIUM

TOUCH NOT THE CAT BOT A GLOVE

1. James Ritchie. **2.** William F. Pilter. **3.** Alexander MacMorran. **4.** Cluny Macpherson.

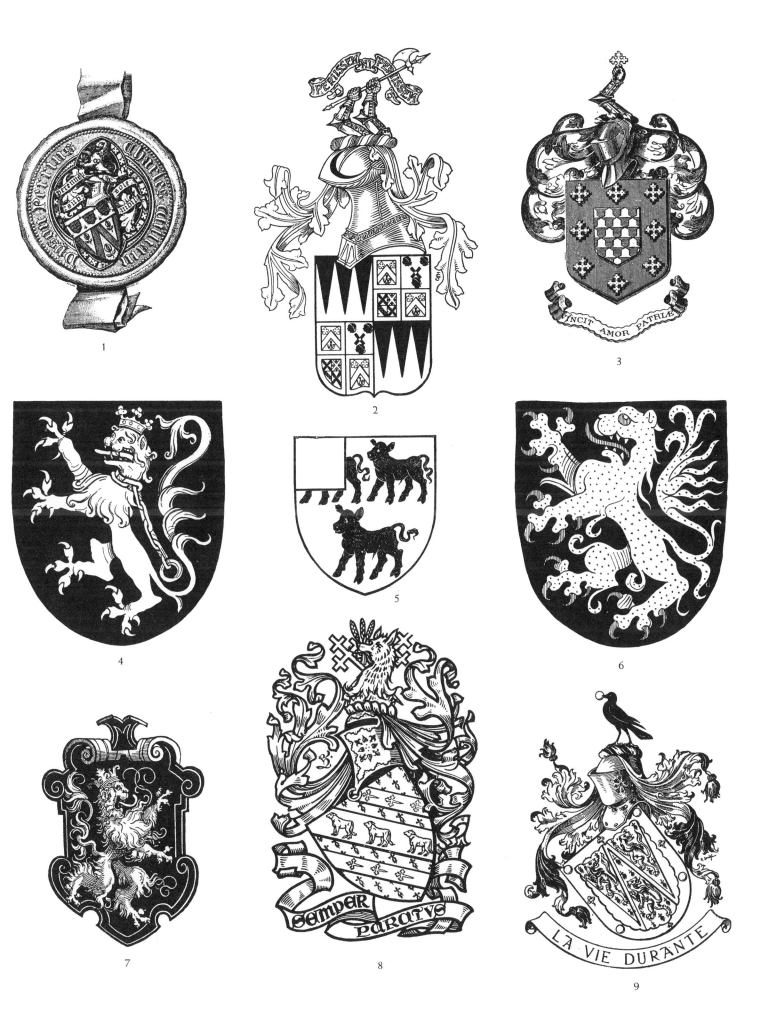

1. Charles W. Perrins (bookplate). 2. Alexander W. Anstruther-Duncan. 3. Molesworth. 4. A lion rampant. 5. John H. Metcalfe. 6 & 7. Lions rampant. 8. Lawrence W. Vaile. 9. Moses Cornwall.

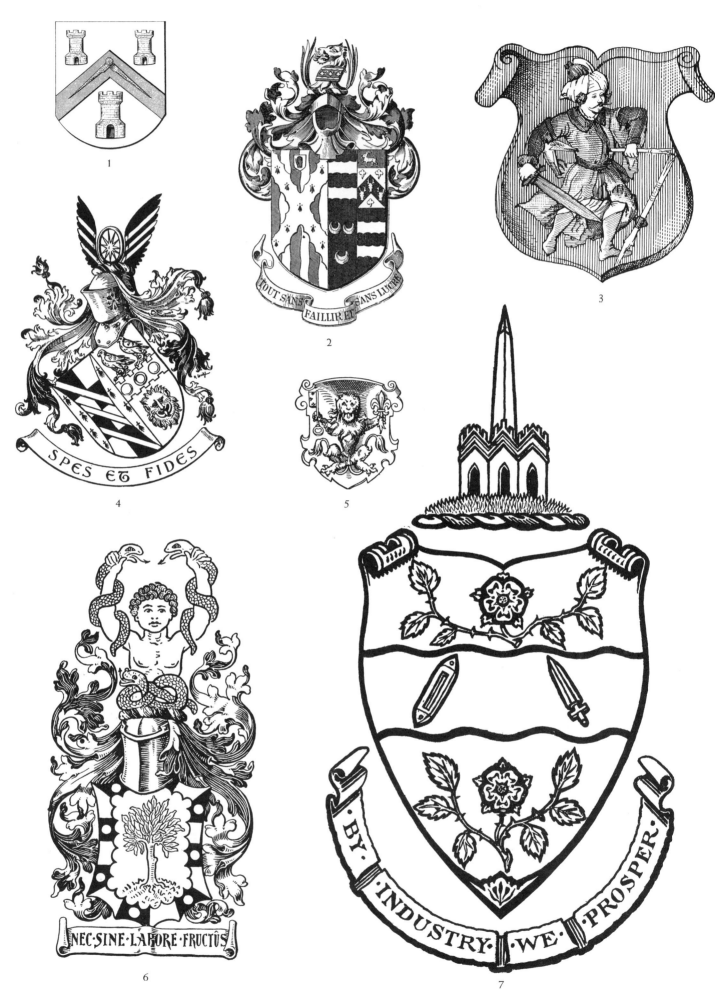

1. The Mason's Company, Edinburgh. 2. Sir Offley Wakeman. 3. Peter Dévay de Deva. 4. John E. Clauson. 5. Sebastian Schärtlin von Burtenbach. 6. Frederick Clifford. 7. The Town of Todmorden.

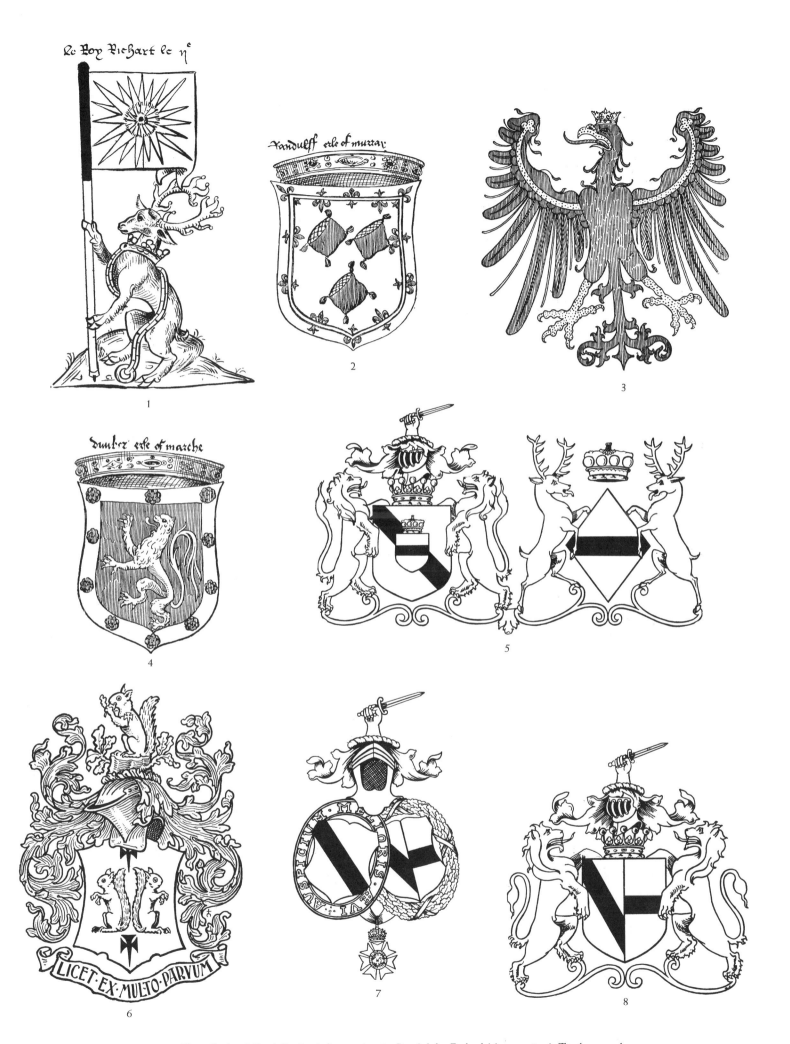

1. King Richard II of England (banner). 2. Randolph, Earl of Moray. 3. A Tirolean eagle.
4. Dunbar, Earl of March. 5. Conjoined arms. 6. Arthur W. Samuels. 7 & 8. Conjoined arms.

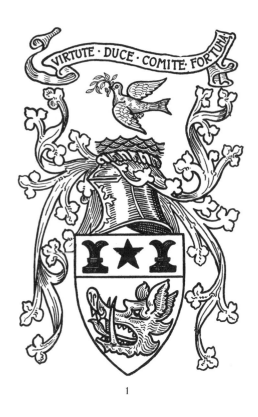

1

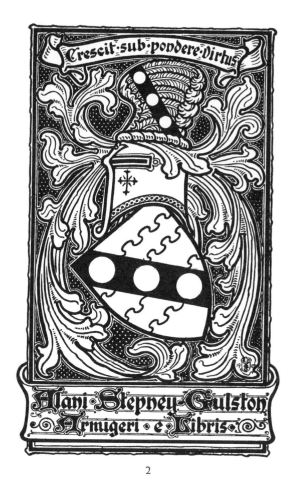

2

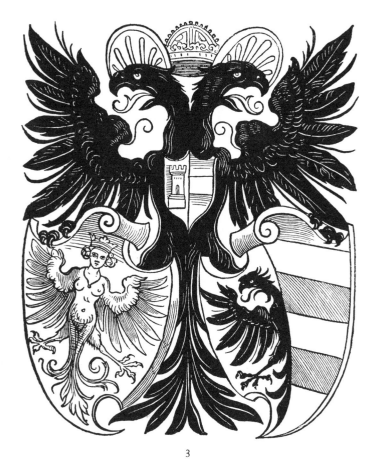

3

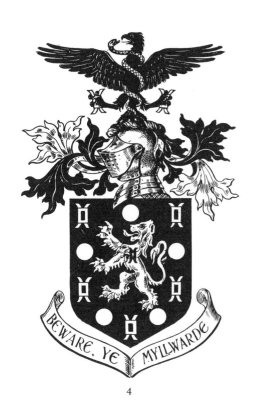

4

1. Alexander K. Smith-Shand. **2.** Alan S. Gulston (bookplate). **3.** The City of Nuremberg.
4. William J. Millard.

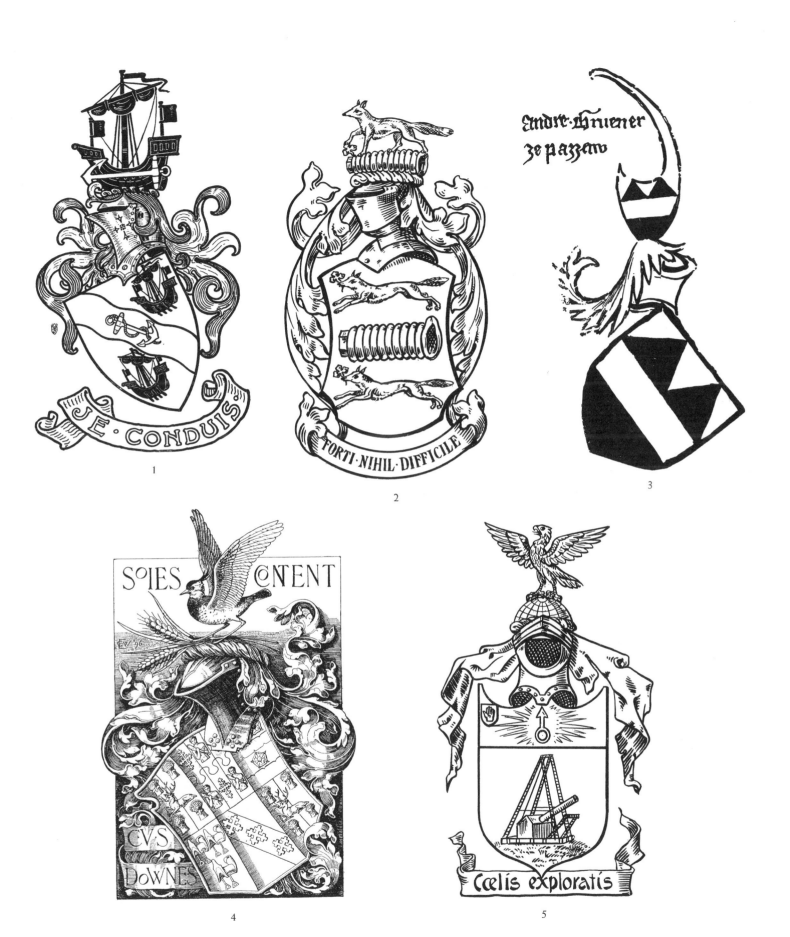

1. Conder. 2. Samson Fox. 3. Andrew Gruener. 4. Charles V. Downes (bookplate). 5. Sir William J. Herschel.

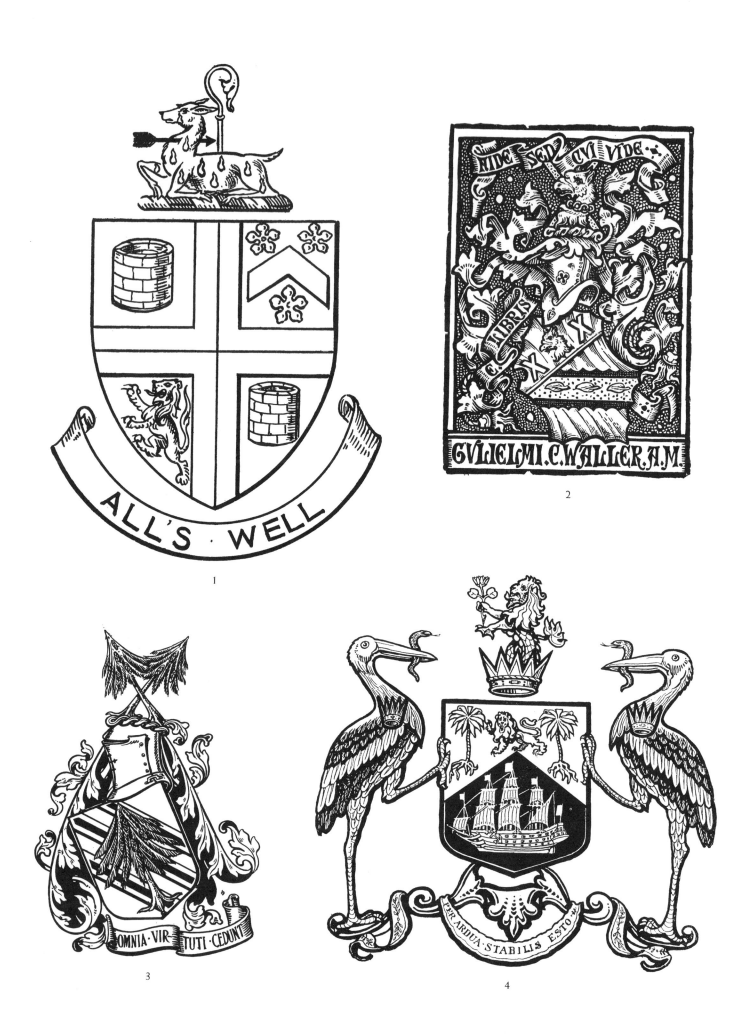

1. The Borough of Camberwell. **2.** William C. Waller (bookplate). **3.** C. H. De la Ferté. **4.** The City of Calcutta.

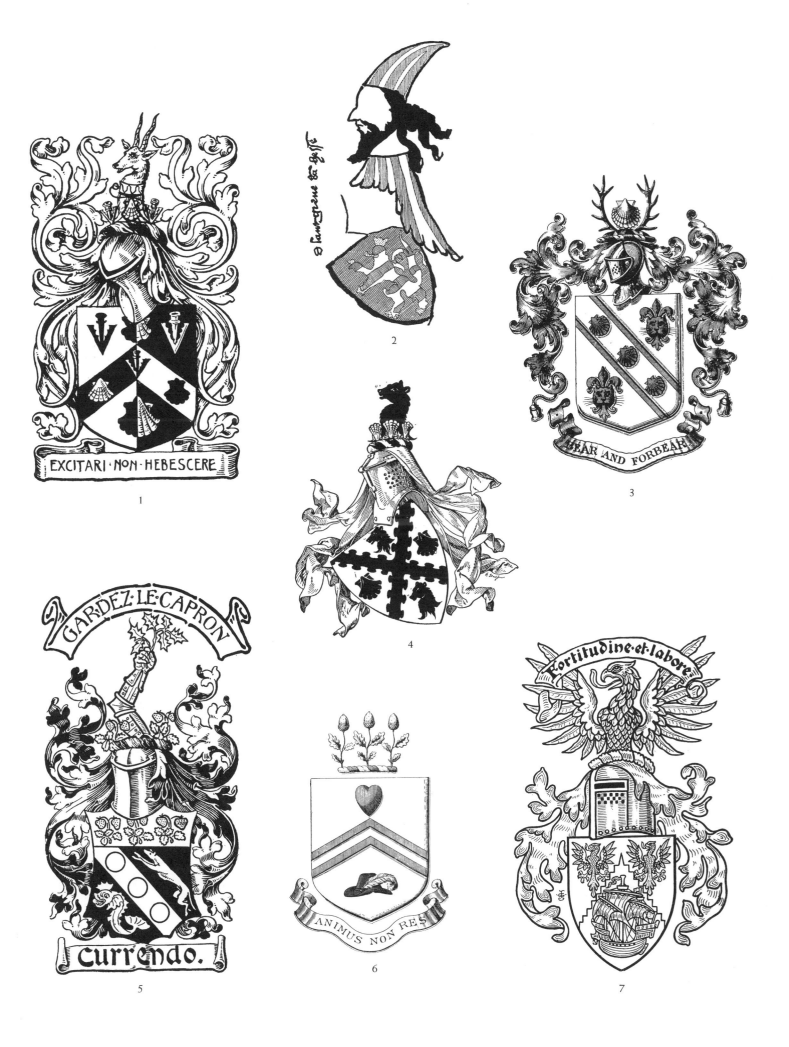

EXCITARI · NON · HEBESCERE

1

2

BEAR AND FORBEAR

3

GARDEZ · LE · CAPRON

currendo.

5

ANIMUS NON RES

6

Fortitudine · et · labore

7

1. William H. Foster. **2.** The Landgrave of Hesse. **3.** Charles F. Burnard. **4.** Basil J. Beridge.
5. Edward O. Hollist. **6.** Edward Huth. **7.** Arthur A. Reid.

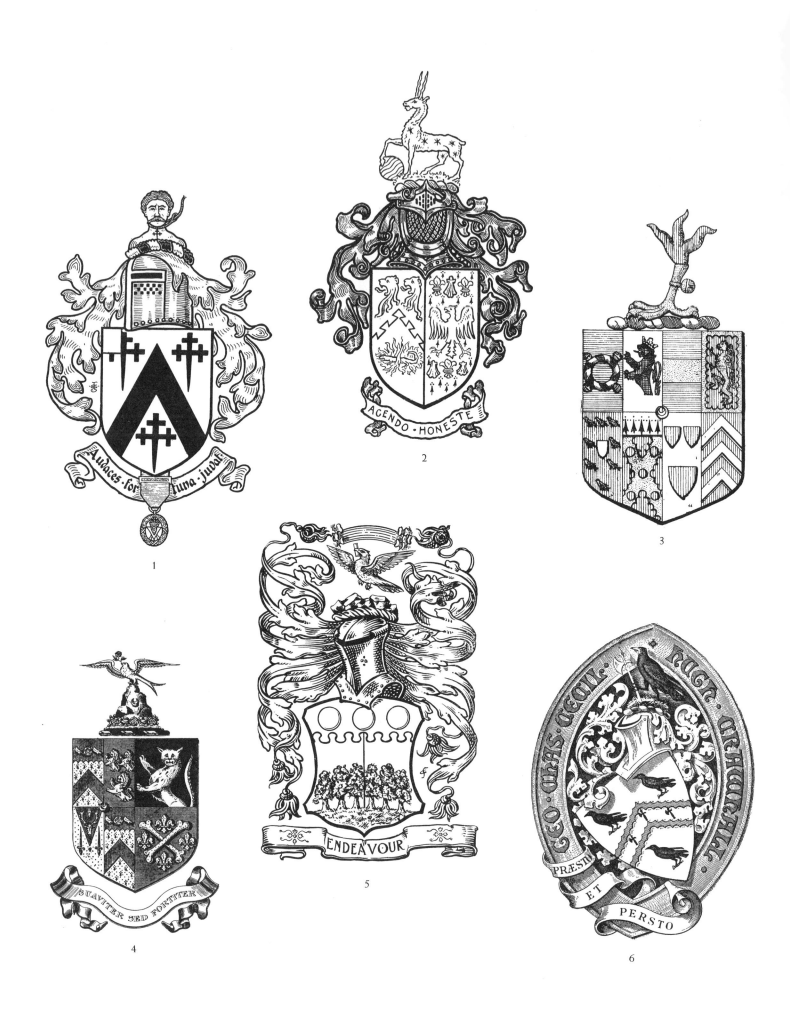

1. Cyril J. Davenport. 2. Sir William Farmer. 3. Joscelin of the "Libertie of St. Bartholomew the Greate." 4. Francis P. Smith. 5. William Goldthorpe. 6. George C. Crawhall.

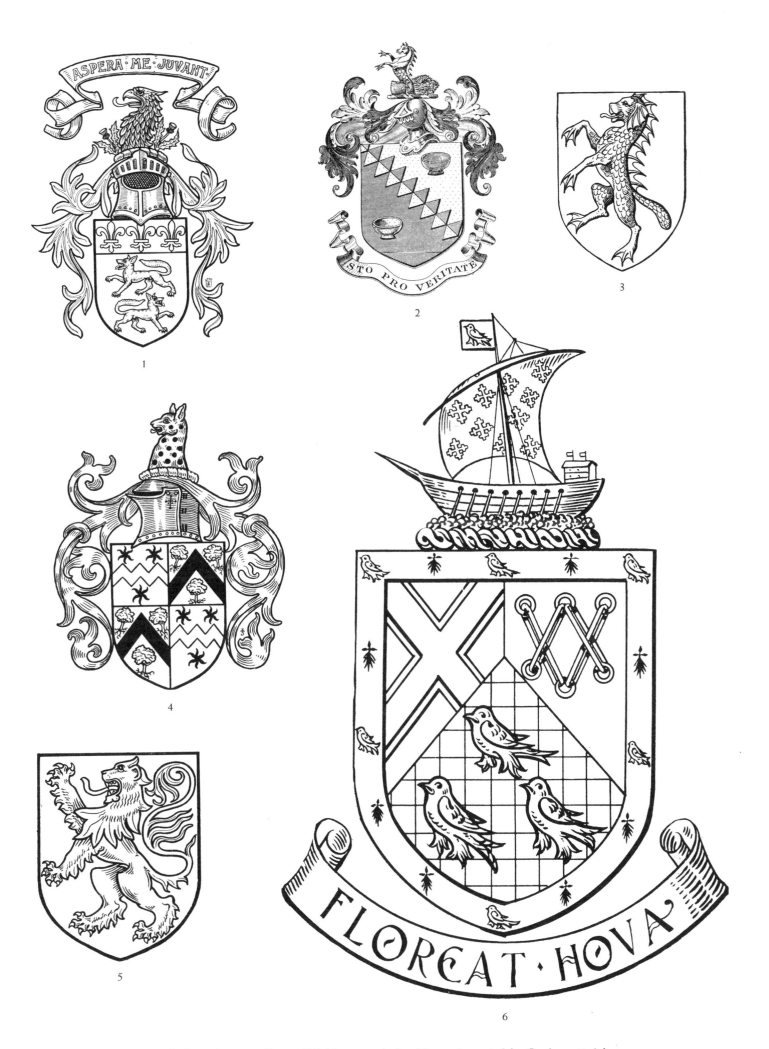

1. Sir James Low. 2. George F. Bolding. 3. An heraldic sea dog. 4. John Comber. 5. A lion rampant. 6. The Borough of Hove.

13

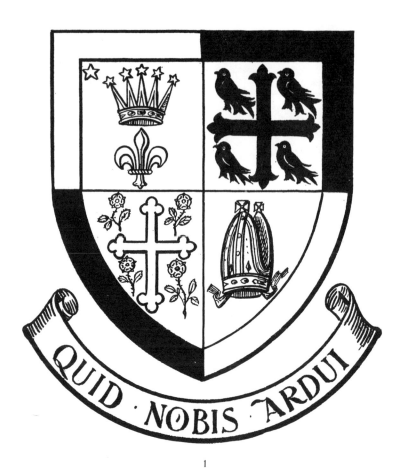

1

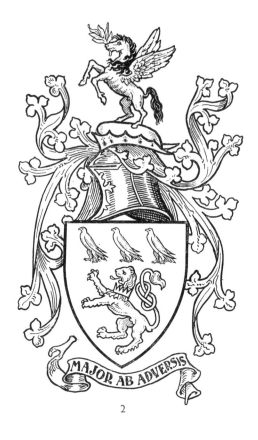

2

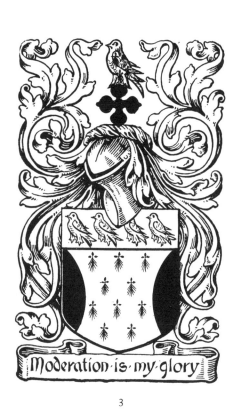

3

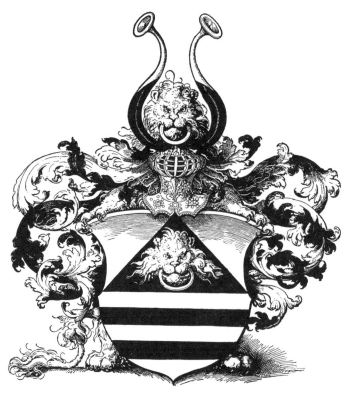

4

1. The Royal Borough of Kensington. **2.** Cecil E. Bewes. **3.** Godfrey Fitzhugh. **4.** Heinrich Rubische.

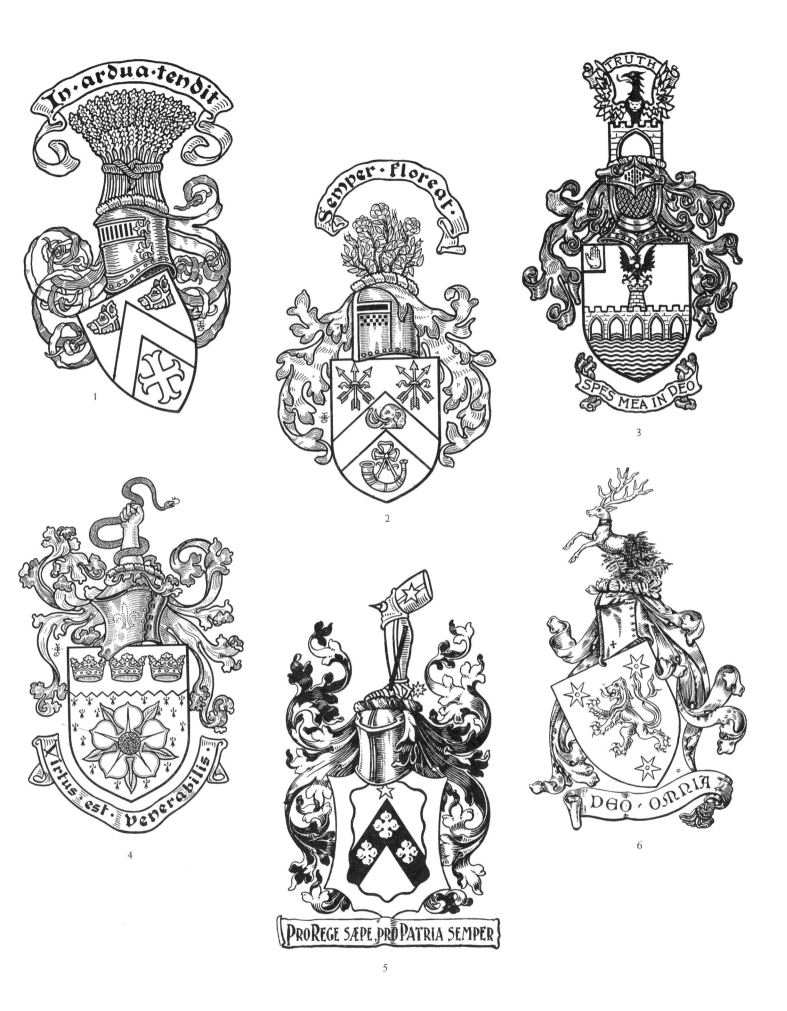

1. John Polson. 2. John D. Inverarity. 3. Sir Wroth A. Lethbridge. 4. Stephen Leech.
5. Frederic J. Eyre. 6. George L. Harter.

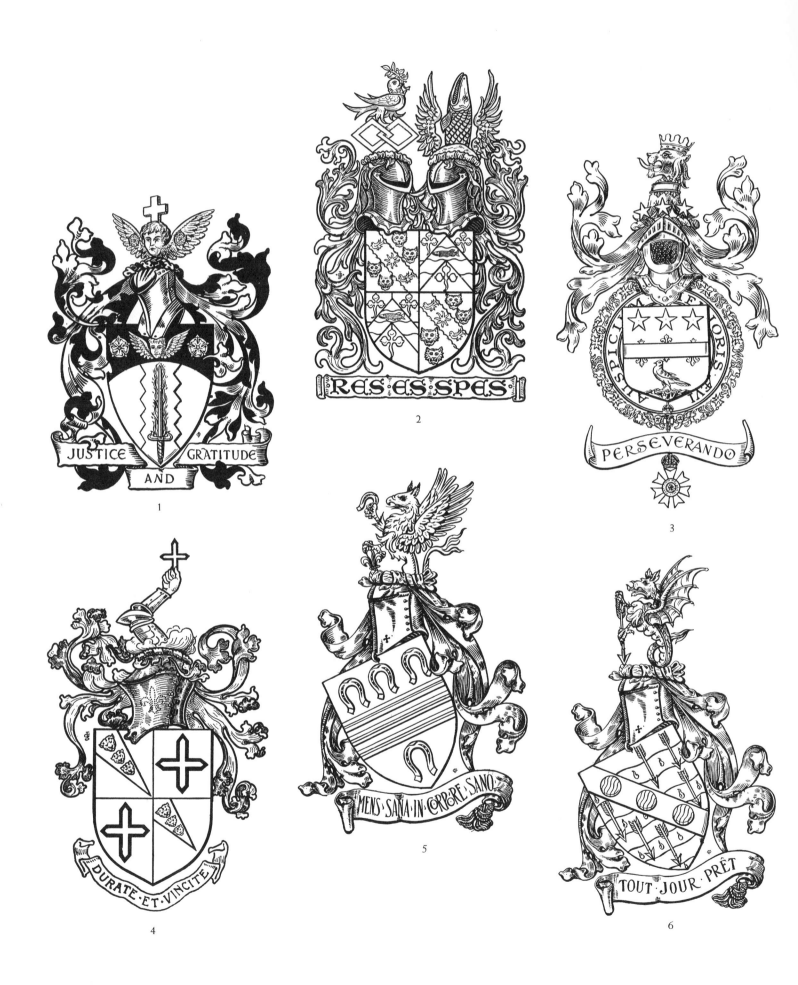

1. John Maddocks. 2. John M. Pyke-Nott. 3. Sir Cecil C. Smith. 4. James E. Darbishire.
5. Thomas D. Burlton. 6. James Mansergh.

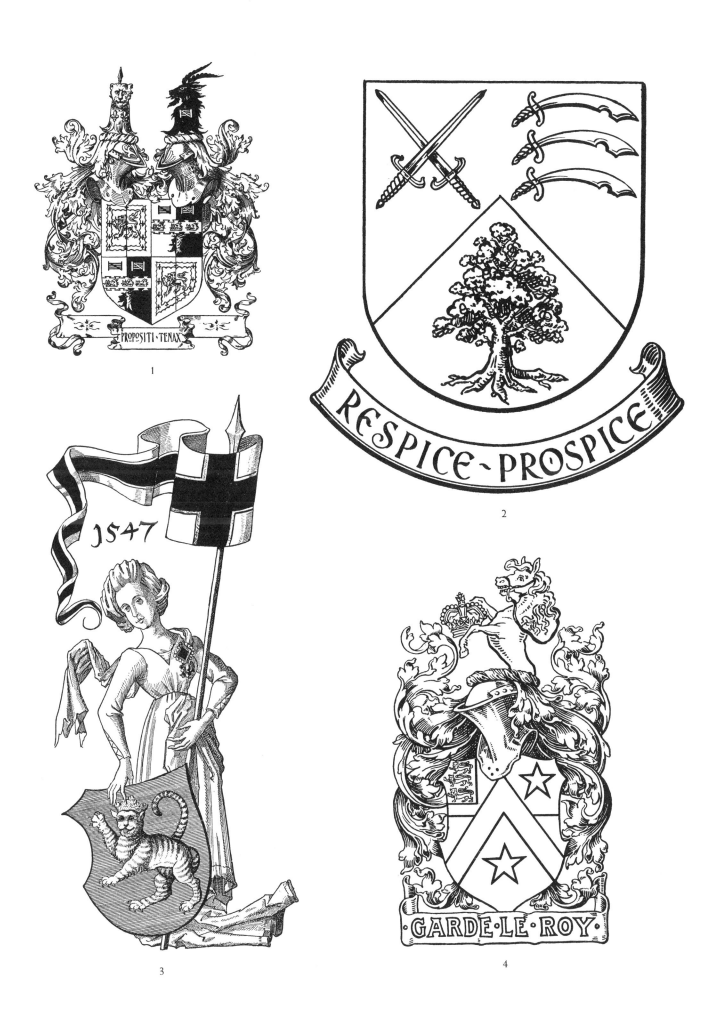

1. Yeatman-Biggs. 2. The Borough of Ealing. 3. The Genealogical Society "at the Sign of the Cat"
(device). 4. Lane.

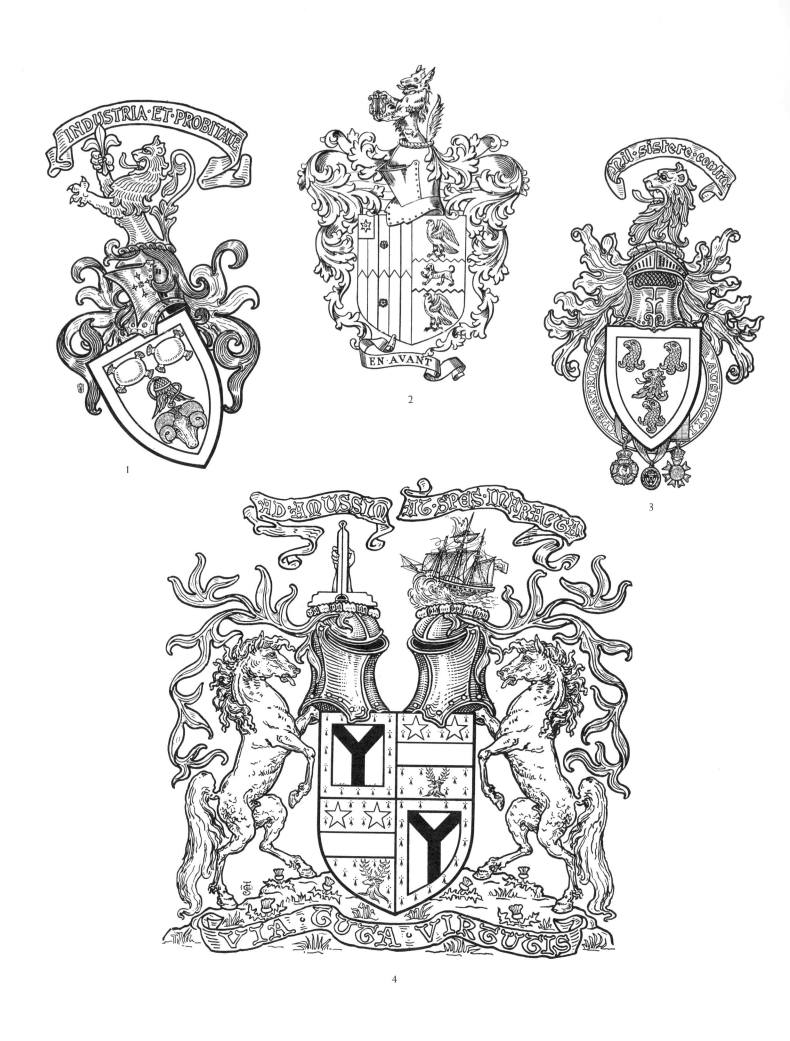

1. Alexander F. Roberts. 2. Ernest A. Ebblewhite. 3. Sir Arthur Nicolson. 4. John A. Cunninghame.

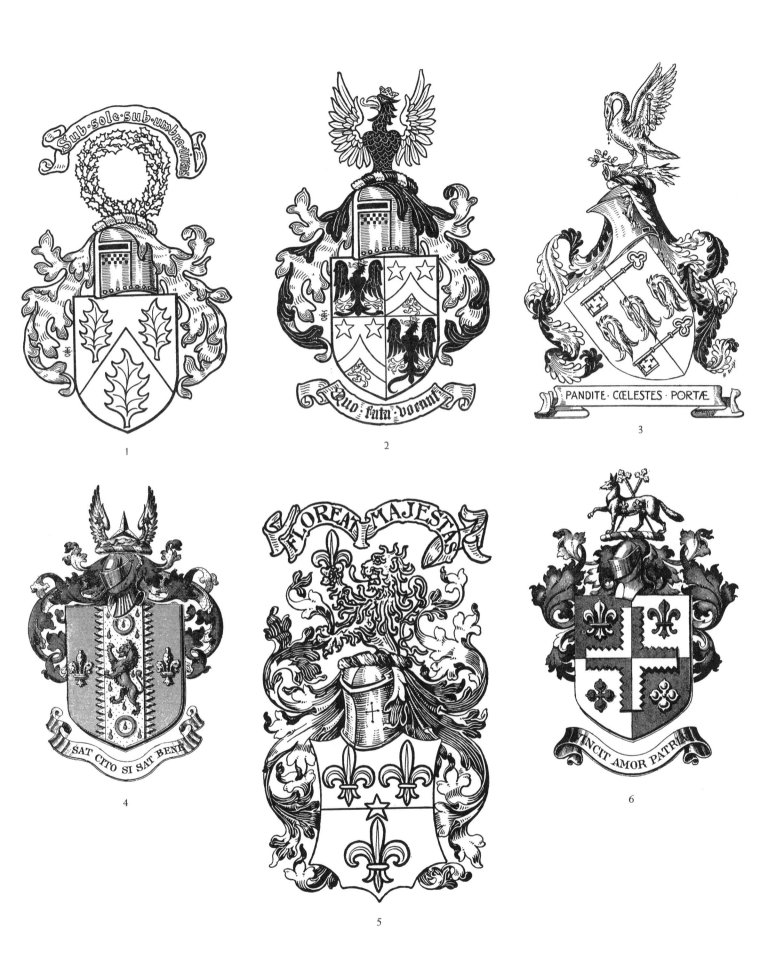

Sub·sole·sub·umbra·virens

Quo fata vocant

PANDITE · CŒLESTES · PORTÆ

SAT CITO SI SAT BENE

FLOREAT MAJESTAS

VINCIT AMOR PATRI

1 2 3 4 5 6

1. Thomas Irvine. **2.** Rodolph L. Aldercron. **3.** William Gibson. **4.** Jeremiah Colman. **5.** James
M. Brown. **6.** Edward Ashworth.

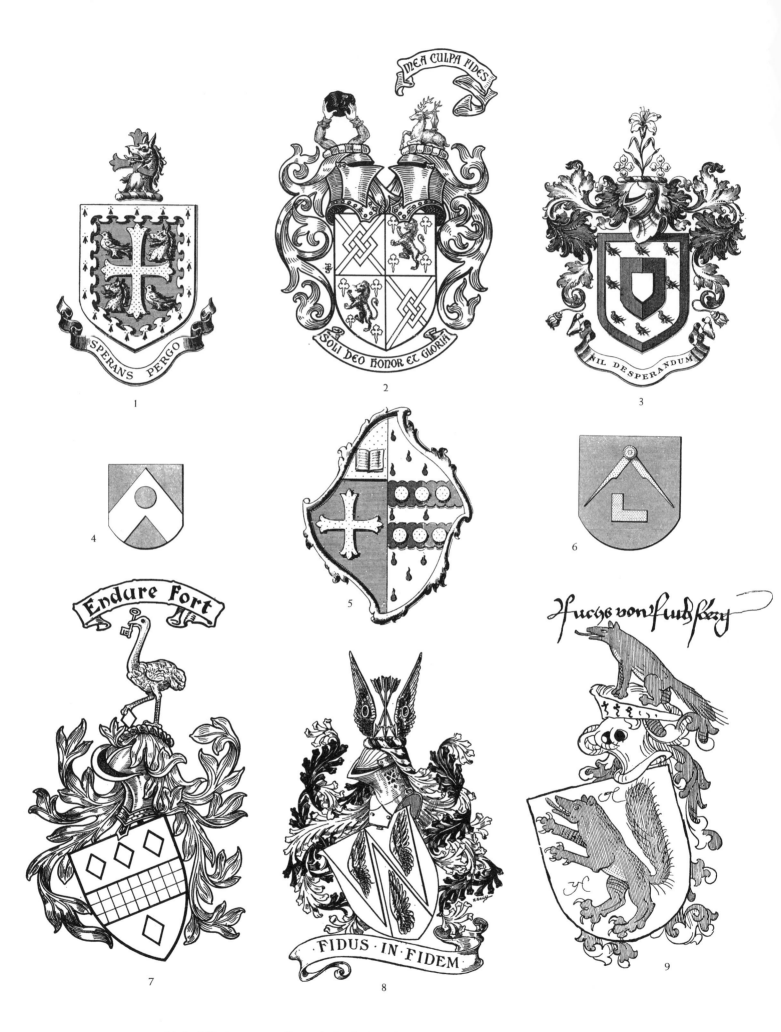

1. Michael Tomkinson. 2. Denys A. Lawlor-Huddleston. 3. Alfred Chadwick. 4. The Joiners, Metz. 5. Enriqueta A. Rylands. 6. The Carpenters, Villefranche. 7. Thomas Lindsay. 8. Charles E. Williams. 9. Fuchs von Fuchsberg.

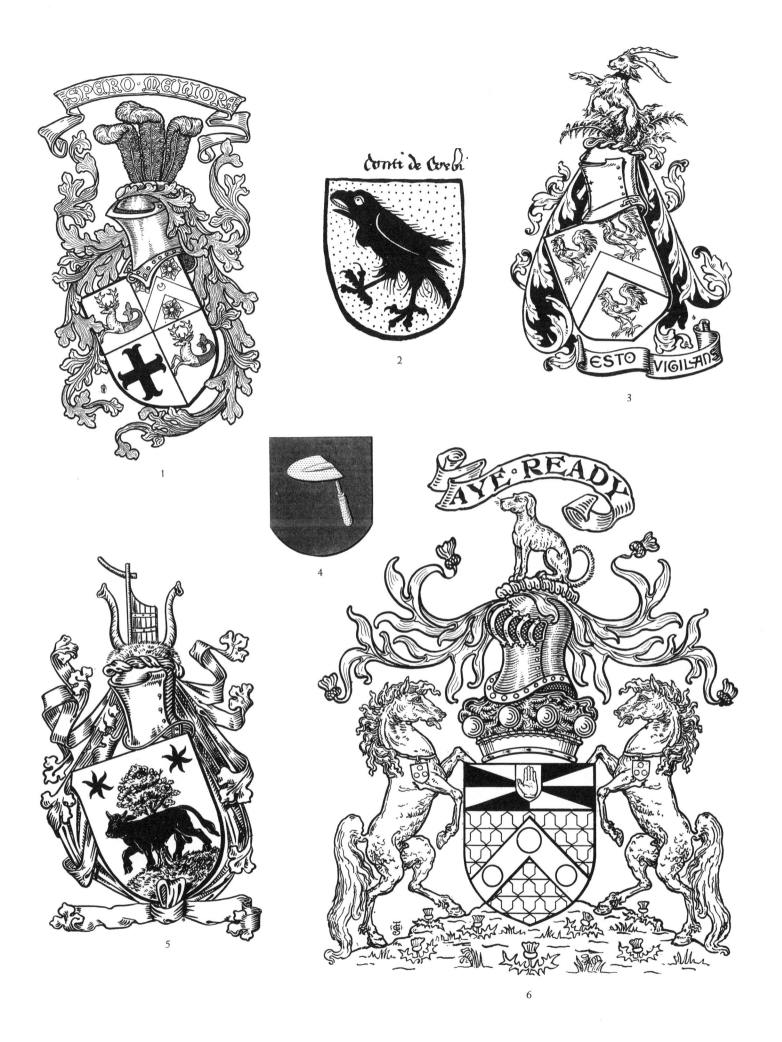

1. Marindin. 2. (?)Corbet. 3. Wilson Lloyd. 4. The Masons, Tours. 5. Harry W. Verelst.
6. Sir William W. Hozier, Lord Newlands.

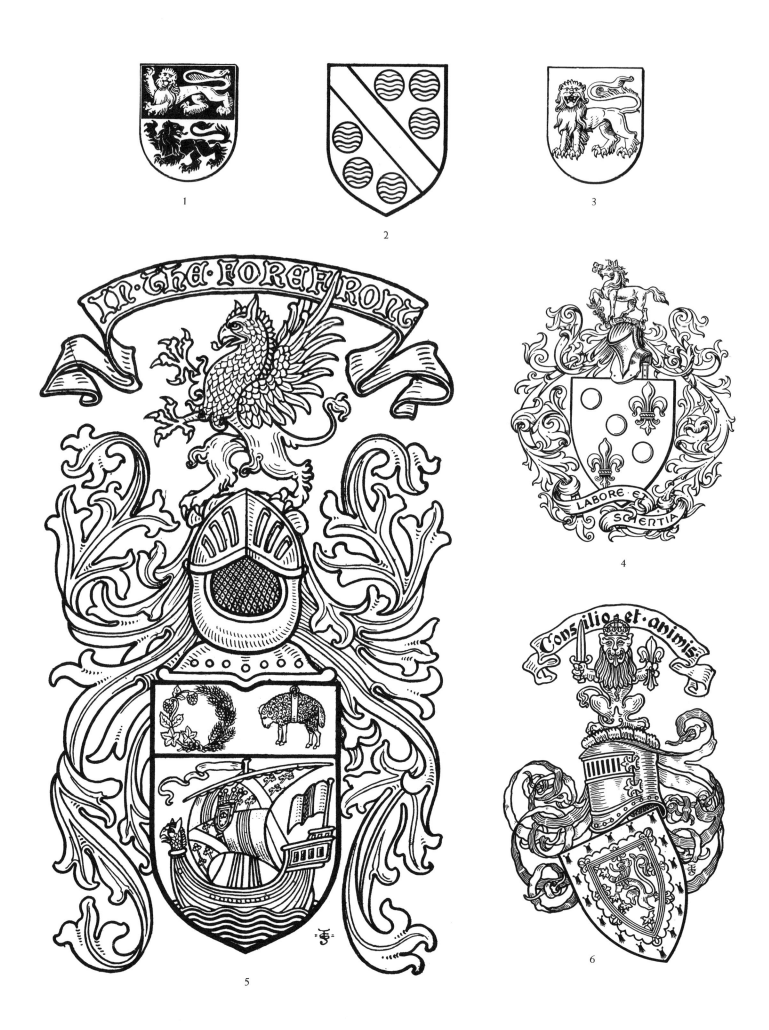

1. ABOVE: A lion passant guardant; BELOW: A lion passant regardant. 2. The Lords Stourton.
3. A lion statant guardant. 4. John Ince. 5. The Burgh of Alloa. 6. Alexander C. Maitland.

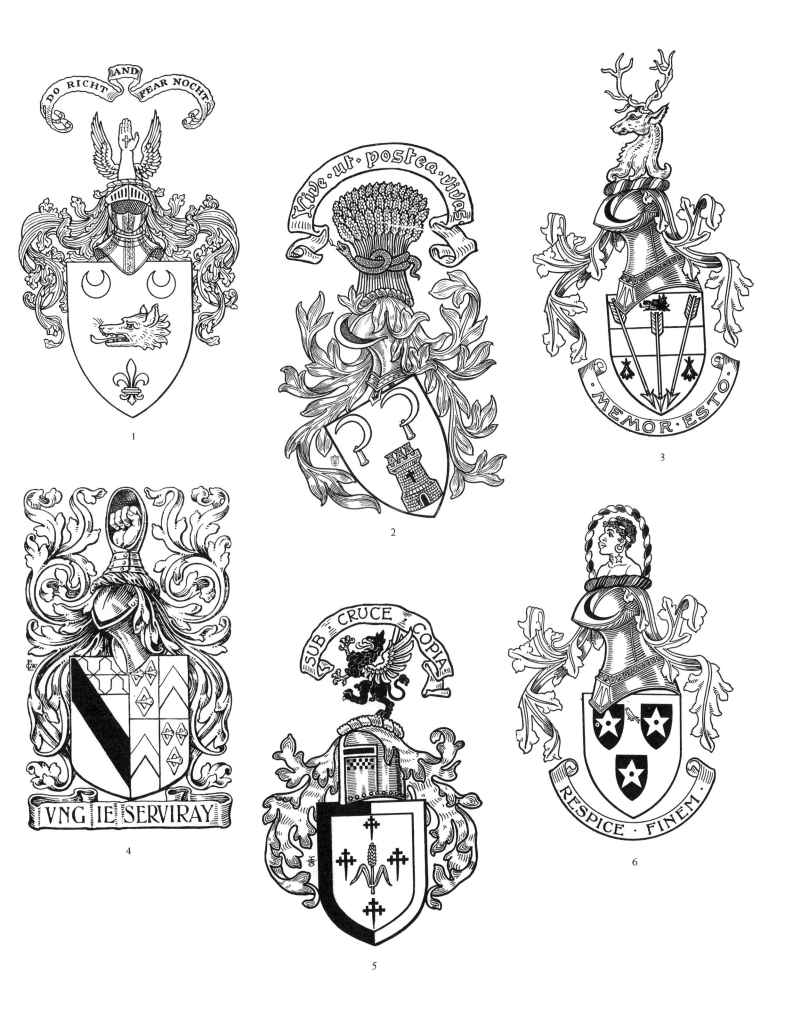

1. Sir Noel Paton. 2. Johnson Shearer. 3. John H. Hutchison. 4. Basil T. Fitz-Herbert.
5. Alexander Cross. 6. James Lumb.

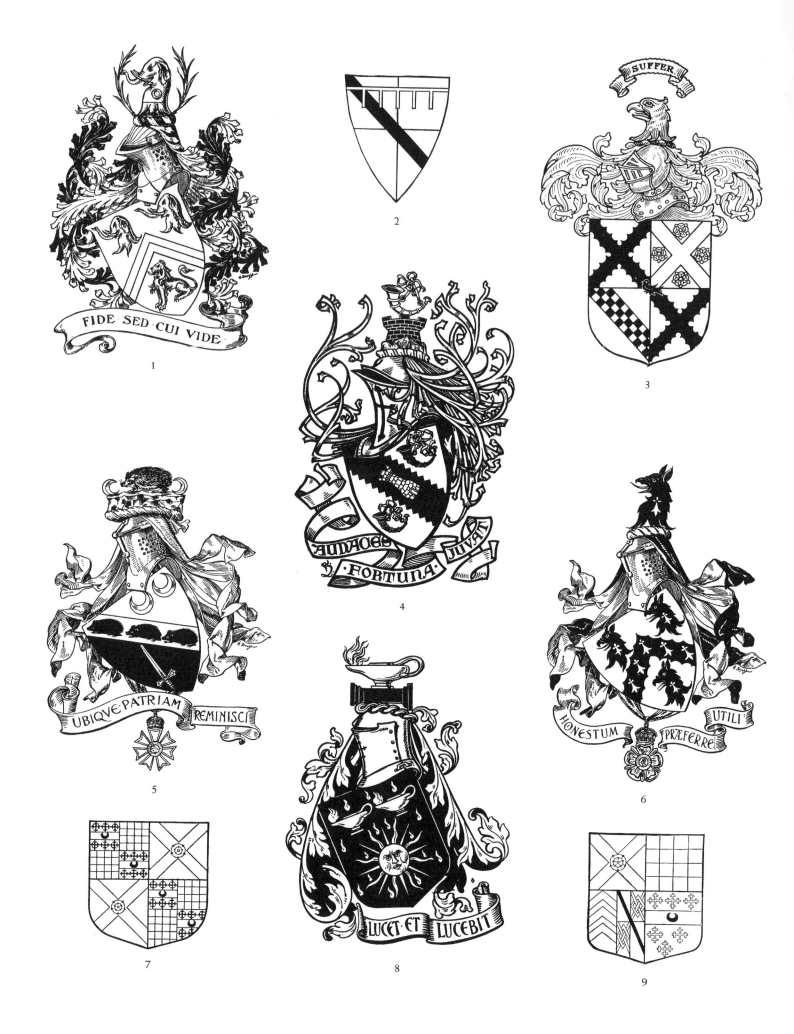

FIDE·SED·CUI·VIDE

SUFFER

AUDACES FORTUNA·JUVAT

UBIQVE·PATRIAM REMINISCI

HONESTUM PRÆFERRE UTILI

LUCET·ET·LUCEBIT

1. William H. Saunders. 2. John de Lacy, Earl of Lincoln. 3. James Haldane. 4. William R. Horncastle. 5. Walter H. Harris. 6. Frederick D. Raikes. 7. Edward Nevill, Baron Abergavenny. 8. Henry A. Willey. 9. George Nevill, Baron Abergavenny.

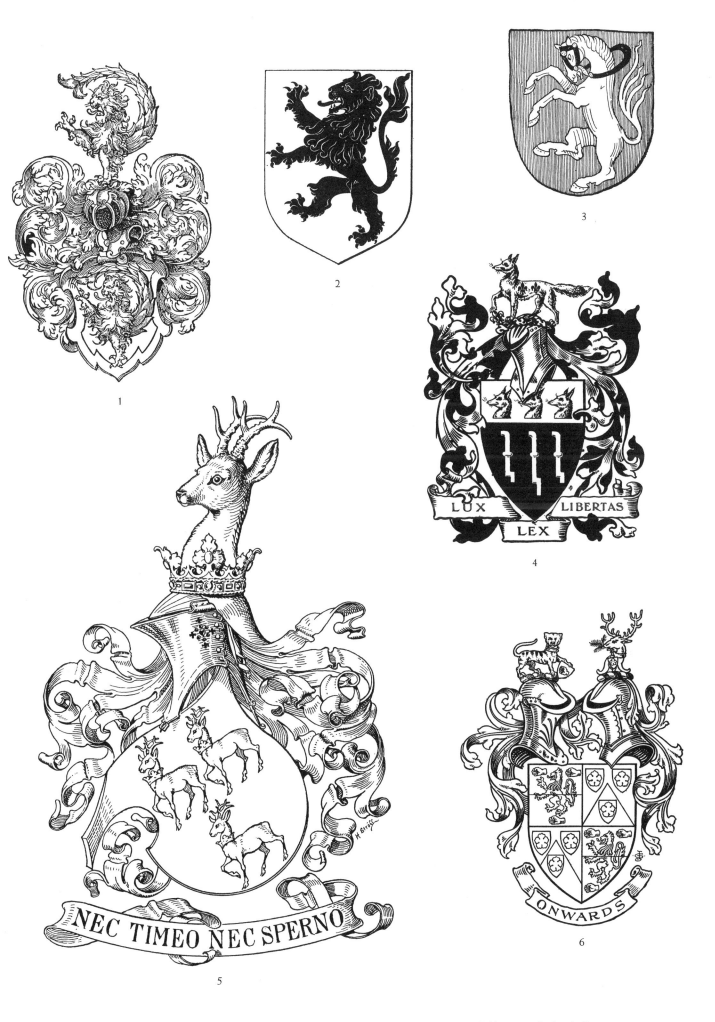

1. Imhof. 2. A lion rampant. 3. Von Frouberg. 4. William Colfox. 5. Richard Greene.
6. Charles Frazer-Mackintosh.

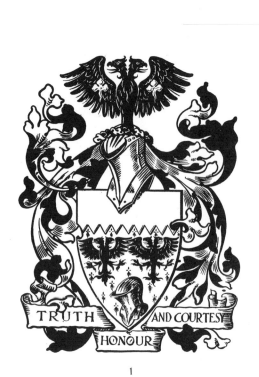

1

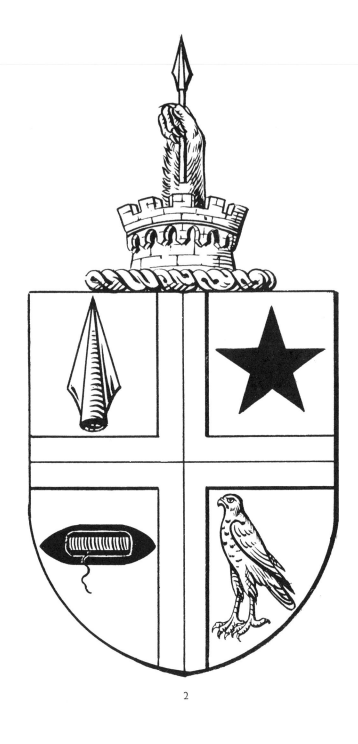

3

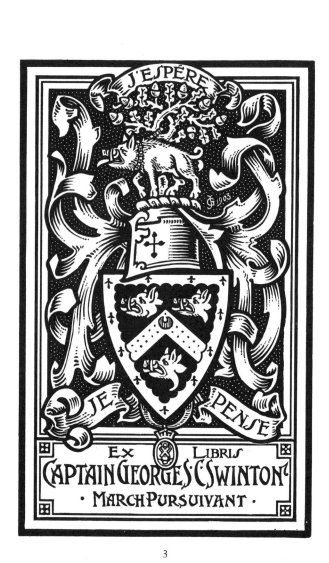

2

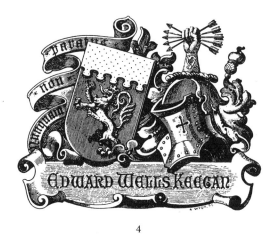

4

1. Robert George. 2. The Town of Leigh. 3. George S. Swinton (bookplate). 4. Edward W. Keegan.

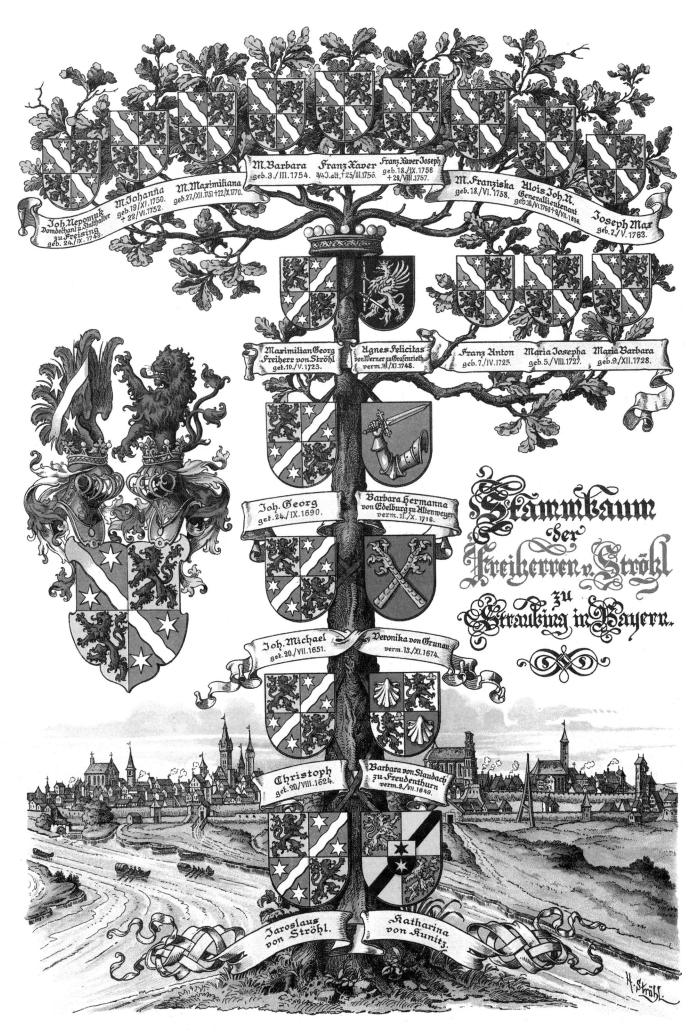

Stammbaum der Freiherren von Ströhl zu Straubing in Bayern [Family Tree of the Barons von Ströhl of Straubing in Bavaria].

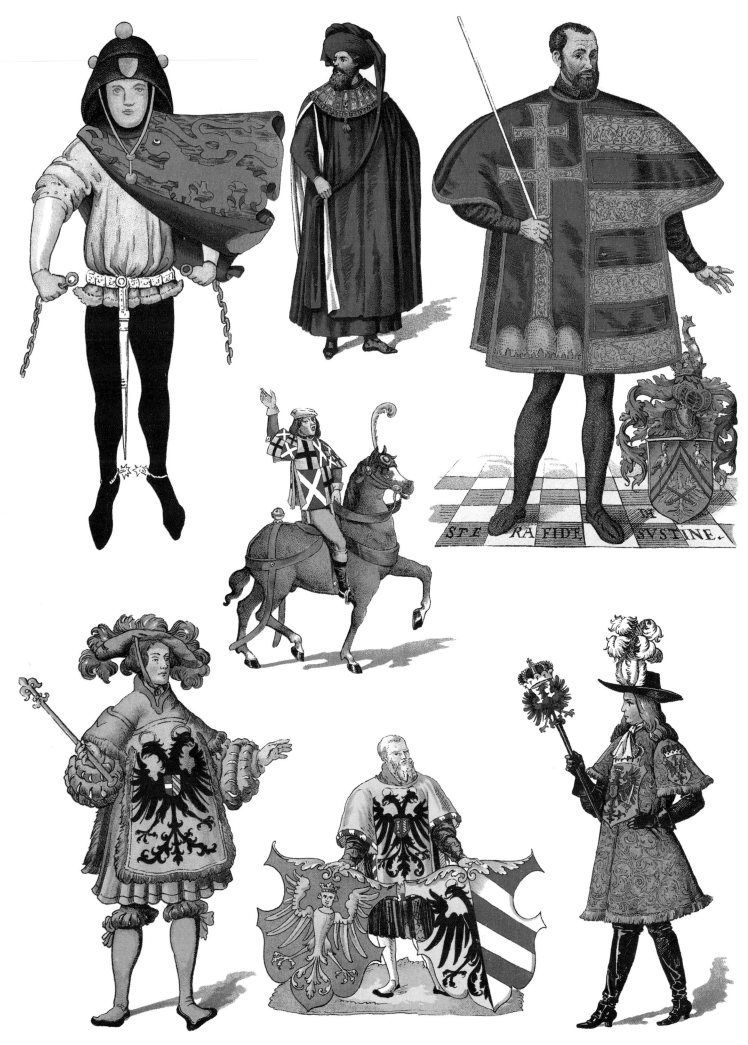

Heralds in official dress.

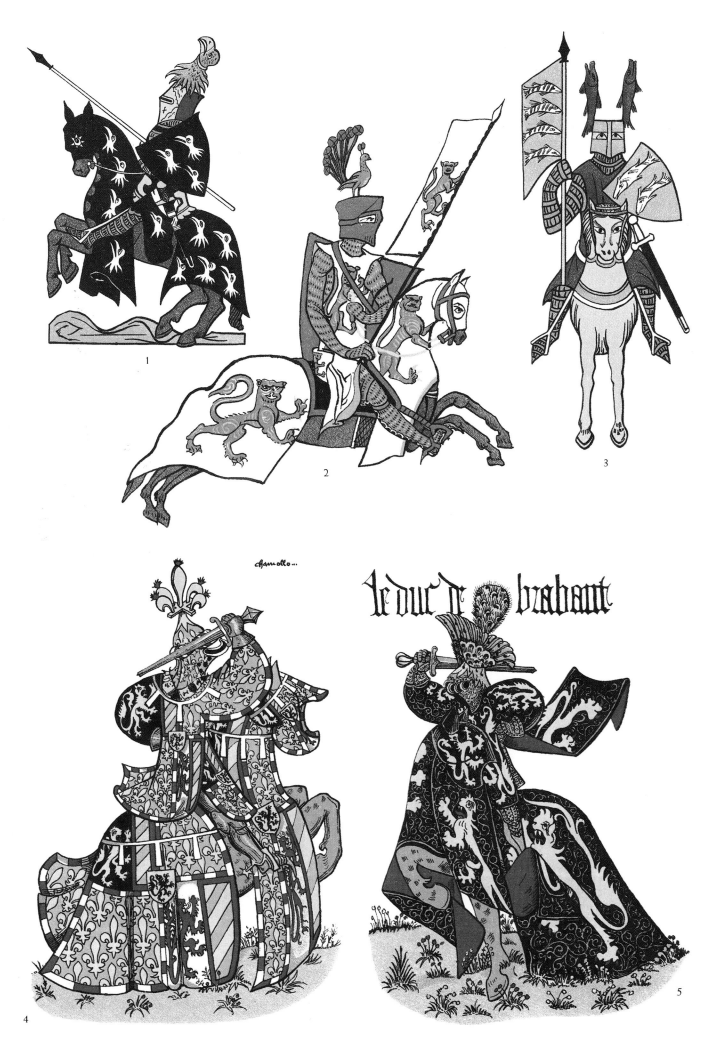

1. Hartmann von Aue. 2. Lazarius Marcellinus Gerardini. 3. Wahsmut von Künzing. 4. Charles the Bold, Count of Charolais. 5. The Duke of Brabant.

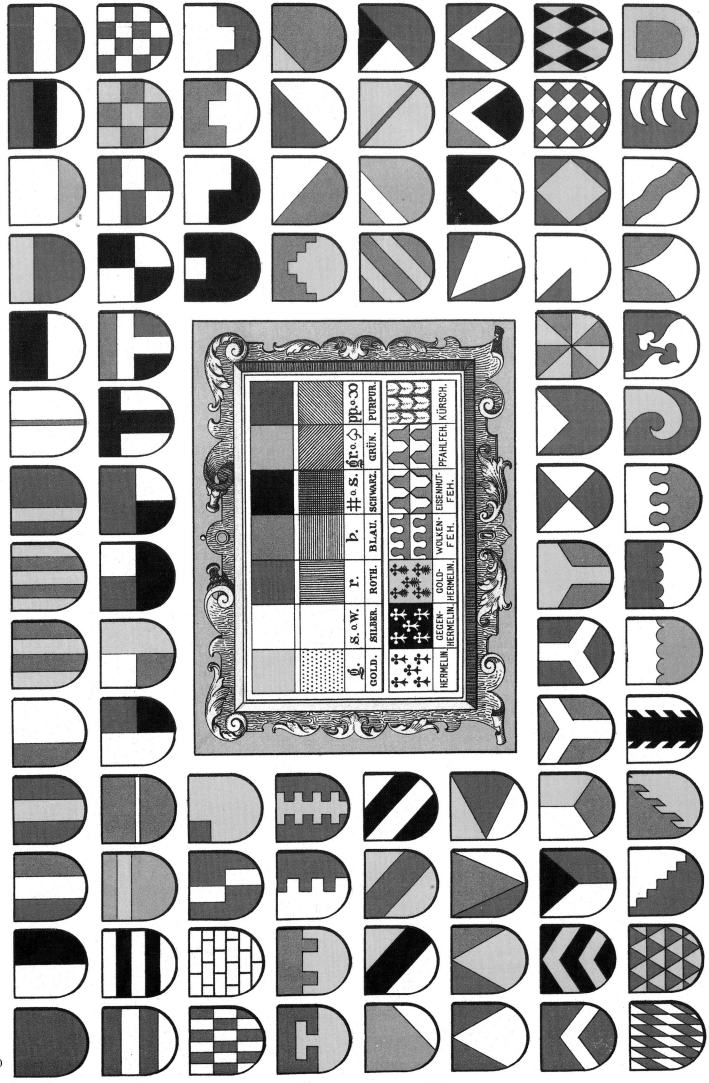

Ordinaries and lines of partition.

GOTHISCHE · DAMASZIERUNG ·

·:· RENAISSANCE · DAMASZIERUNG ·:·

Ordinaries and other heraldic charges.

31

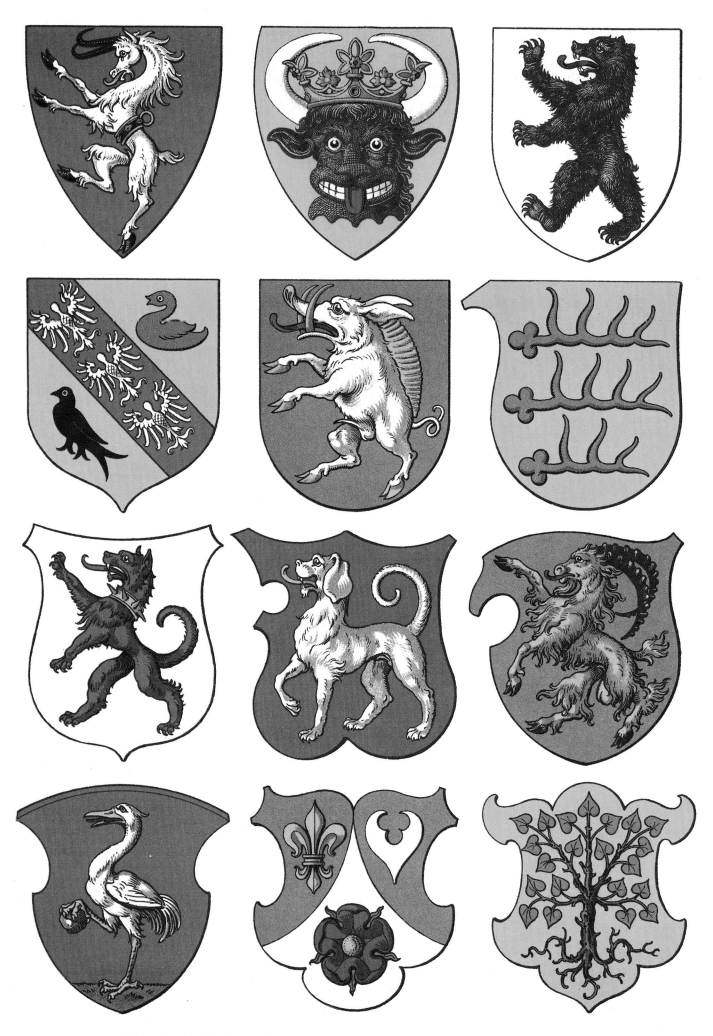

A chronological table showing the changing shape of the armorial shield from the fourteenth to the sixteenth century.

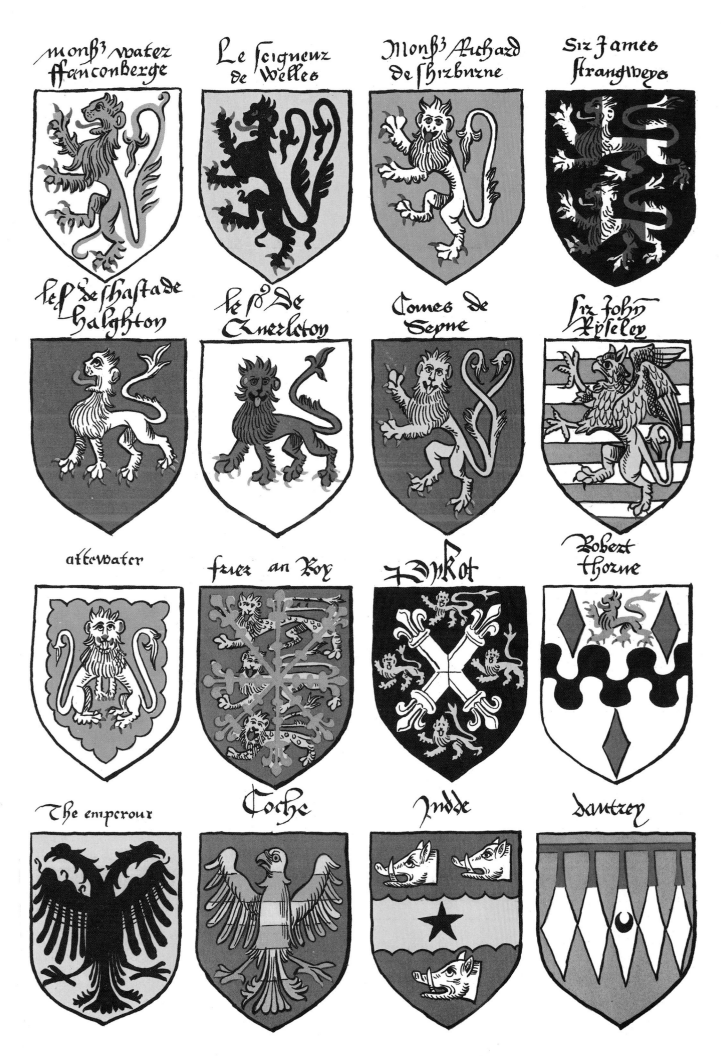

monßr watez ffauconberge

Le feigneuz de Welles

Monßr Richard de fhrzburne

Siz James ftrangweys

le ß de fhaftade halghton

le ß de Anerleton

Comes de Seyne

Siz John Xyfeley

attewater

freres an Roy

Dykot

Robert thorne

The emperour

Coche

Indde

dautzey

Arms from the sixteenth-century *Prince Arthur's Book.*

33

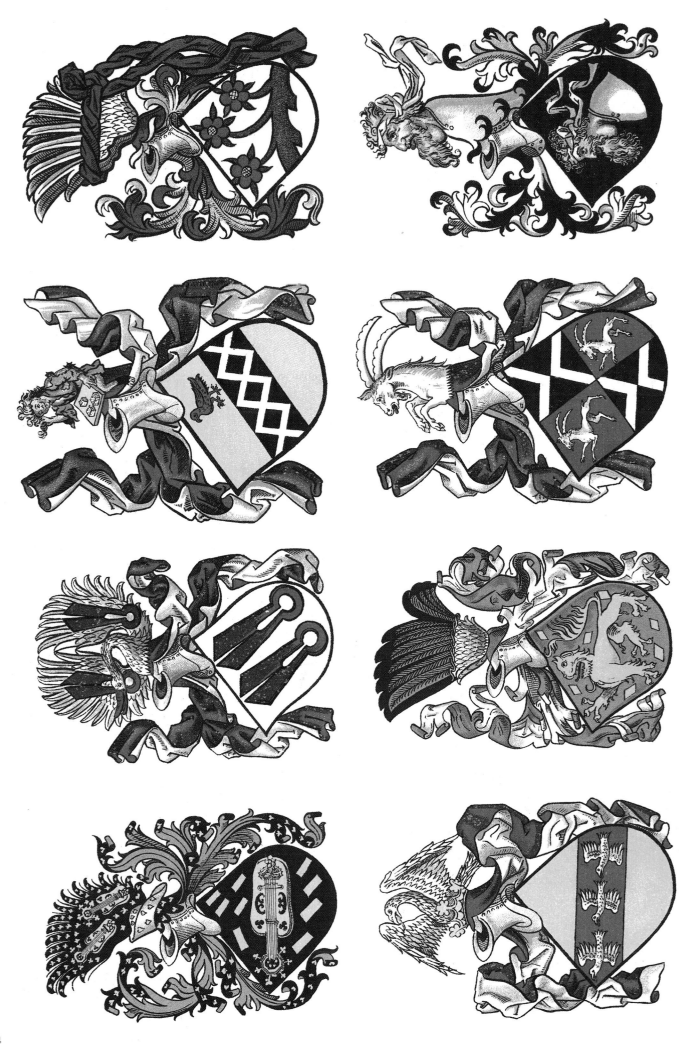

Arms from the fifteenth-century *Schieblersches Wappenbuch* [Schiebler Book of Arms].

1. The King of Bohemia. 2. The Emperor of Trebizond.

35

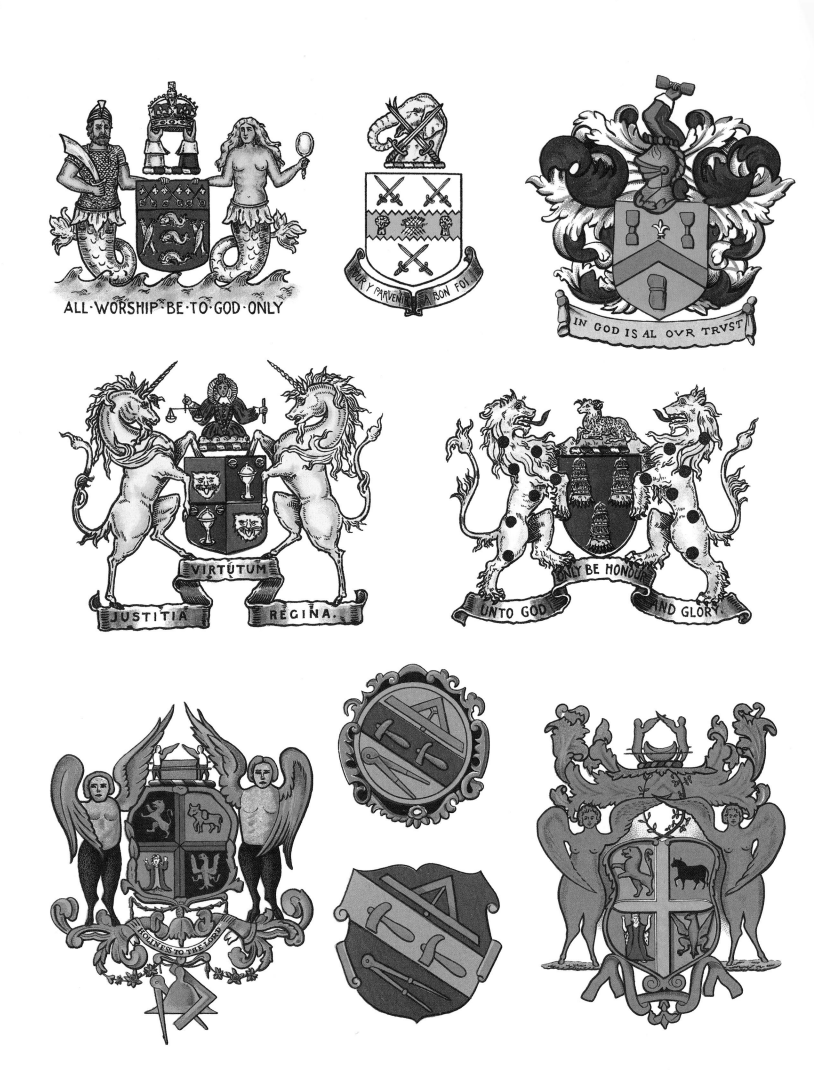

Arms of companies and Masonic lodges.

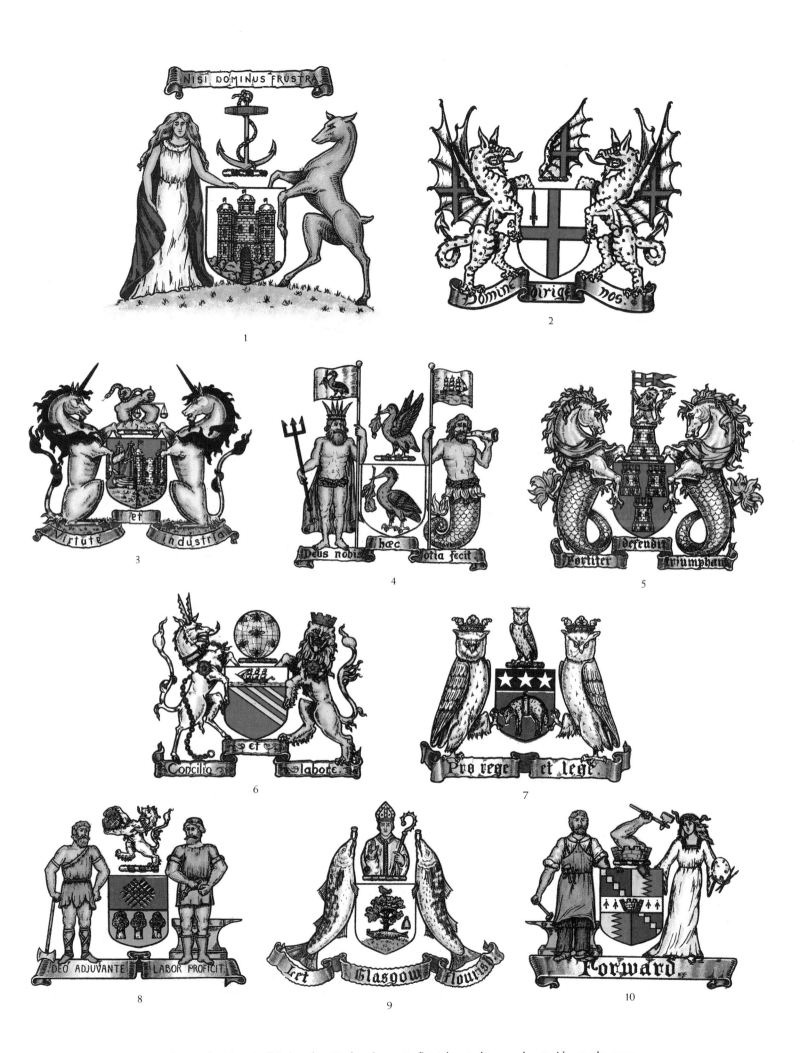

Arms of cities: **1**. Edinburgh. **2**. London. **3**. Bristol. **4**. Liverpool. **5**. Newcastle upon Tyne. **6**. Manchester. **7**. Leeds. **8**. Sheffield. **9**. Glasgow. **10**. Birmingham.

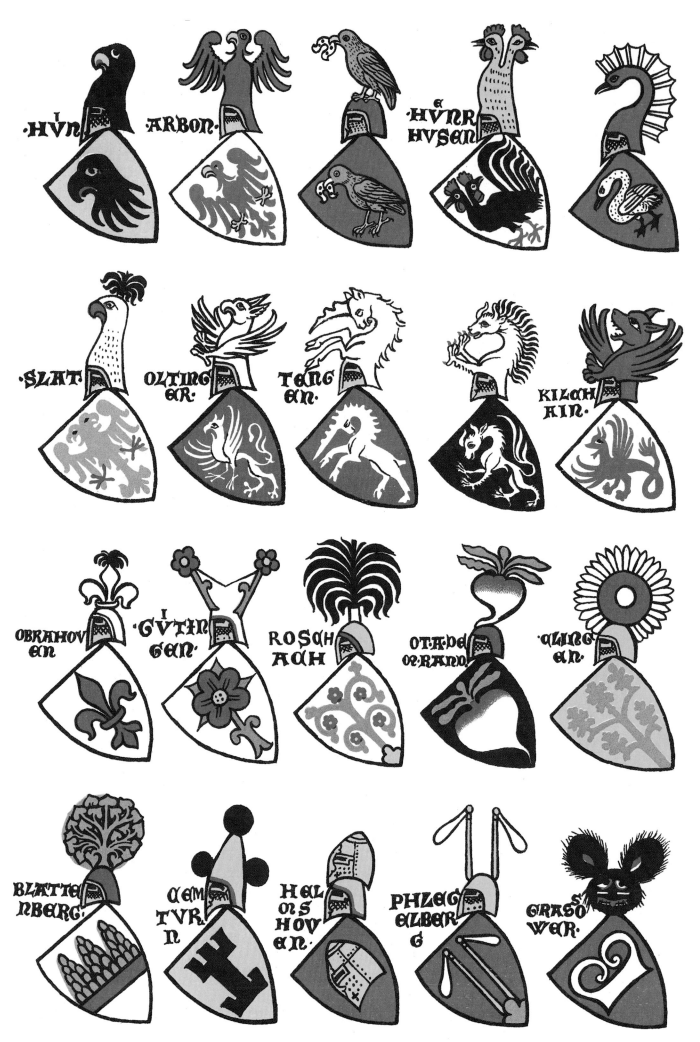

Arms from the fourteenth-century *Züricher Wappenrolle* [Zurich Roll of Arms].

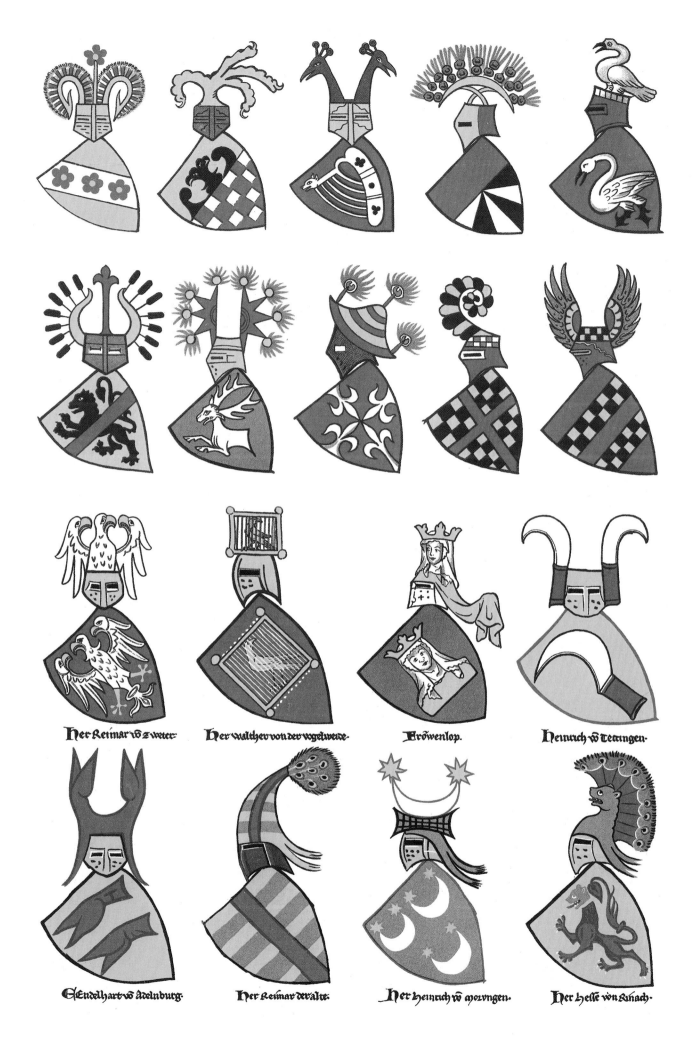

Her Reimar võ zweter· Her walther von der vogelwerte· Frŏwenlop· Heinrich võ Tettingen·

Endelhart võ adelnburg· Her Reimar deralte· Her heinrich võ mozvngen· Her helle võ Sinach·

Arms from the Weingarten and Heidelberg minnesinger songbooks.

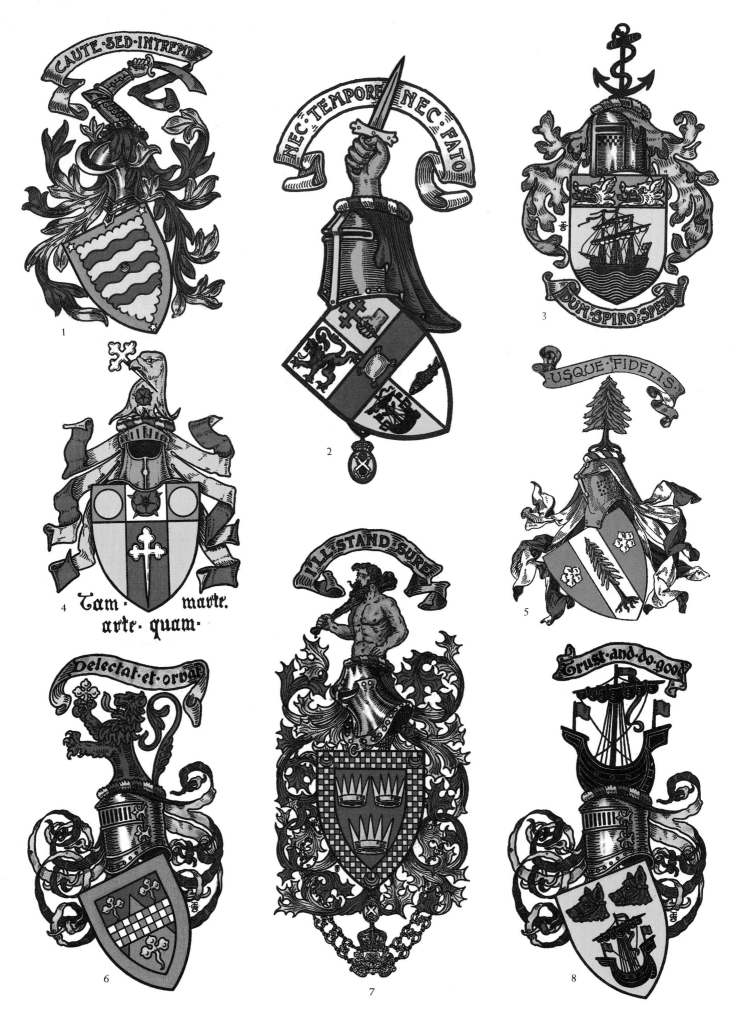

1. Reginald H. Drummond. 2. William R. Macdonald. 3. Albemarle O. Dewar. 4. Sir Thomas Wright. 5. J. W. Melles. 6. Matthew W. Hervey. 7. Francis J. Grant. 8. John A. Galbraith.

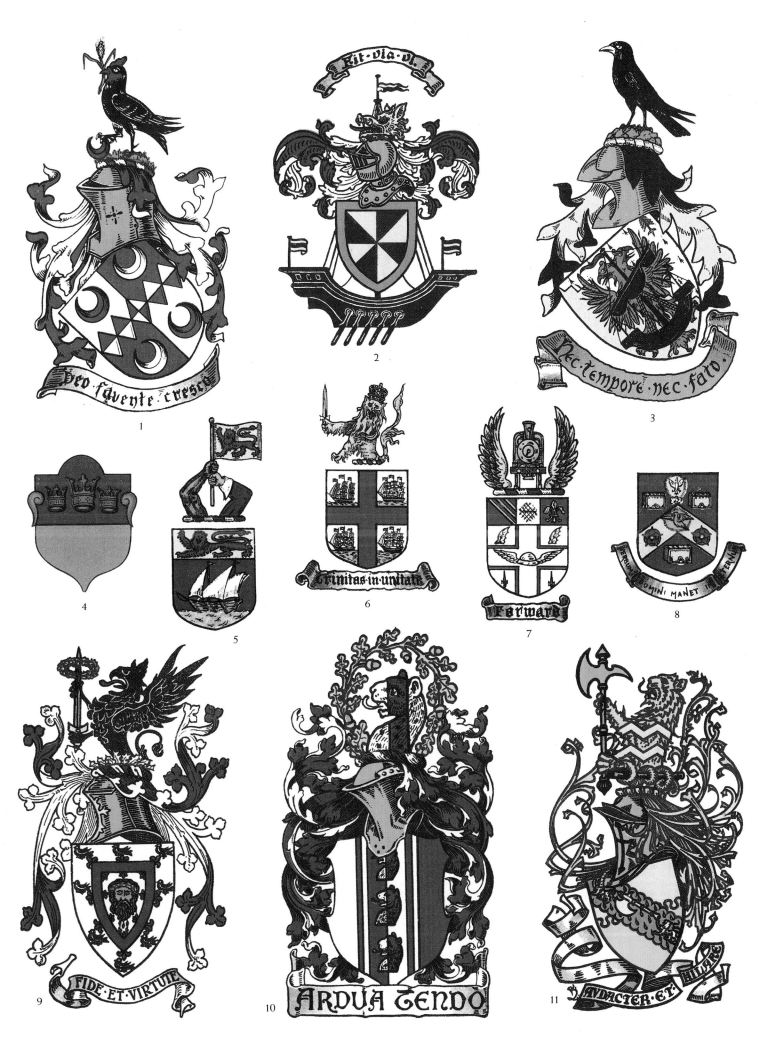

1. Bartlett. 2. Campbell. 3. William K. Macdonald. 4. The City of Cologne. 5. The North Borneo Company. 6. The Trinity House. 7. The Central London Railway. 8. A stationers' company. 9. Robert Gladstone. 10. Samuel A. Brain. 11. Peter H. Emerson.

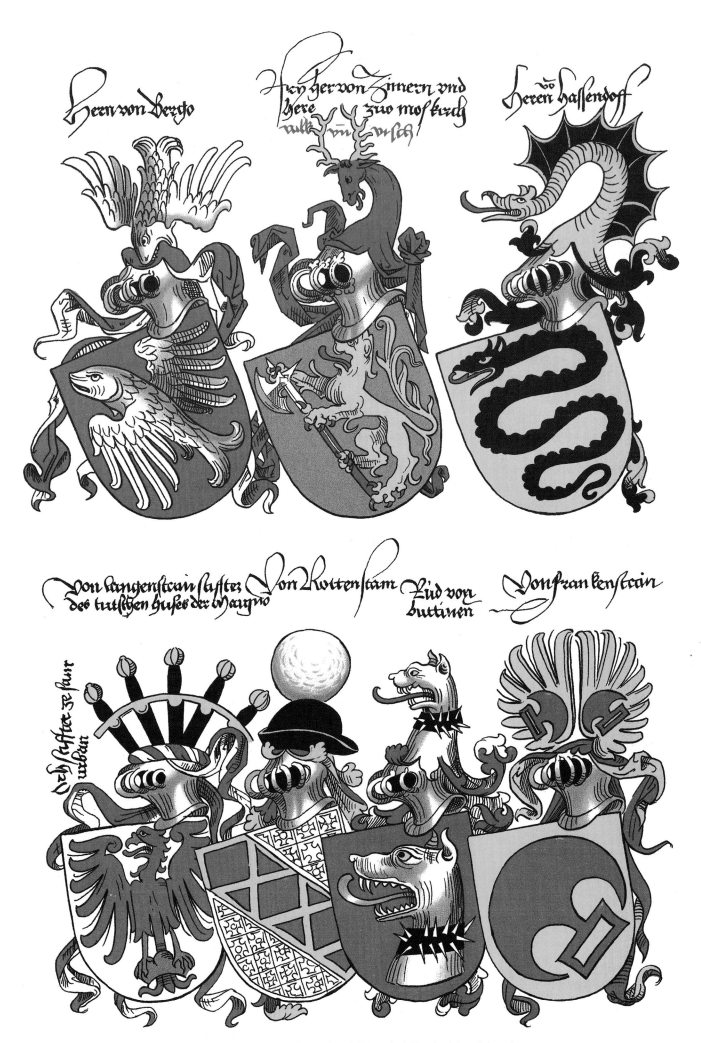

Arms from Conrad Grünenberg's *Wappenbuch* [Book of Arms] (1483).

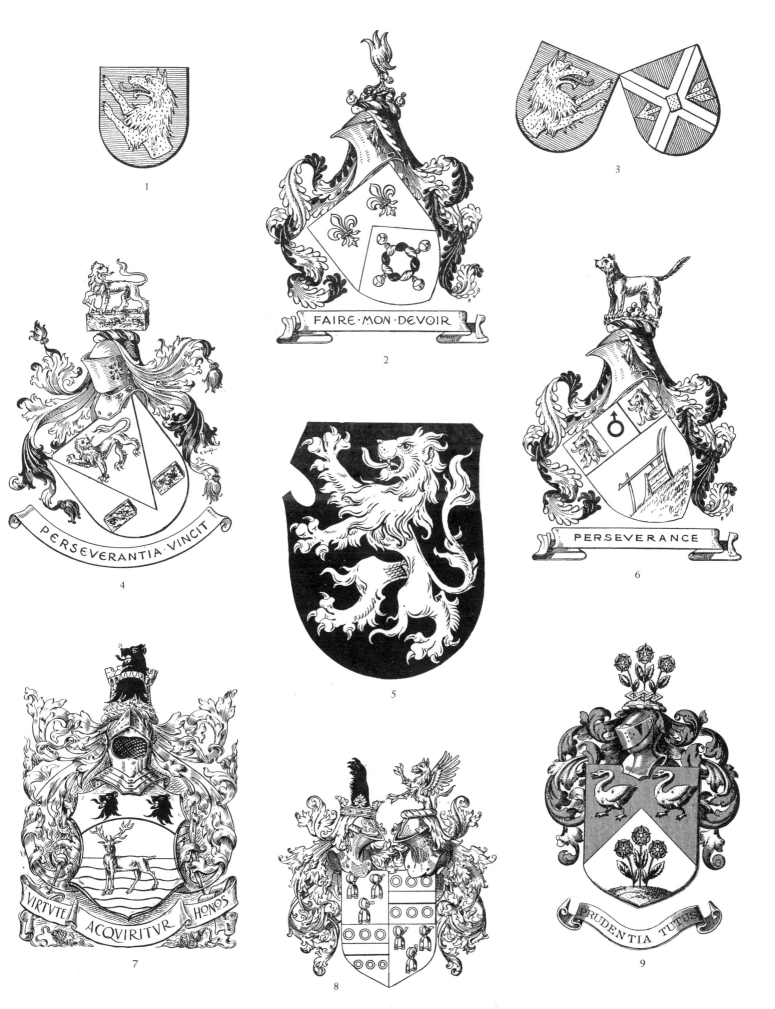

1. Hans Wolf. 2. Walter Joslin. 3. LEFT: Hans Wolf; RIGHT: Catherina Waraus. 4. George Farren. 5. A lion rampant. 6. Codrington F. Crawshay. 7. Sir Thomas Richardson. 8. Edward S. Lucas-Scudamore. 9. Brodribb.

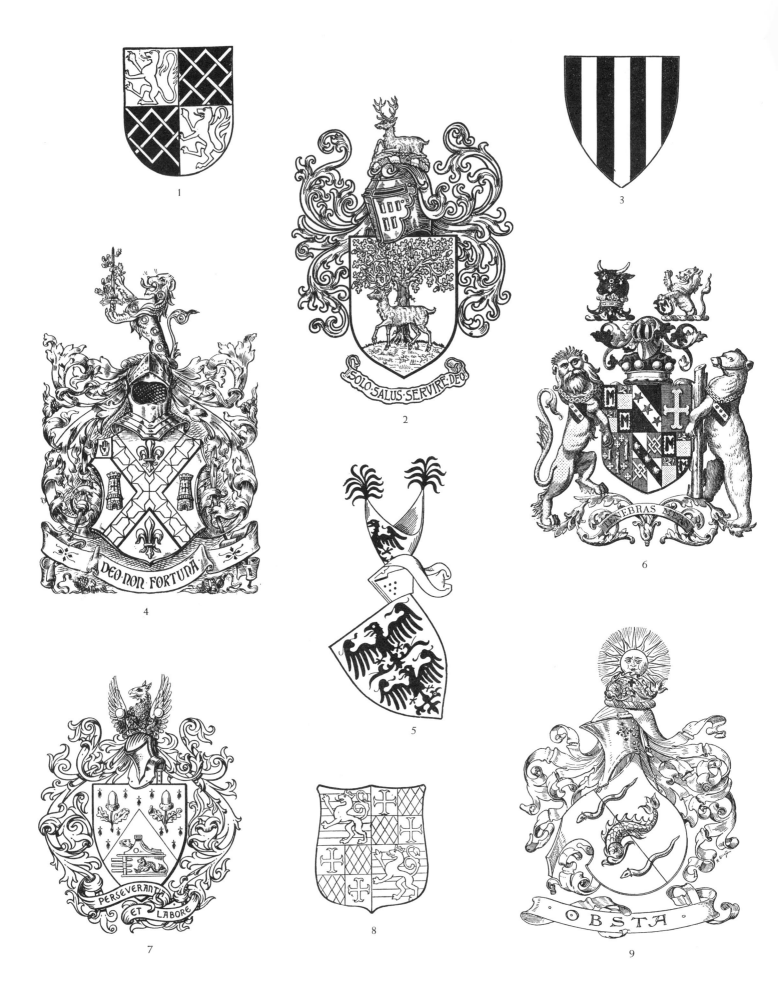

1. John Fitz Alan, Earl of Arundel. 2. George W. Rothe. 3. David de Strabolgi, Earl of Athol.
4. Sir James T. Chance. 5. Honberg. 6. Lord Donington. 7. Duncan G. Pitcher. 8. Charles
Brandon, Duke of Suffolk. 9. Richard A. Ellis.

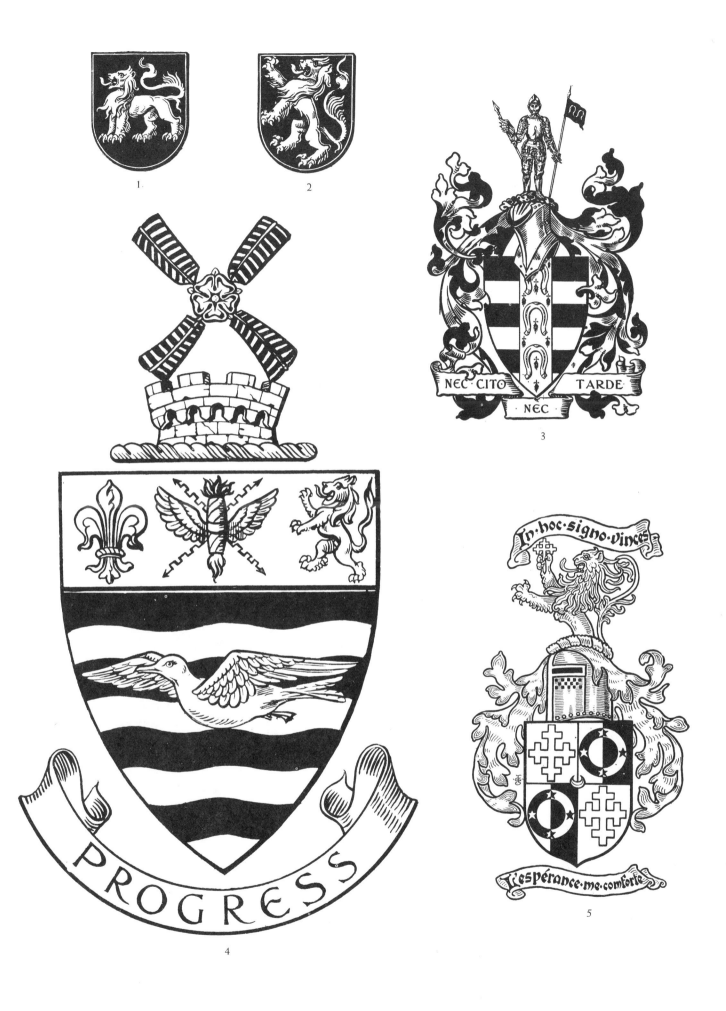

NEC CITO TARDE

NEC

In·hoc·signo·vinces

PROGRESS

L'espérance·me·comforte

1. A lion statant. **2.** A lion rampant. **3.** Julian Marshall. **4.** The Borough of Blackpool. **5.** Robert Berry.

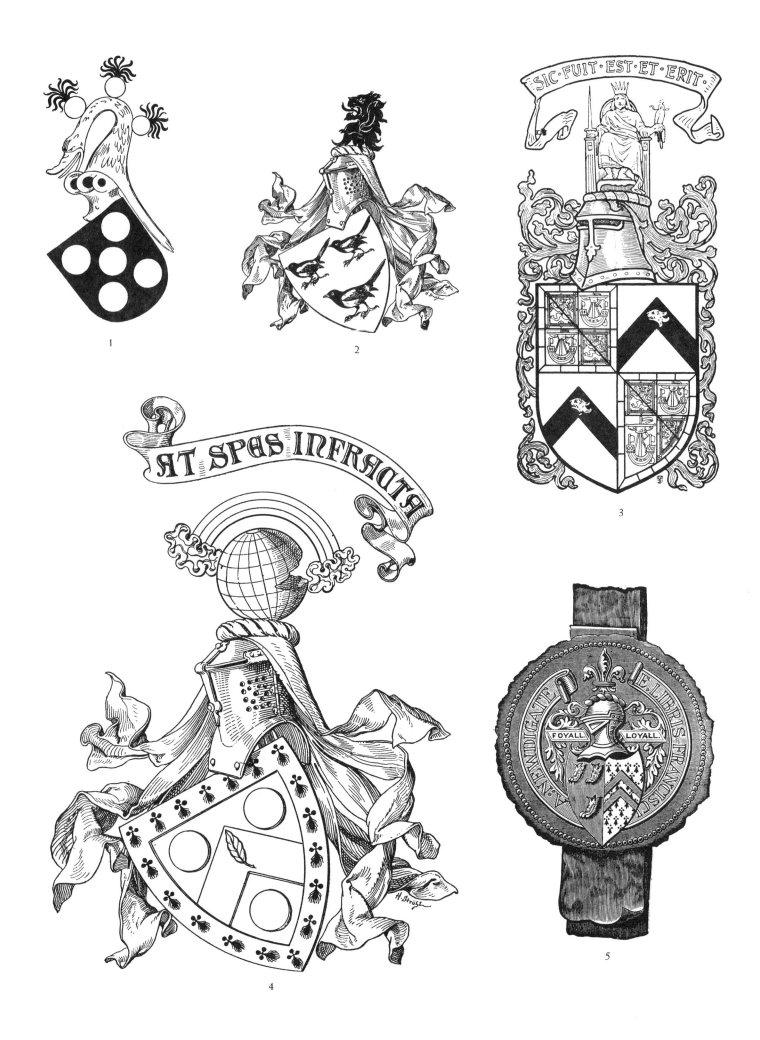

1. Sickingen.　2. Richard D. Dusgate.　3. Charles B. Stewart.　4. James F. Hope.　5. Francis A. Newdigate (bookplate).

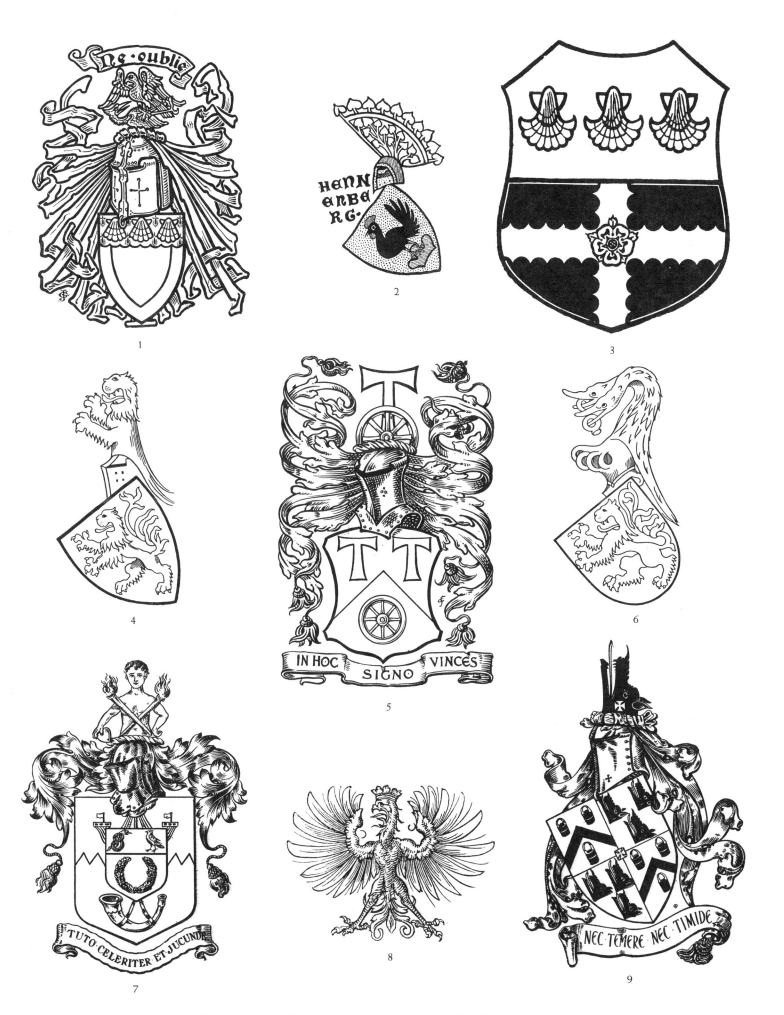

1. James N. Graham. 2. The Counts von Hennenberg. 3. The University Extension College, Reading. 4. The Counts von Hapsburg. 5. John R. Carter. 6. The Counts von Hapsburg-Lauffenberg. 7. Arthur Wall. 8. An heraldic eagle. 9. Thomas P. Pemberton.

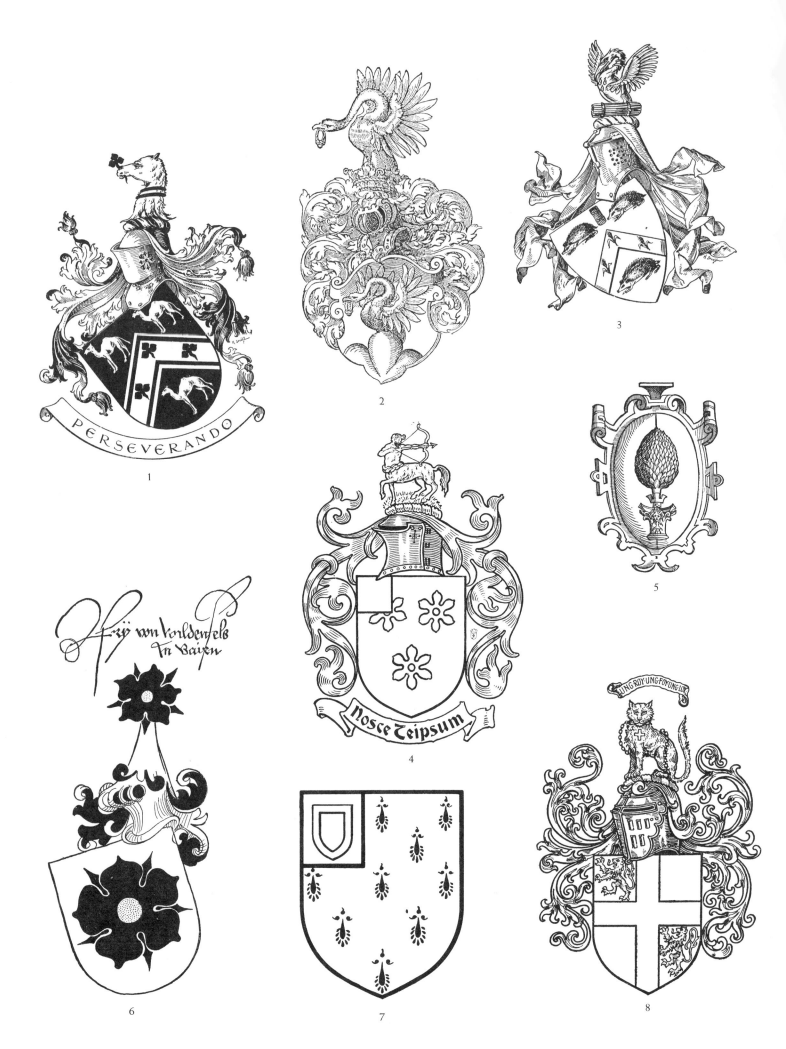

1. George H. Cammel. 2. Gremp. 3. Alfred Harris. 4. Frederick A. Lambert. 5. The City of Augsburg. 6. Baron von Wildenfels. 7. Surtees. 8. Ulick J. Burke.

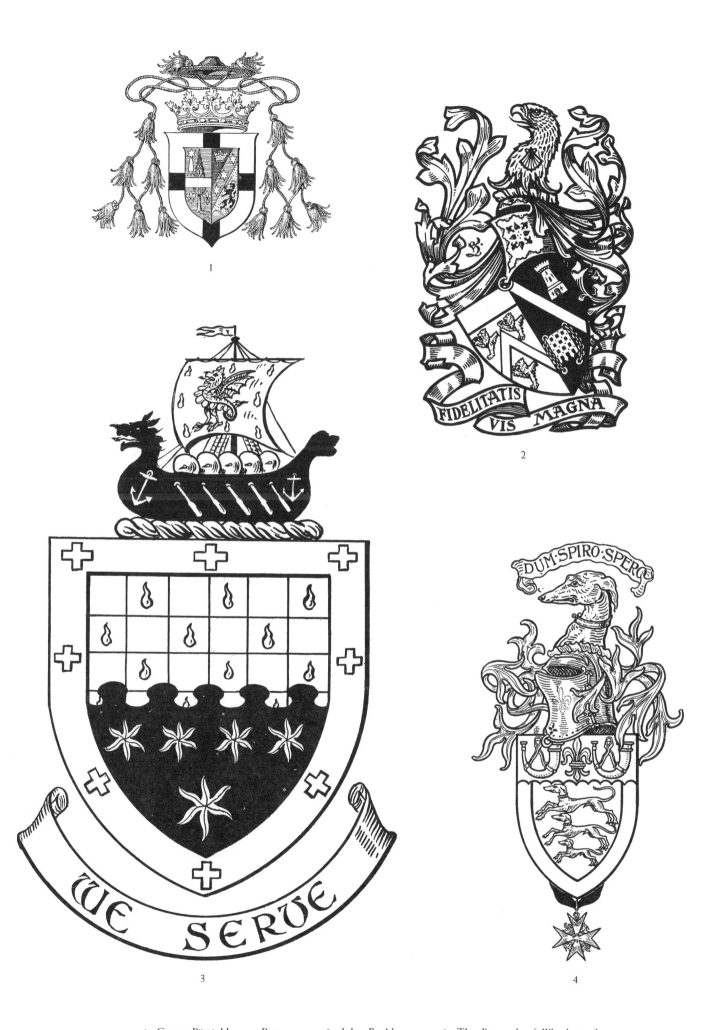

1. Count Pöttickh von Pettenegg. 2. John R. Newman. 3. The Borough of Wandsworth.
4. Charles Hunter.

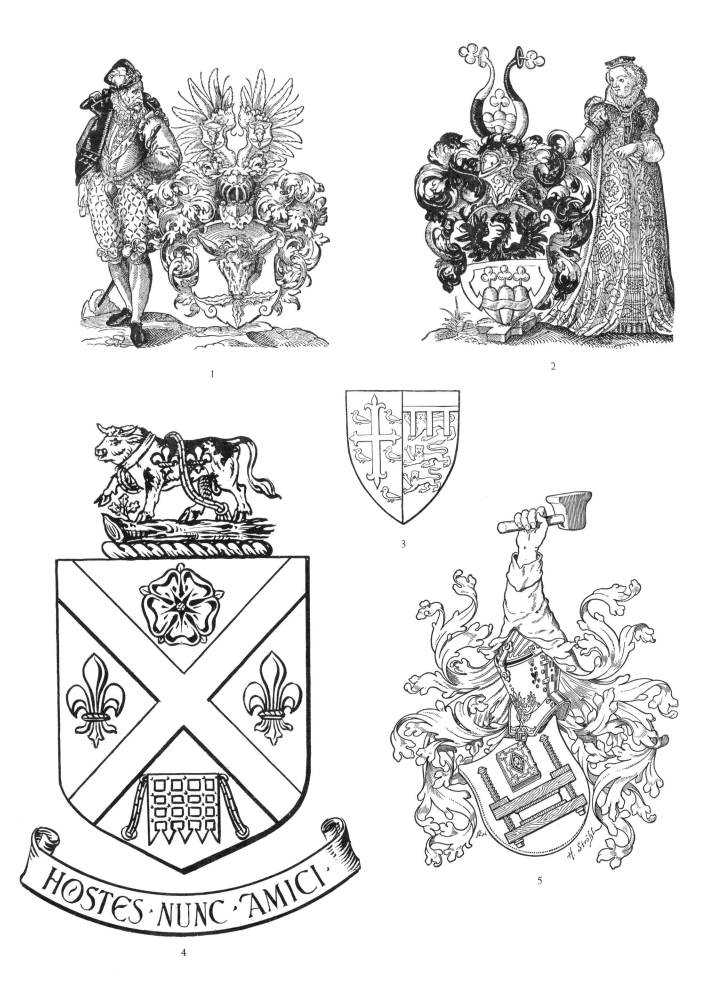

1. Riedesel. 2. Steinheimer. 3. Thomas de Mowbray, Duke of Norfolk. 4. The Town of Abergavenny. 5. A bookbinders' guild.

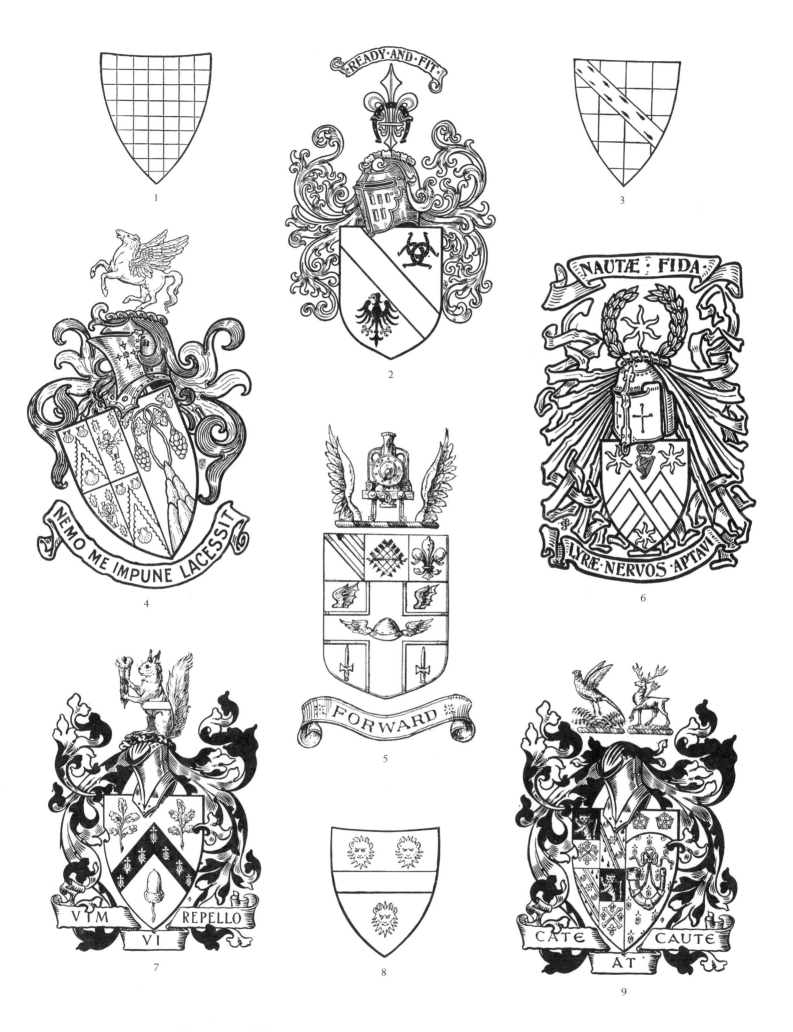

1. Warenne. 2. William Smith. 3. Henry, Earl of Warwick. 4. Tankerville J. Chamberlayne.
5. The Great Central Railway. 6. Edward J. Sirr. 7. William J. Baldwin. 8. Michael de la Pole,
Earl of Suffolk. 9. Alfred S. Scott-Gatty.

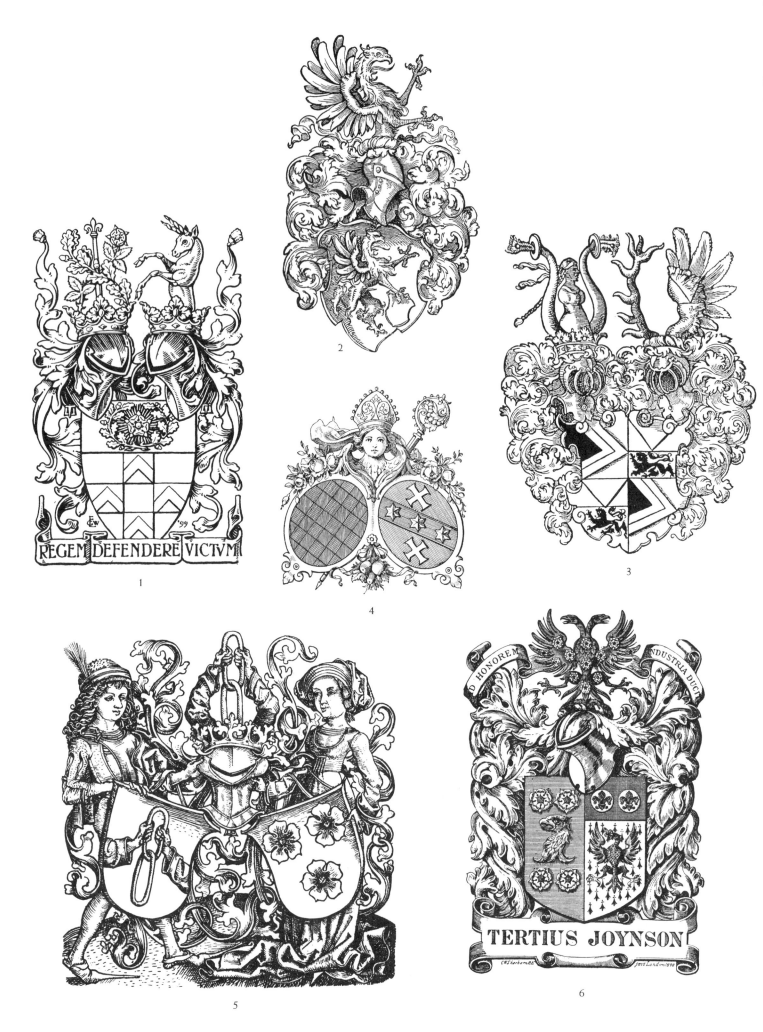

REGEM DEFENDERE VICTVM

TERTIUS JOYNSON

1. Robert Whitgreave. 2 & 3. German arms. 4. LEFT: The Abbey of Geras; RIGHT: Abbot Michael Wallner. 5. LEFT: Bernhard von Rohrbach; RIGHT: Eilchen von Holzhausen. 6. Tertius Joynson (bookplate).

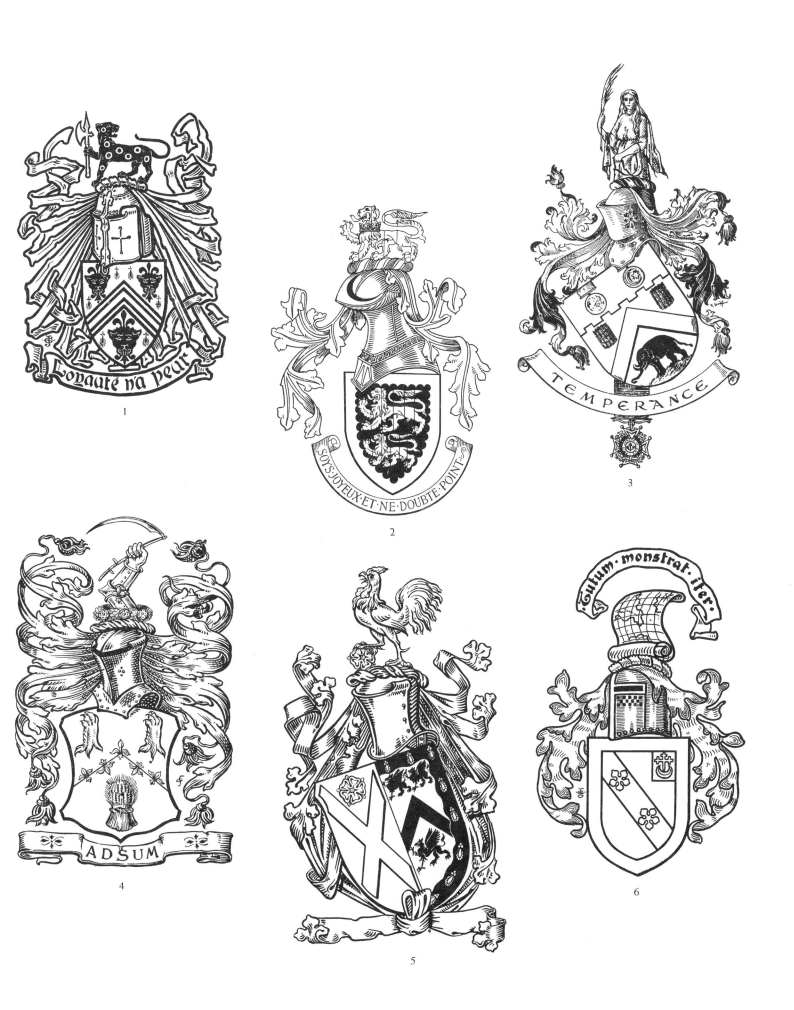

1. Joseph H. Noble.　2. Leonard R. Strangways.　3. William W. Goodfellow.　4. Henry
J. Dumas.　5. Laurence Currie.　6. Henry Cook.

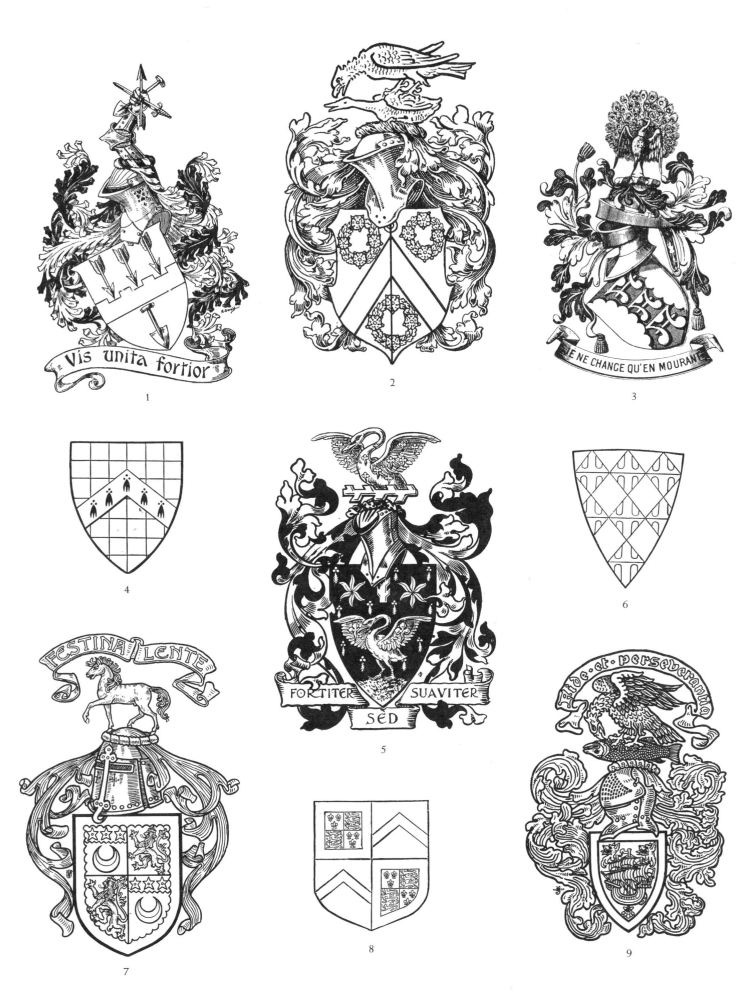

1. Eli G. Hales. 2. R. E. Yerburgh. 3. Edward C. Roose. 4. Thomas, Earl of Warwick.
5. Muntz. 6. Hubert de Burgh, Earl of Kent. 7. William Trotter. 8. Edward Stafford, Duke
of Buckingham. 9. James D. Lumsden.

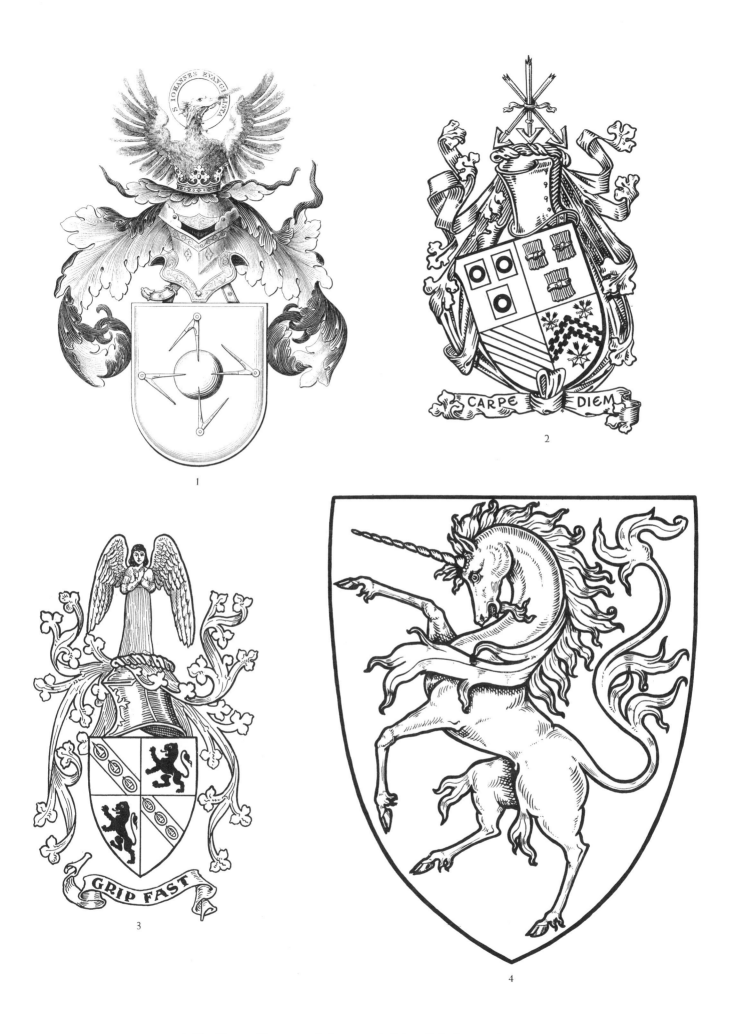

1. The Masons, Germany. 2. Paynter. 3. Robert C. Leslie. 4. A unicorn rampant.

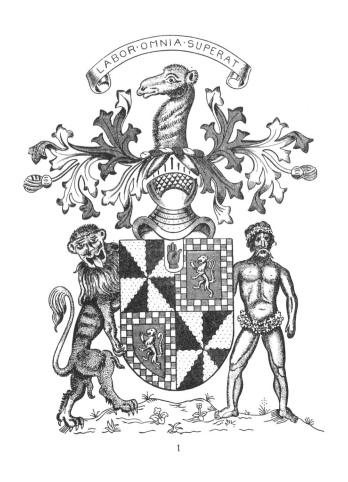

1

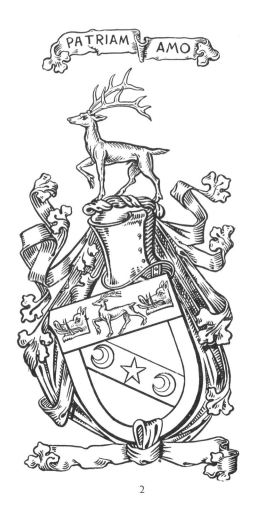

2

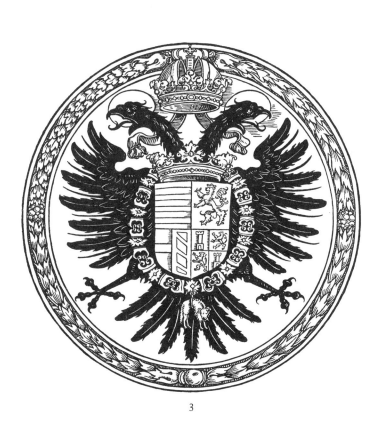

3

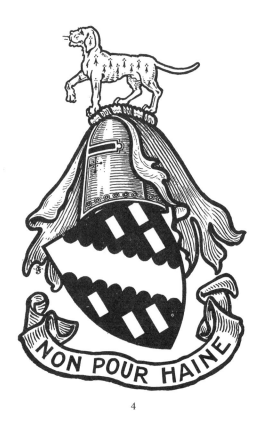

4

1. Sir Archibald S. Campbell. **2.** John A. Scott. **3.** The Roman-German Empire. **4.** Arthur H. Alington.

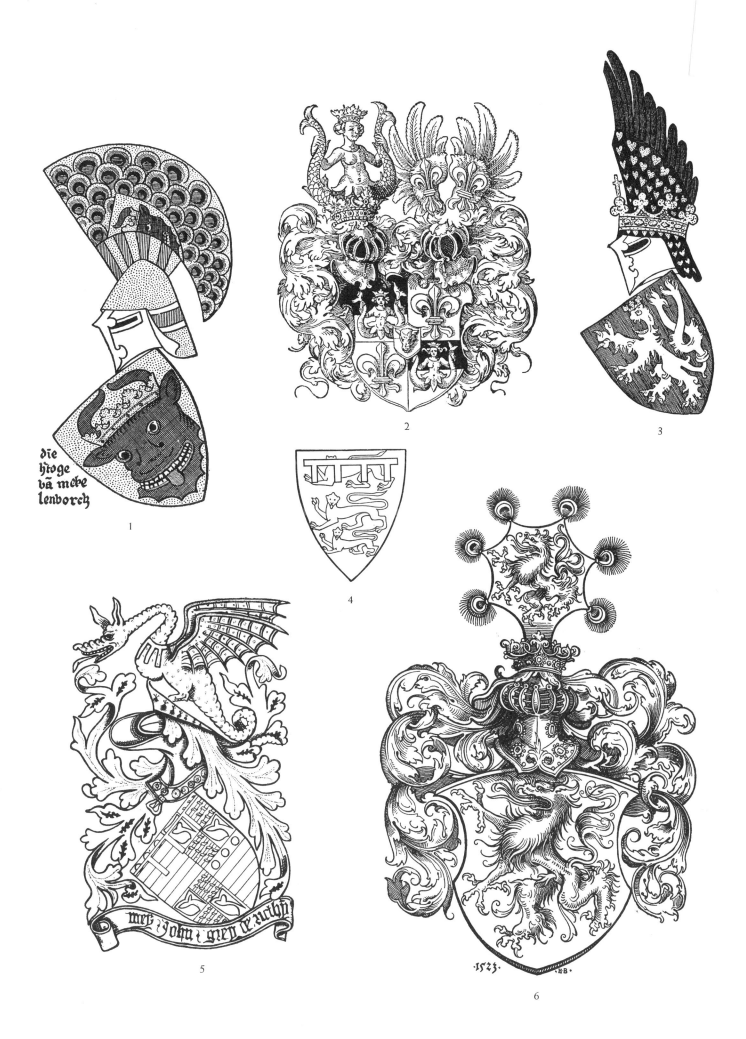

1. The Dukes of Mecklenburg. 2. Rieter. 3. The Kingdom of Bohemia. 4. Edmund "Crouchback," Earl of Lancaster. 5. Sir John Grey. 6. The Province of Styria.

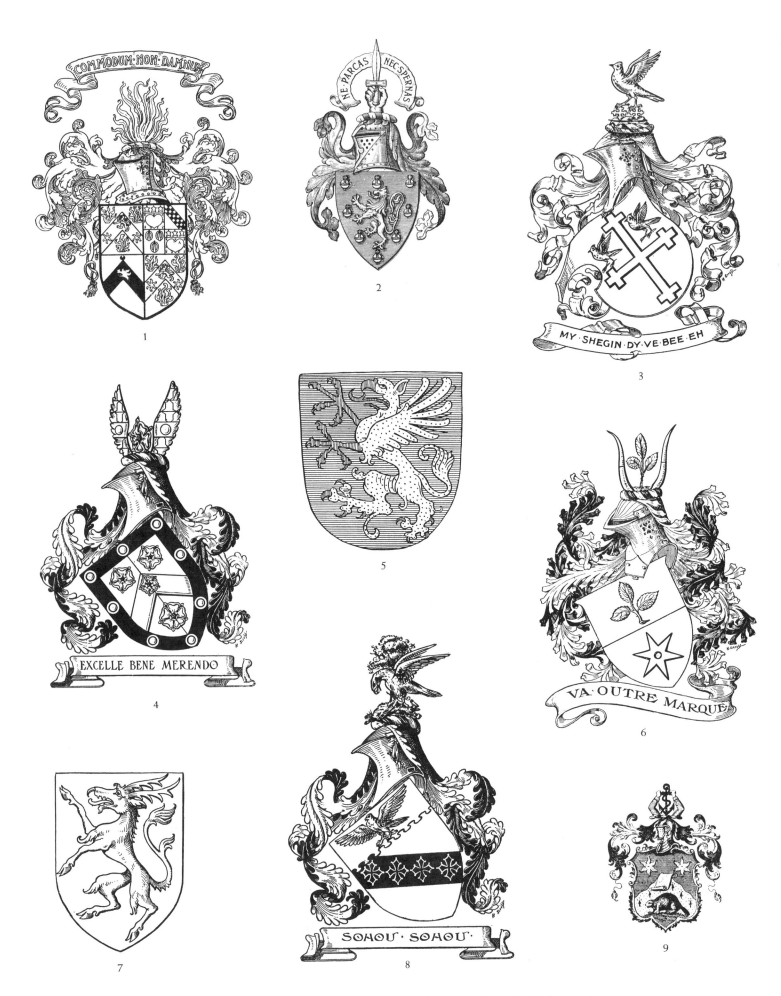

COMMODUM·NON·DAMNUM

NE·PARCAS NEC·SPERNAS

MY·SHEGIN·DY·VE·BEE·EH

EXCELLE BENE MERENDO

VA·OUTRE MARQUE

SOHOU·SOHOU

1. Alfred Baikie. 2. James Lamont. 3. Thomas G. Mylchreest. 4. Henry D. Eshelby. 5. Imaginary arms ascribed to Judas Maccabaeus. 6. Reginald J. Utermarck. 7. An heraldic antelope. 8. George Cawston. 9. Alfred C. Christopher.

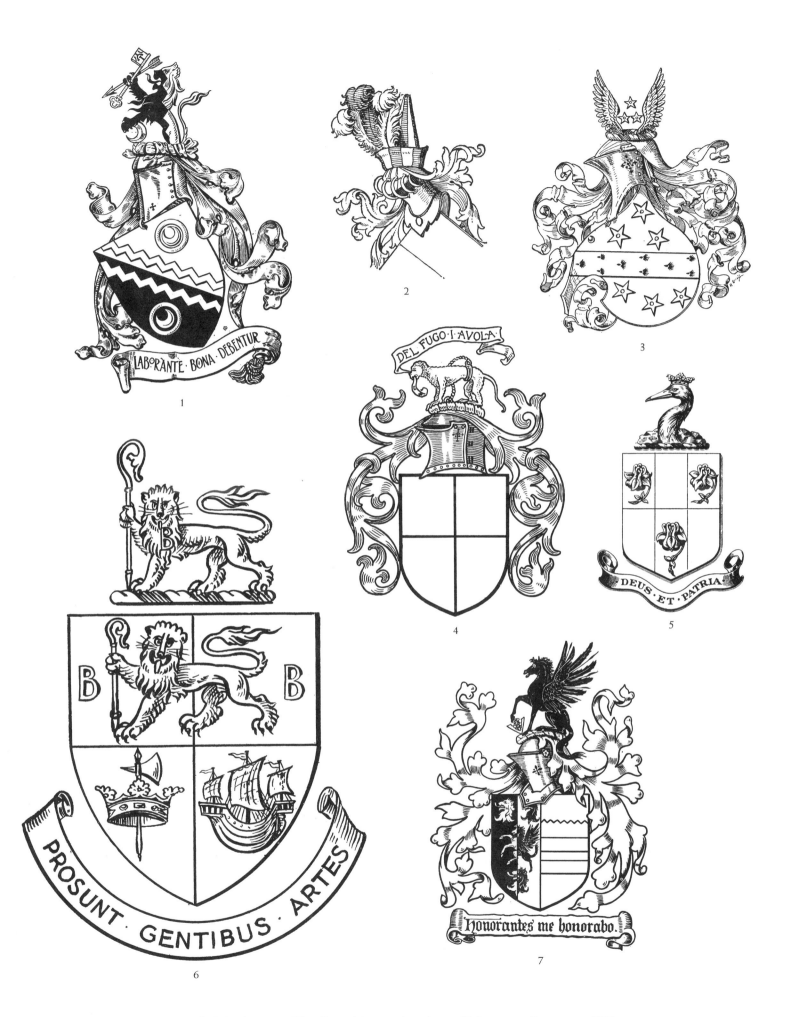

LABORANTE · BONA · DEBENTUR

1

2

DEL · FUGO · I · AVOLA

3

DEUS · ET · PATRIA

4

5

PROSUNT · GENTIBUS · ARTES

6

honorantes me honorabo.

7

1. Frank Debenham. 2. The City of Leipzig (crest). 3. Holbrow. 4. Berners. 5. William
S. Cadman. 6. The Borough of Bermondsey. 7. John M. Richardson.

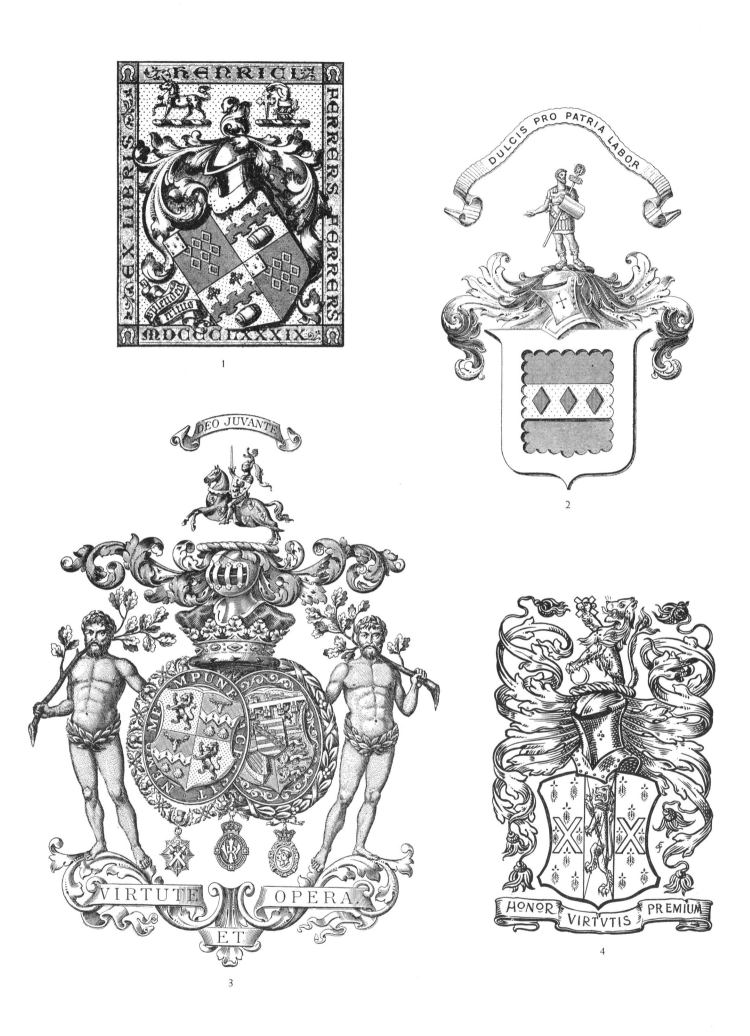

1. Henry Ferrers (bookplate). 2. Robert M. M'Kerrell. 3. LEFT: The Duke of Fife; RIGHT: Her Royal Highness the Duchess of Fife. 4. Albert J. Gould.

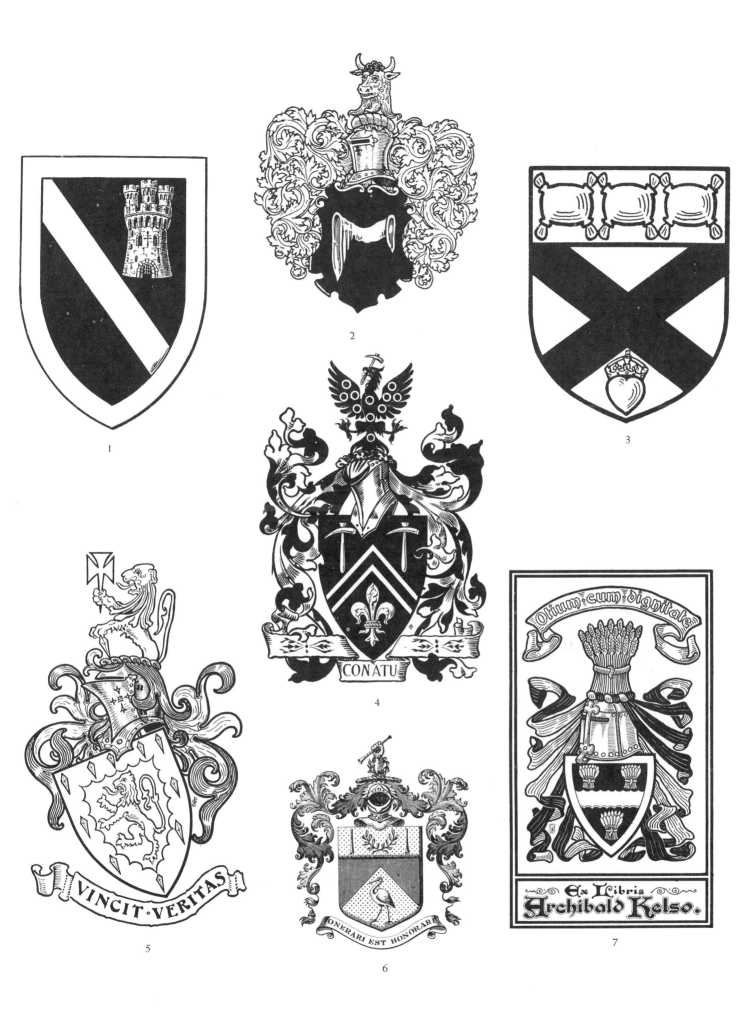

1. Thomas L. Plunkett. 2. William H. Wharton. 3. Johnstone. 4. James P. Mawdsley. 5. Robert
E. Bredon. 6. Sir John Stainer. 7. Archibald Kelso (bookplate).

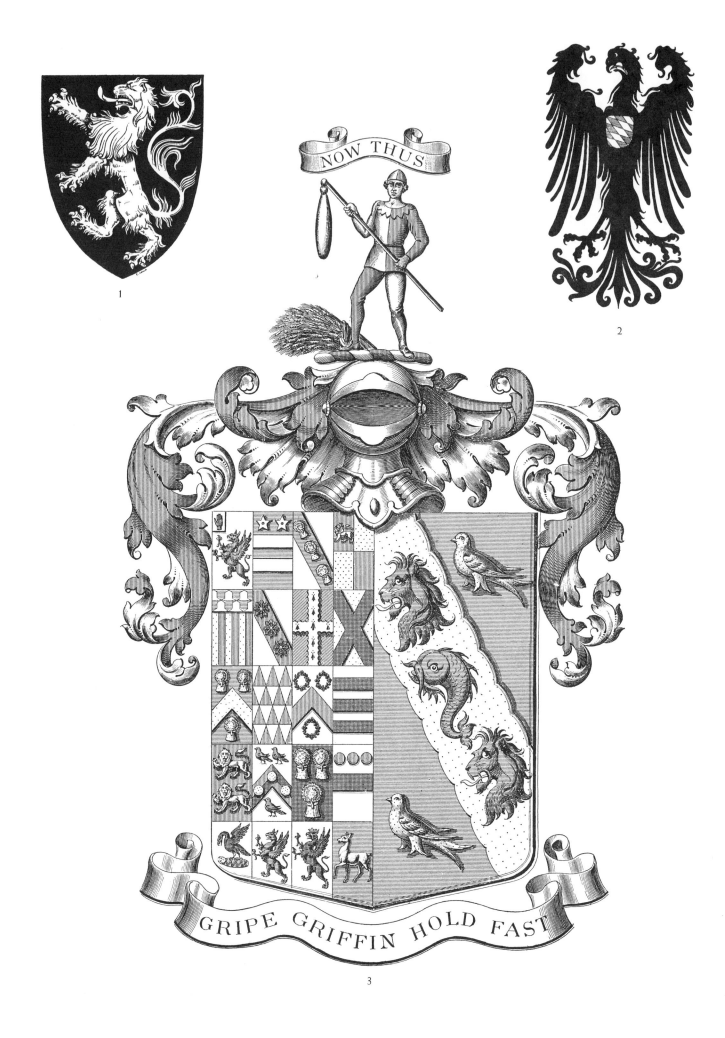

NOW THUS

GRIPE GRIFFIN HOLD FAST

1. A lion rampant.　**2.** The Town of Schongau.　**3.** Sir Humphrey F. de Trafford.

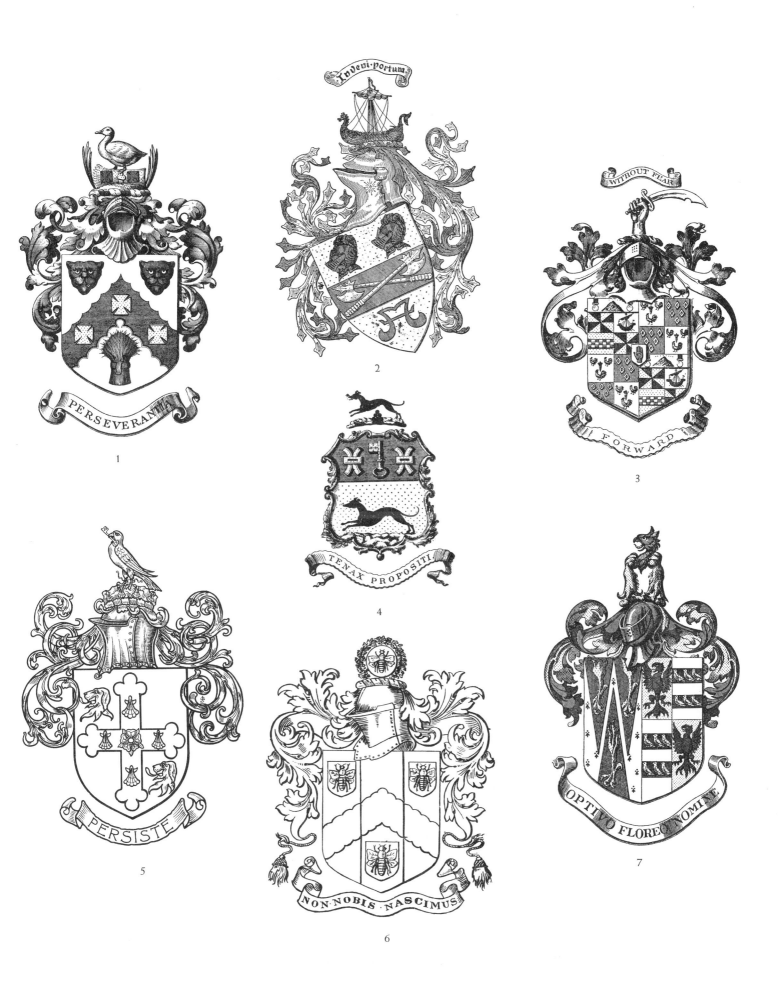

1. Sir Dyce Duckworth. 2. Edward T. Salvesen. 3. Sir Alexander T. Cockburn-Campbell.
4. Edgar J. Elgood. 5. Alfred P. Humphry. 6. Thomas D. Sewell. 7. John W. Willis-Bund.

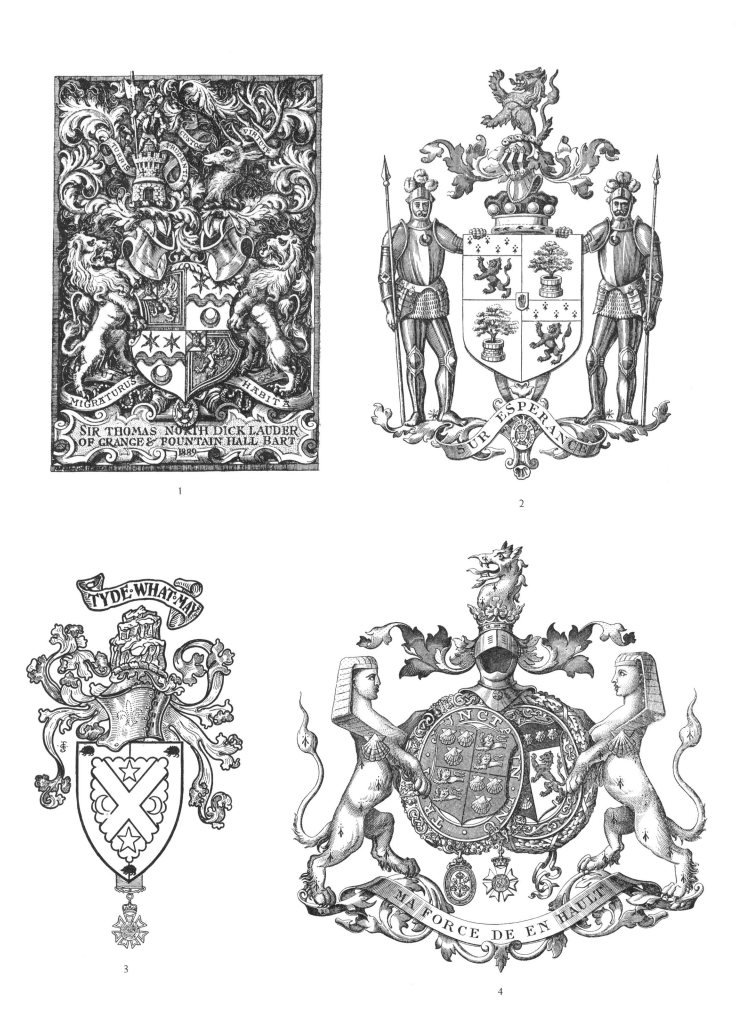

1. Sir Thomas N. Dick-Lauder. 2. Lord Moncrieff. 3. Arthur B. Haig. 4. LEFT: Sir Edward Malet;
RIGHT: Lady Ermyntrude Malet.

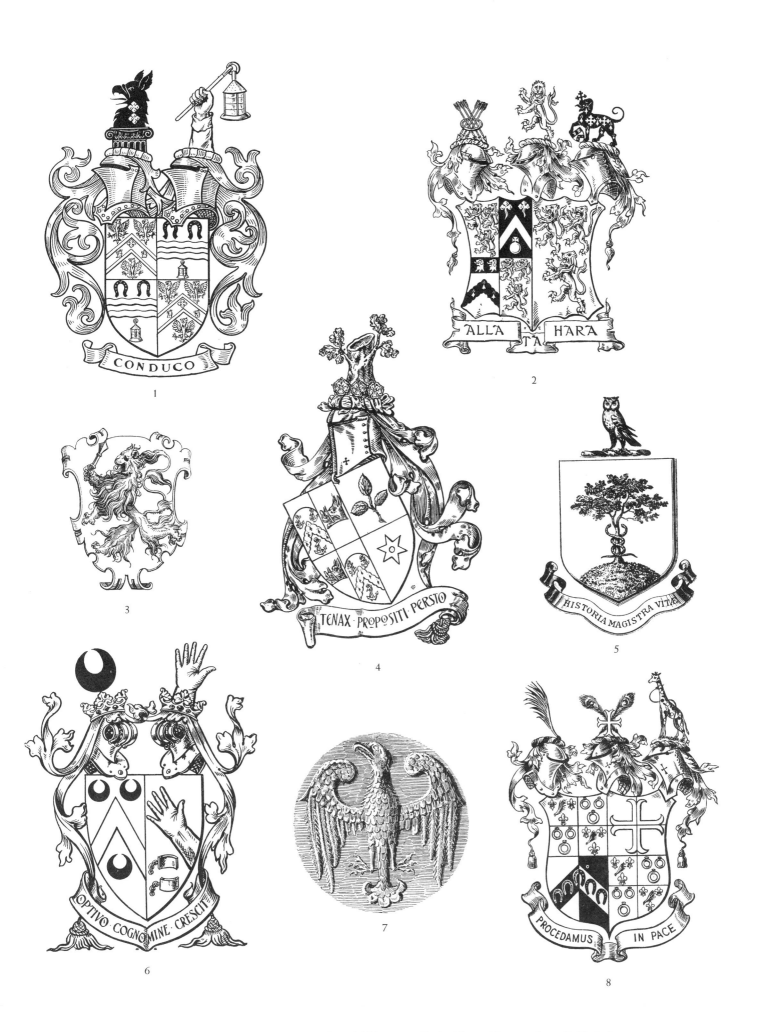

1. Thomas C. Cowper-Essex. 2. G. A. Mildmay. 3. Paulus Hector Mair. 4. James F. Chisholm-Batten. 5. William H. Duignan. 6. John Melvill de Hochepied-Larpent. 7. A Viennese eagle. 8. Cecil T. Crisp-Molineux-Montgomerie.

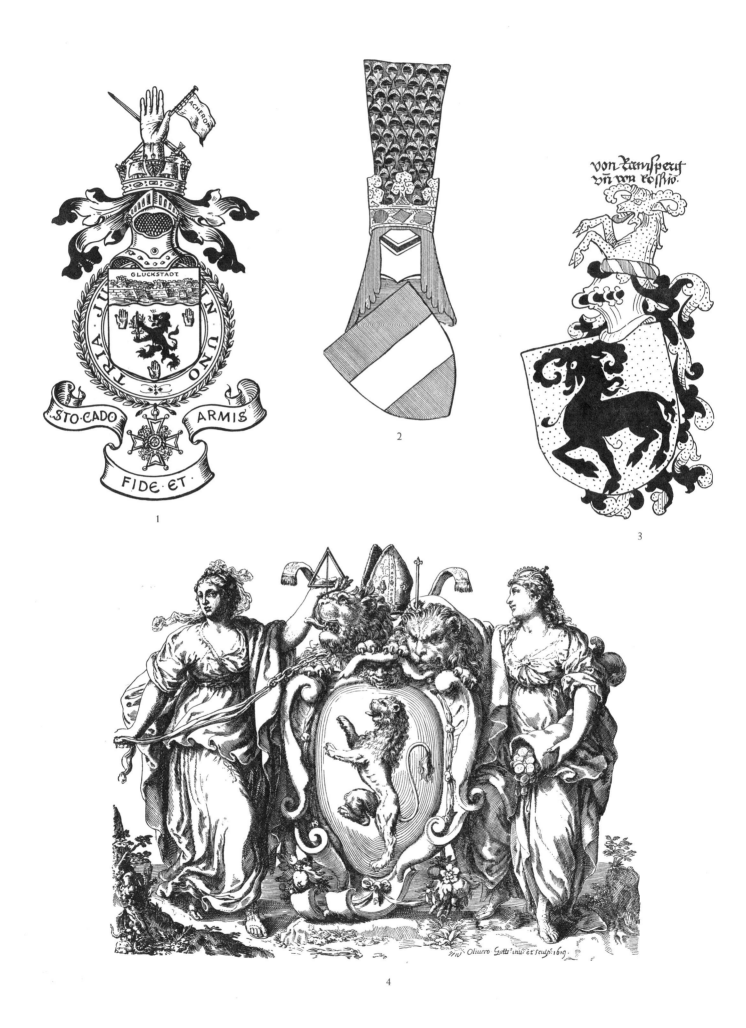

1. Sir Arthur Farquhar. 2. The Austrian Dukes. 3. Von Ramsberg. 4. A bishop.

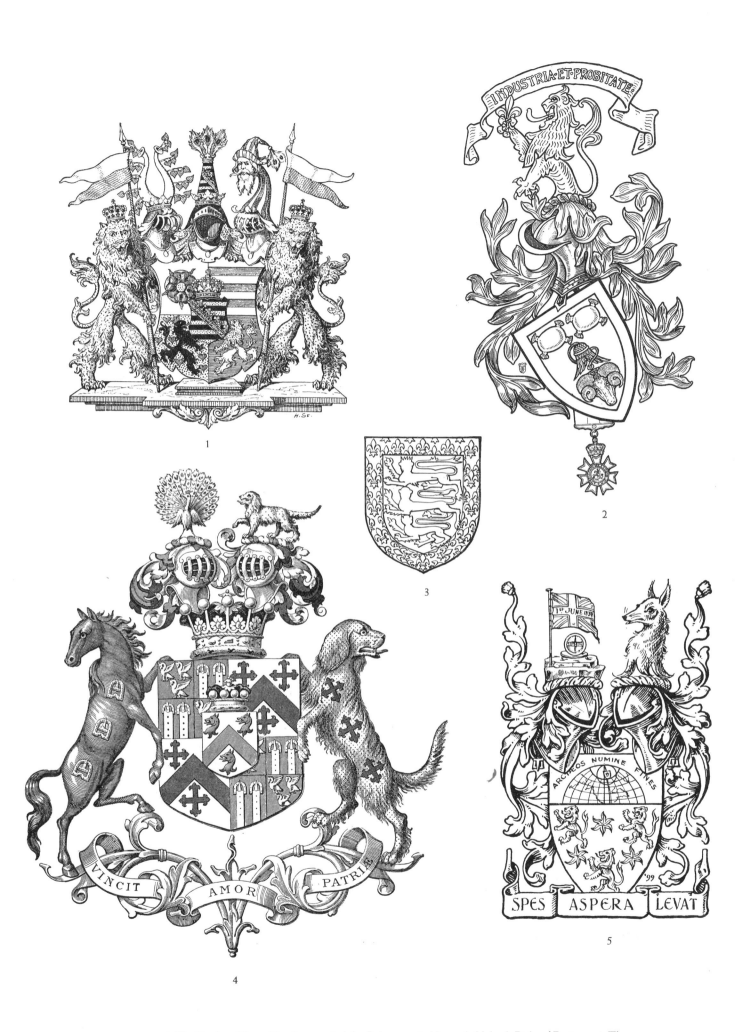

1. The Duchy of Saxe-Altenburg. 2. John Roberts. 3. Henry de Holand, Duke of Exeter. 4. The Earl of Yarborough. 5. J. C. Ross.

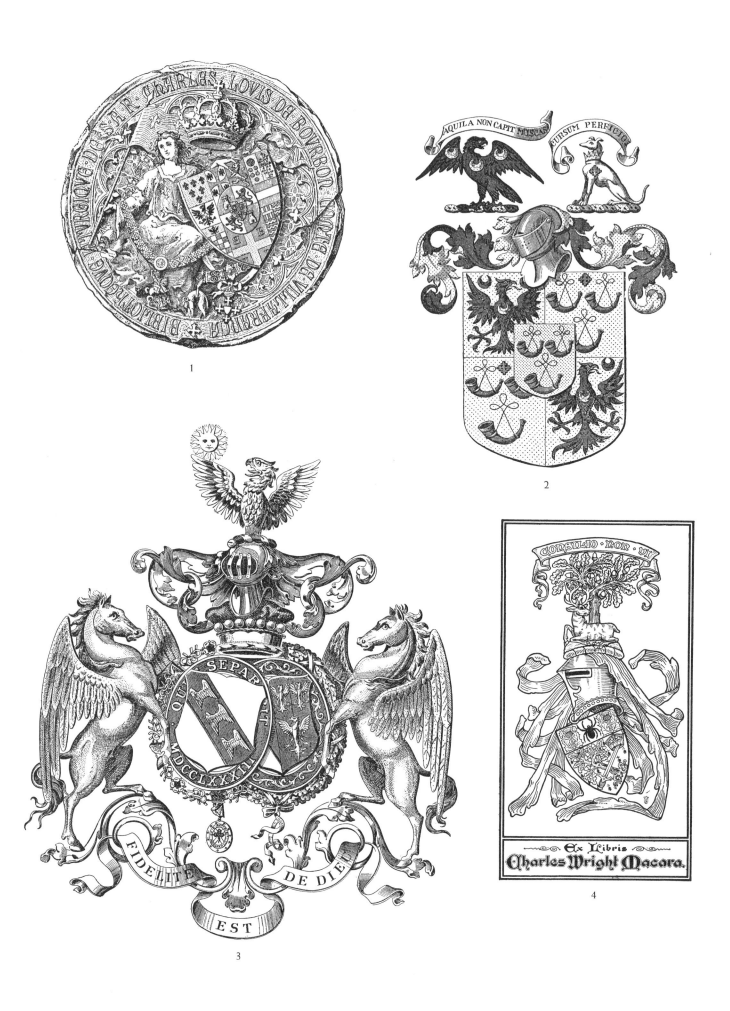

1. Charles Louis de Bourbon (bookplate). 2. Hunter-Weston. 3. Viscount Powerscourt.
4. Charles W. Macara (bookplate).

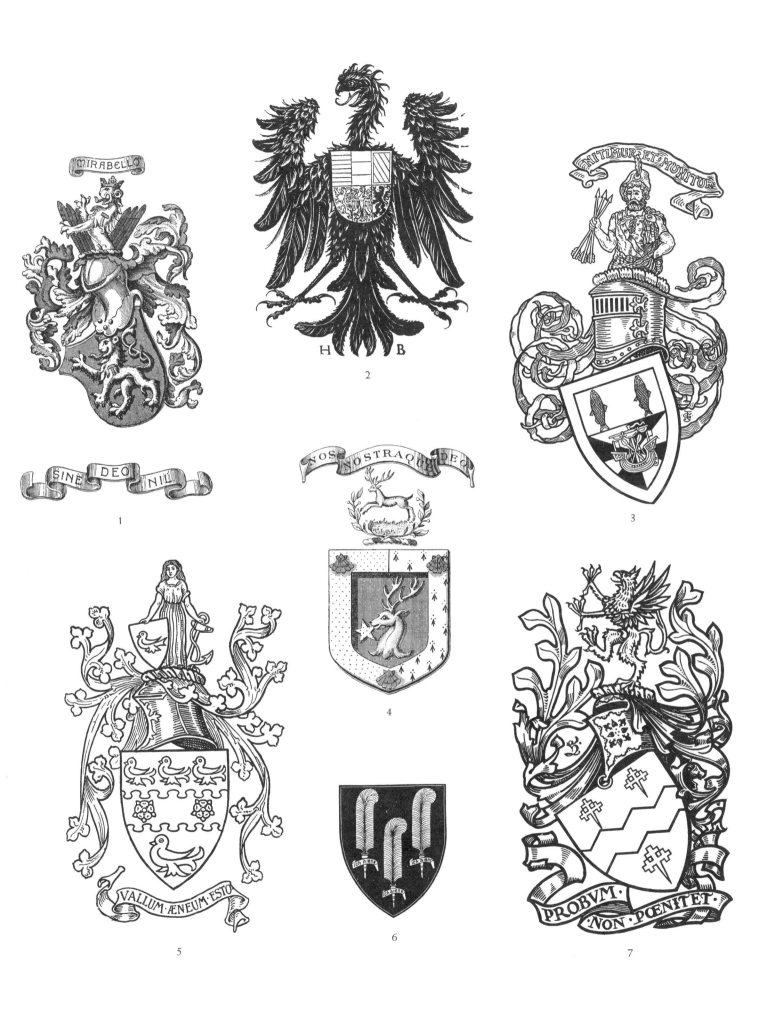

1. Arthur E. Hallen. 2. A German Imperial eagle. 3. Archibald W. Maconochie. 4. Edward Rodger. 5. Ronald Bailey. 6. Edward the Black Prince ("Shield of Peace"). 7. Thomas M. Sandys.

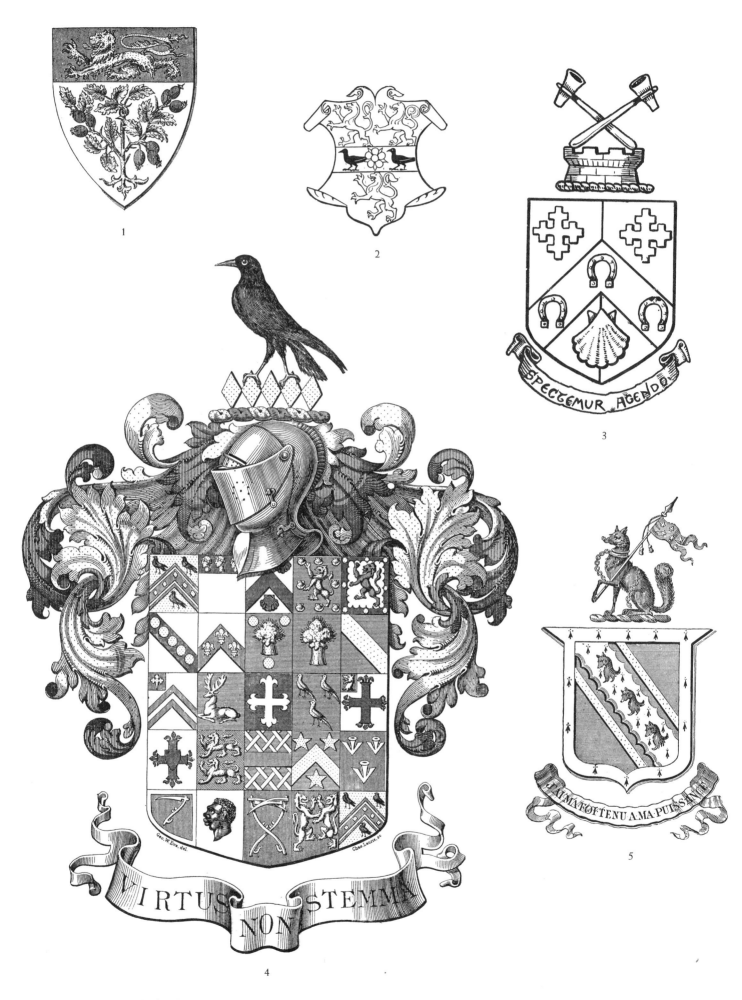

1. Arthur MacMurrogh-Murphy. 2. Thomas Cromwell, Earl of Essex. 3. The Borough of Hammersmith. 4. William G. Taunton. 5. Fox.

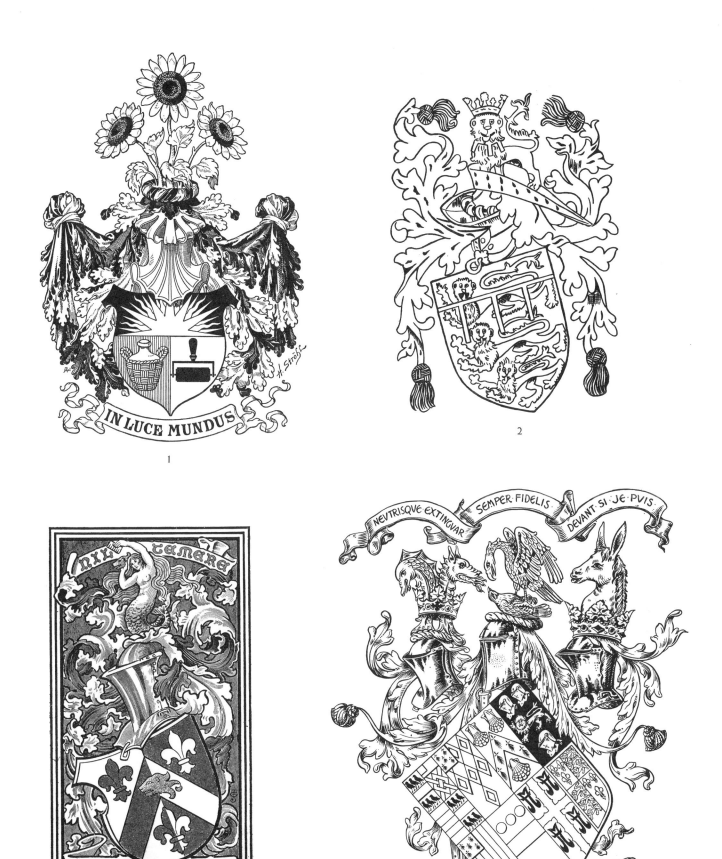

IN LUCE MUNDUS

1

2

NIL TEMERE

EX LIBRIS Balfour, Dawyck

3

NEVTRISQVE·EXTINGVAR SEMPER·FIDELIS DEVANT·SI·JE·PVIS

FESTINA · LENTE

4

1. A photochemigraphists' guild. 2. John Mowbray, Duke of Norfolk. 3. Balfour (bookplate).
4. Charles V. Mainwaring-Ellerker-Onslow.

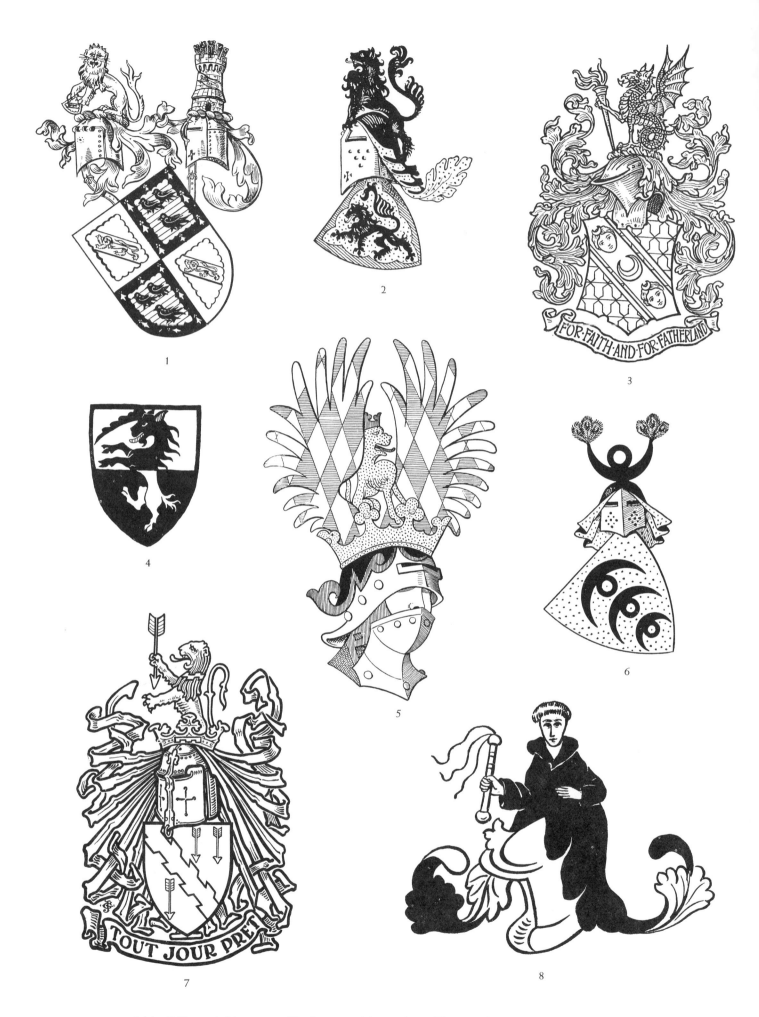

1. John P. Chaworth-Musters. 2. The Barons von Münsterol. 3. Thomas Whewell. 4. An heraldic unicorn. 5. Duke Ludwig of Bavaria (crest). 6. Von Stein. 7. Richard S. Mansergh. 8. Stourton (crest).

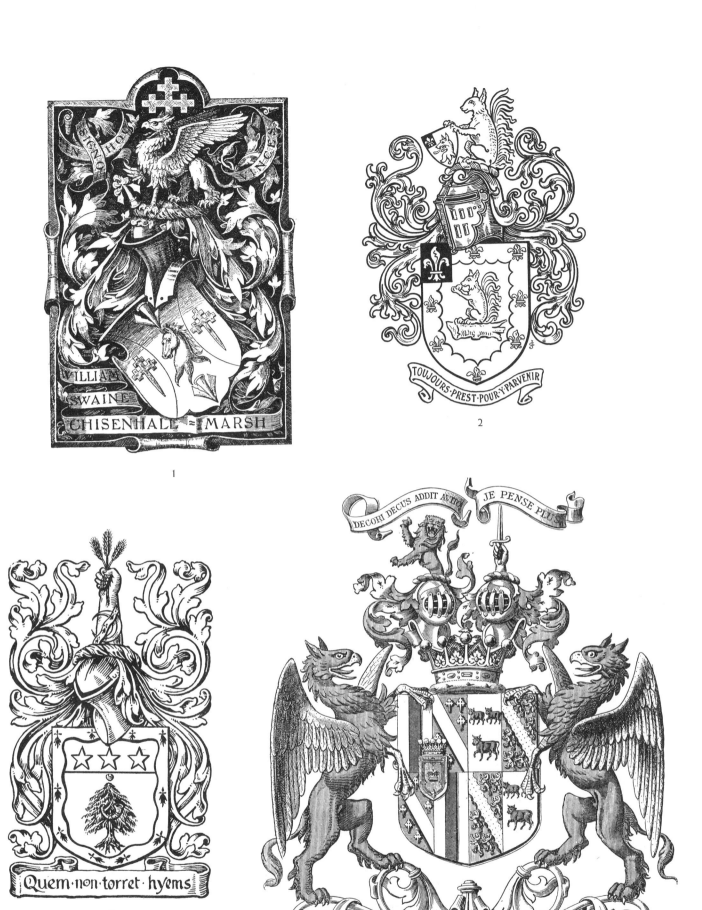

1. William S. Chisenhale-Marsh. 2. Martin J. Sutton. 3. Alexander Kyd. 4. The Earl of Mar.

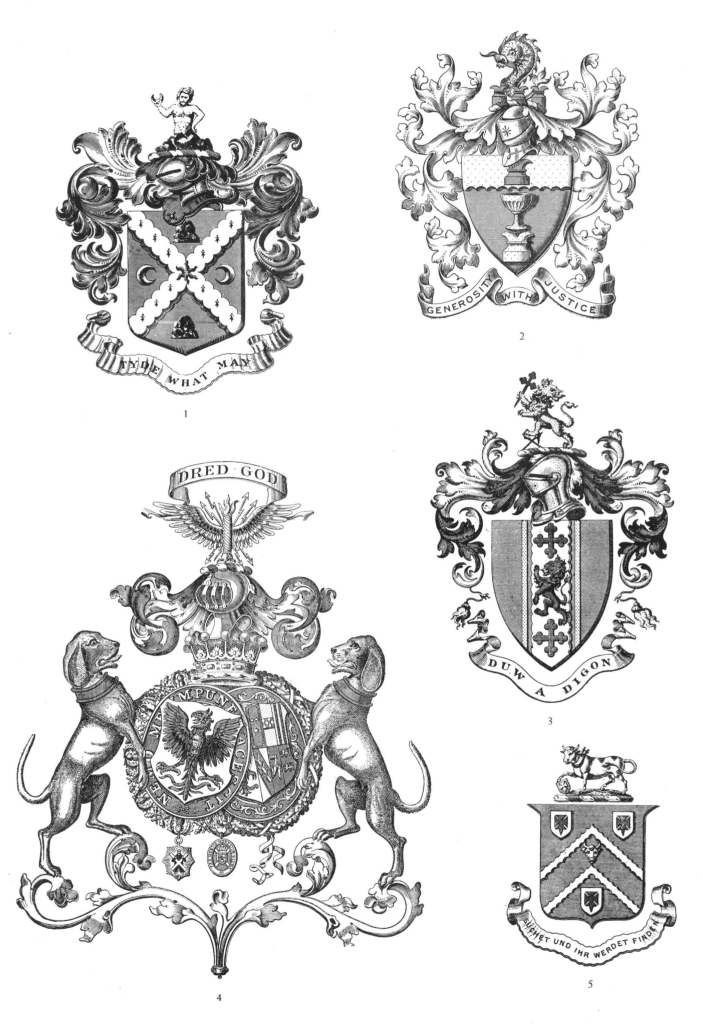

1. Arthur S. Haigh. 2. William M. Smith. 3. Henry L. Pryse. 4. The Earl of Southesk.
5. George S. Ffinden.

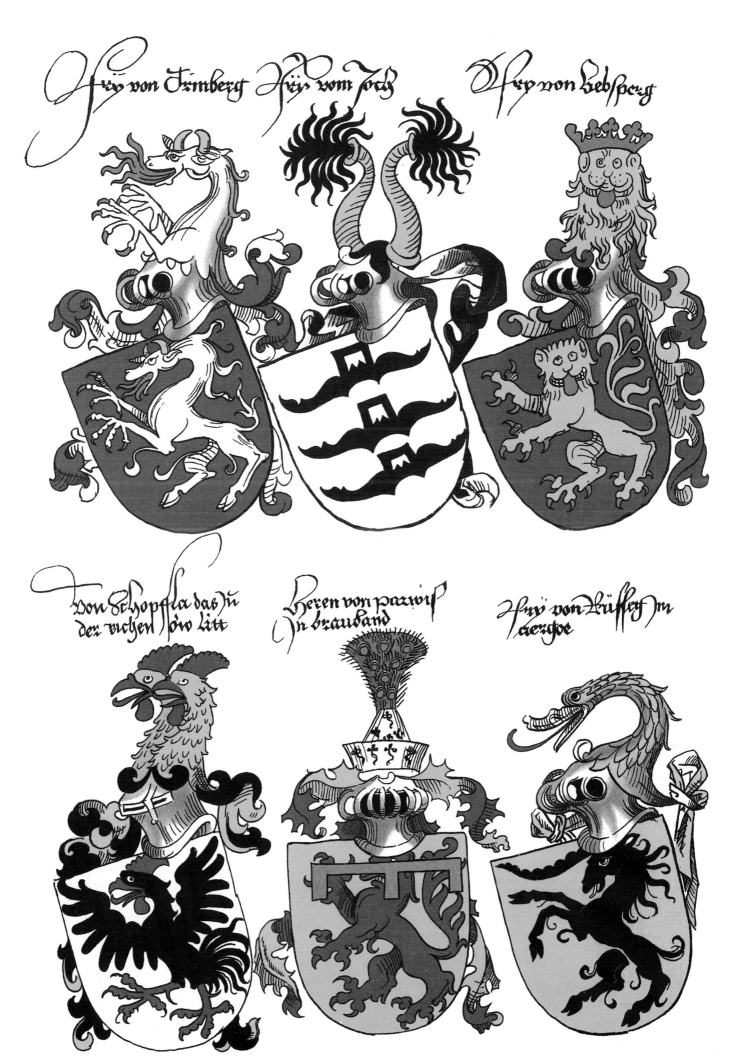

Arms from Conrad Grünenberg's *Wappenbuch* [Book of Arms] (1483).

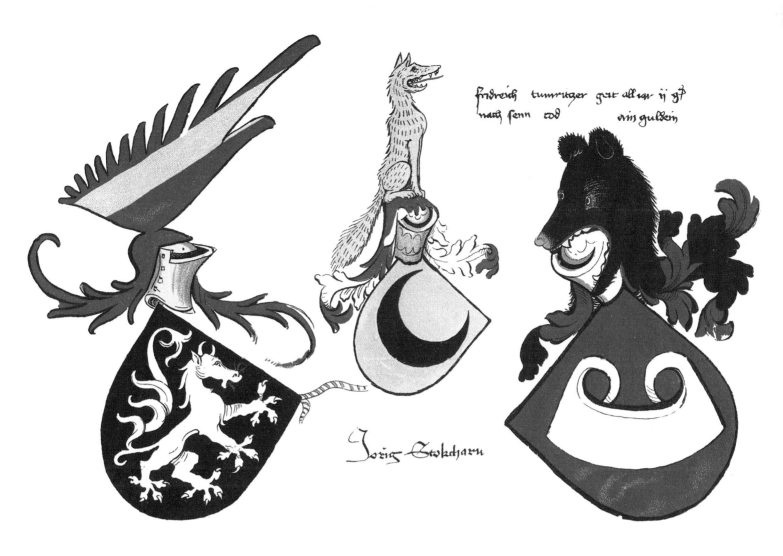

fridreich tunruger gat aller ij g
nach senn tod vm guldein

Joring Stokcharn

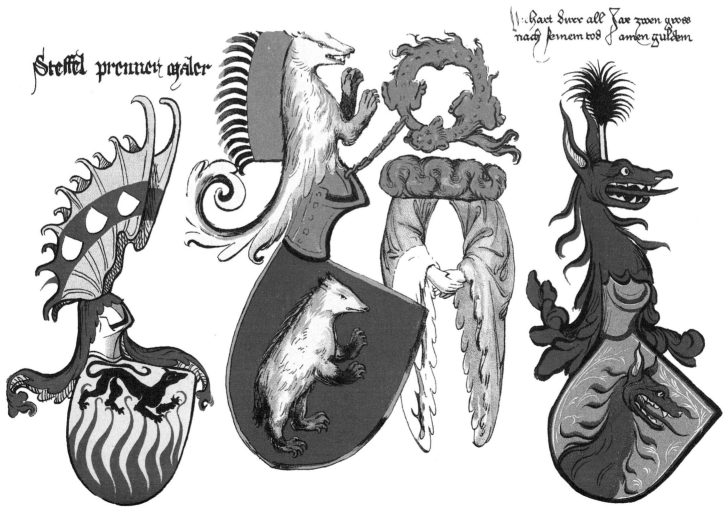

Steffel prennen asaler

Nichart Suer all Jar zwen gros
nach semem tod f amen guldein

Arms from the *Sancti Christophori am Arlberg Bruderschafts Buch* [Book of the Brotherhood of St. Christopher on the Arlberg] (ca. 1350–1647).

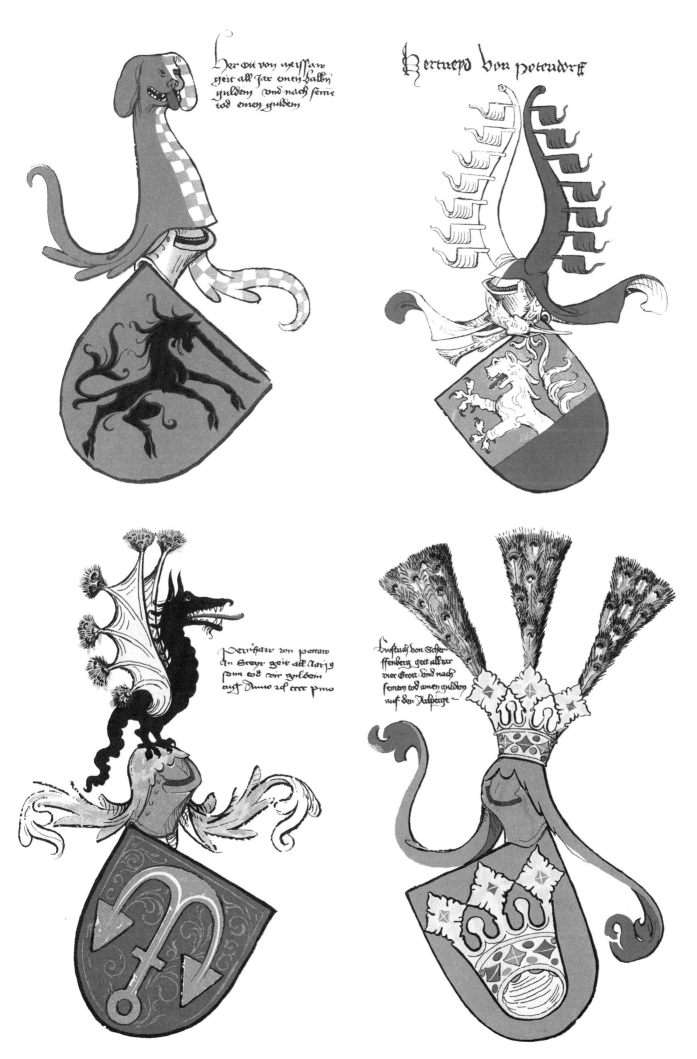

Arms from the *Sancti Christophori am Arlberg Bruderschafts Buch* [Book of the Brotherhood of St. Christopher on the Arlberg] (ca. 1350–1647).

77

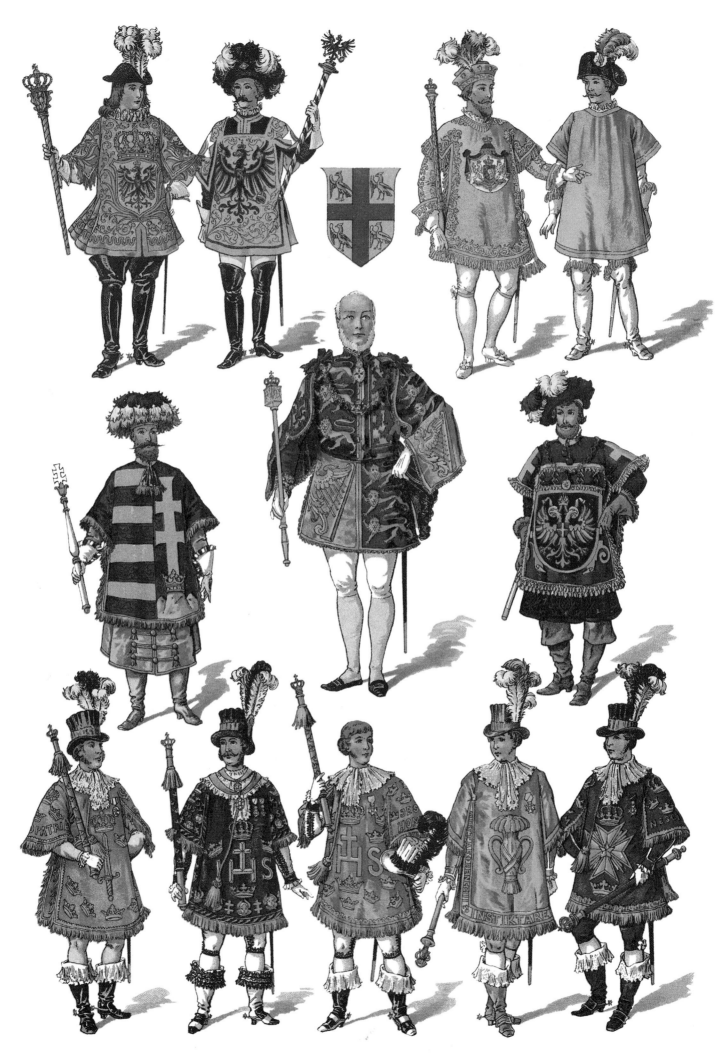

Heralds in official dress.

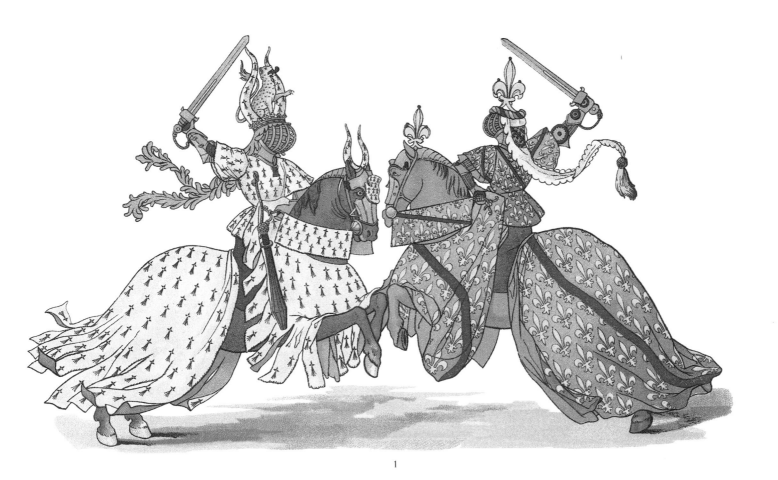

1

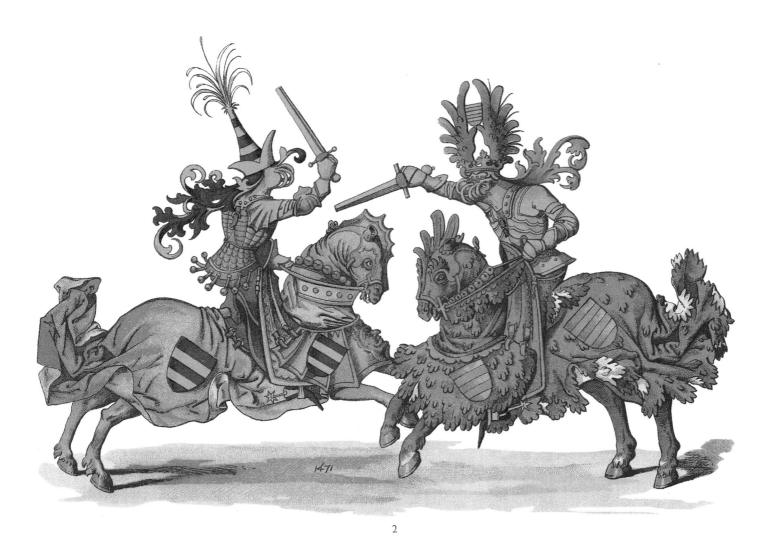

2

1. LEFT: The Duke of Brittany; RIGHT: The Duke of Bourbon. 2. LEFT: Wolmershausen; RIGHT: A Rhenish knight.

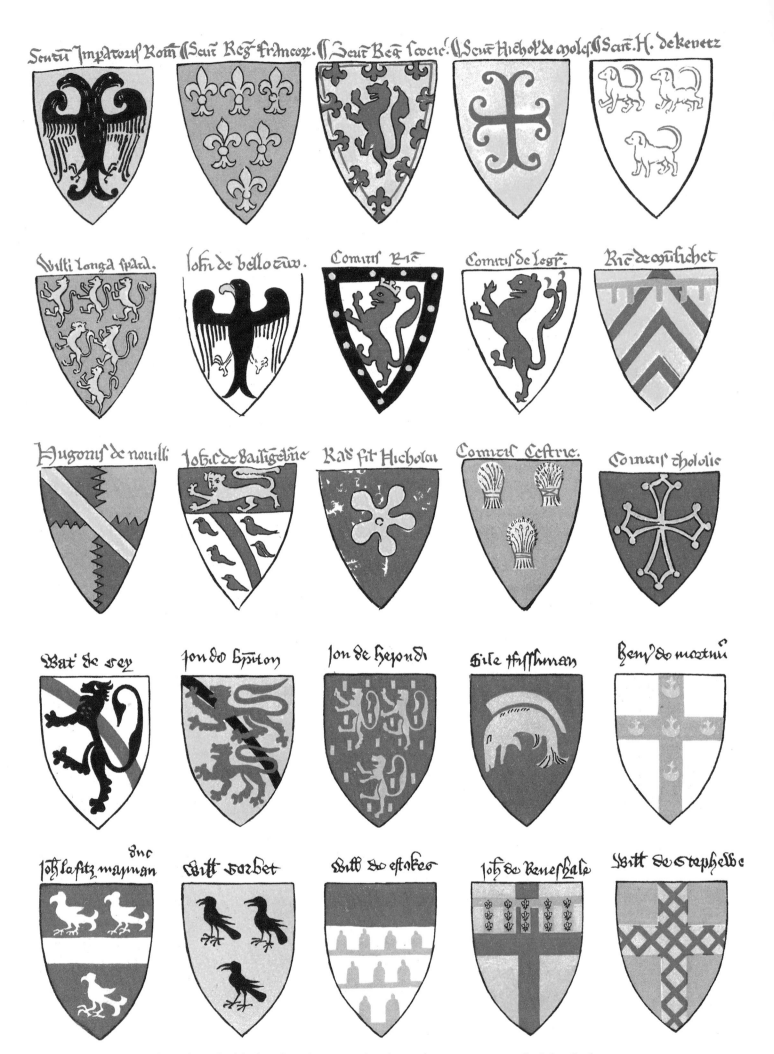

Arms drawn by Matthew Paris (?1200–1259) and arms from an anonymous English roll of arms (ca. 1300).

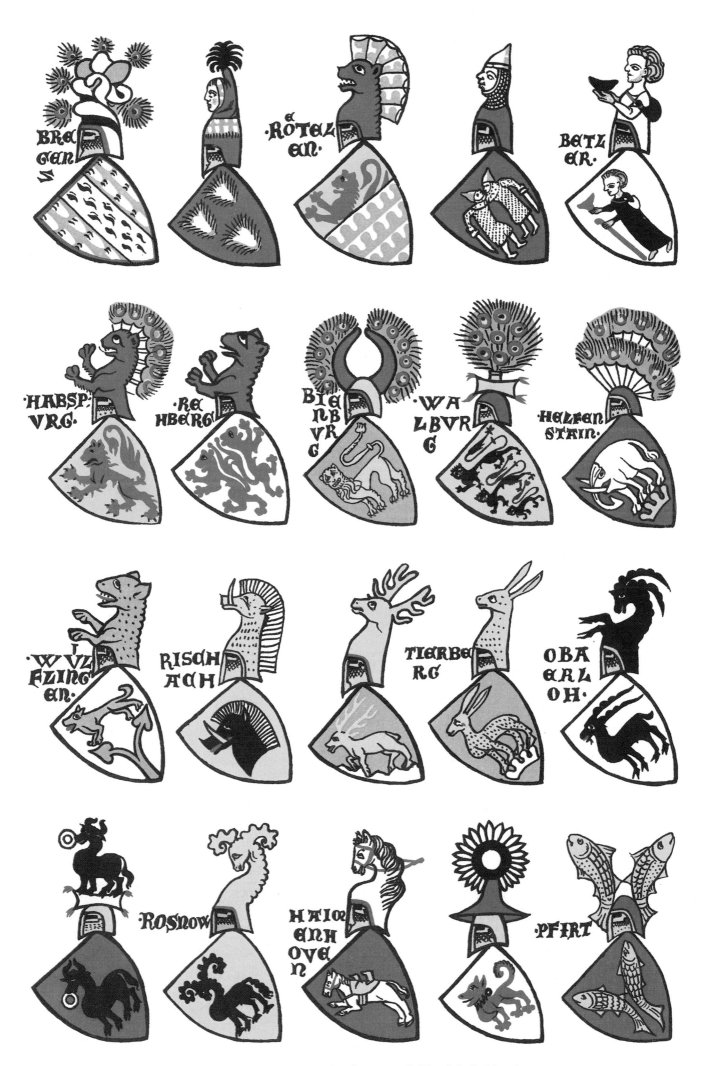

Arms from the fourteenth-century *Züricher Wappenrolle* [Zurich Roll of Arms].

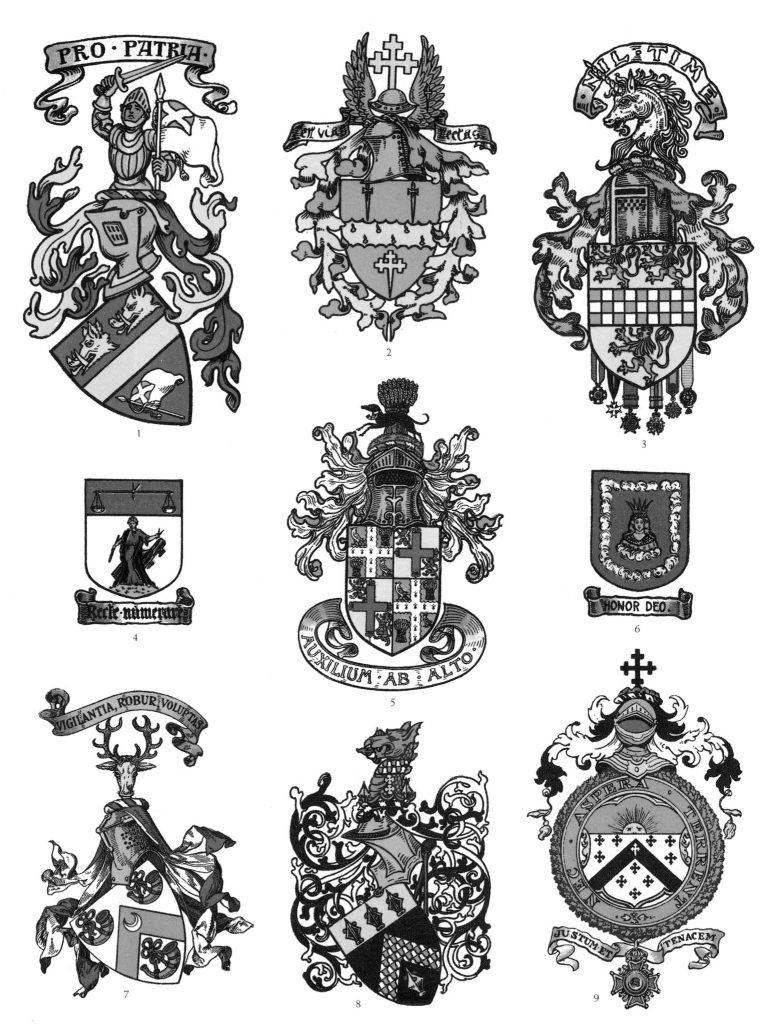

1. W. B. Bannerman. 2. Francis W. Pixley. 3. John A. Stuart. 4. The Institute of Chartered Accountants. 5. Sir John Watney. 6. A mercers' company. 7. Andrew A. Hunter. 8. Howell P. Edwards. 9. Sir Woodbine Parish.

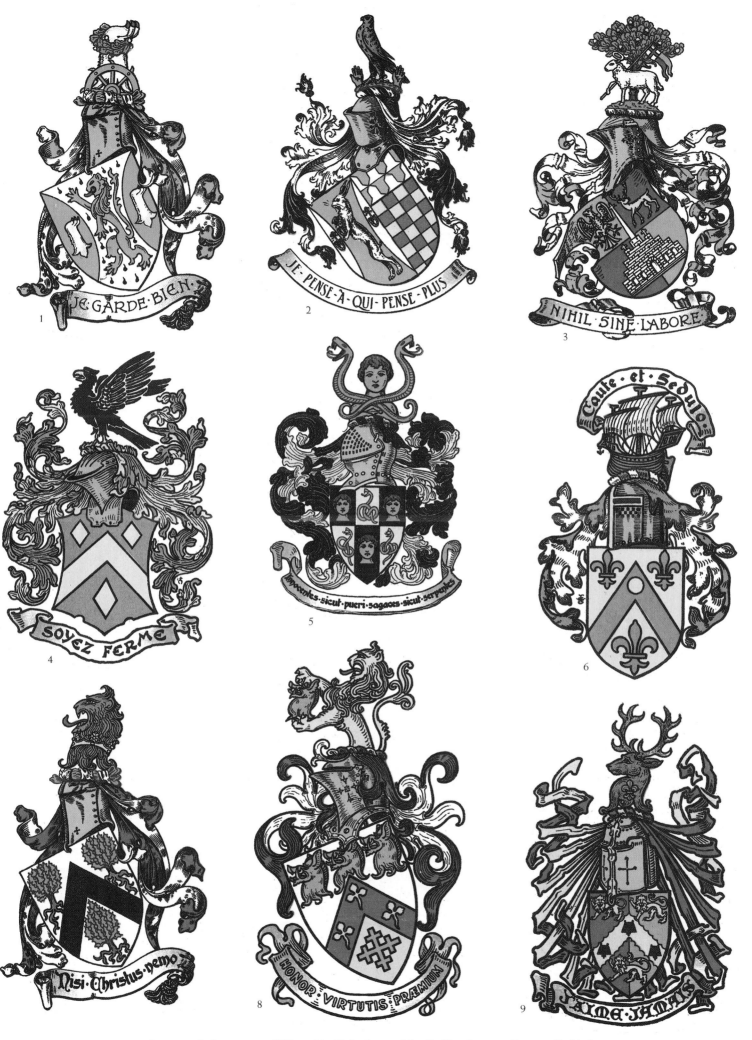

1. JE·GARDE·BIEN.
2. JE·PENSE·À·QUI·PENSE·PLUS.
3. NIHIL·SINE·LABORE.
4. SOYEZ FERME
5. innocentes·sicut·pueri·sagaces·sicut·serpentes
6. Caute·et·Sedulo.
7. Nisi·Christus·nemo
8. HONOR·VIRTUTIS·PRÆMIUM
9. J'AIME·JAMAIS.

1. Benjamin Pickering. 2. William H. Cleland. 3. John G. Templer. 4. Gustavus R. Hyde.
5. Howel J. Price. 6. Brown. 7. Thornton. 8. Henry T. McDermott. 9. Nicholas H. James.

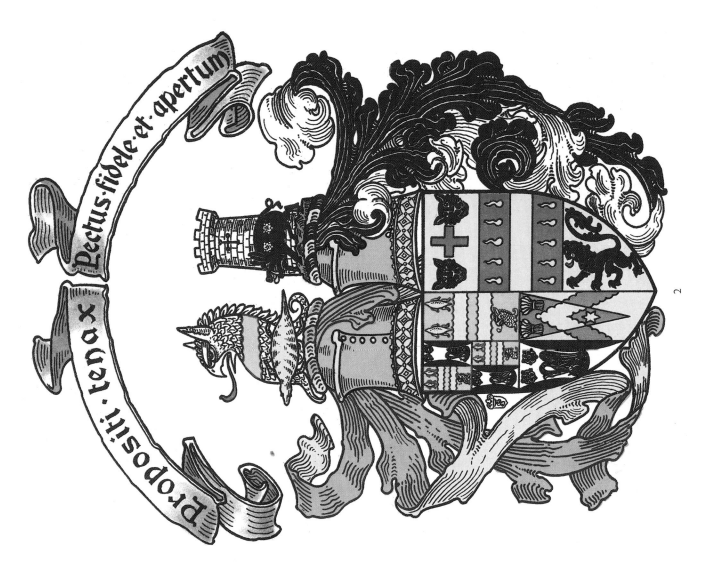

1. Charles W. Perryman. 2. Albert C. Cantrell-Hubbersty.

84

COURAGE

1. Aeneas Chisholm, Bishop of Aberdeen. 2. Cumming-Gordon.

2

1

85

1. King Edward IV of England (badges). 2. Chisholm Gordon-Chisholm. 3. John A. Maconochie-Wellwood. 4. Badges from the sixteenth-century *Prince Arthur's Book*.

J'ESPERE

JE·PENSE

Swinton of that Ilk.

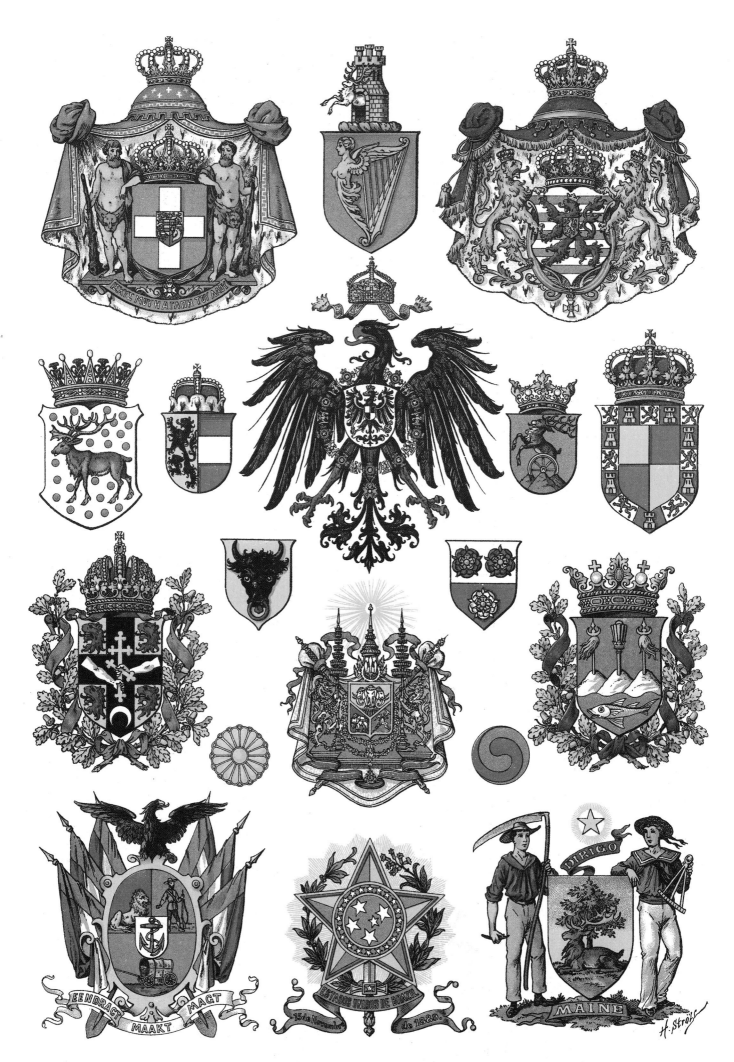

Arms of kingdoms, empires and republics, etc.

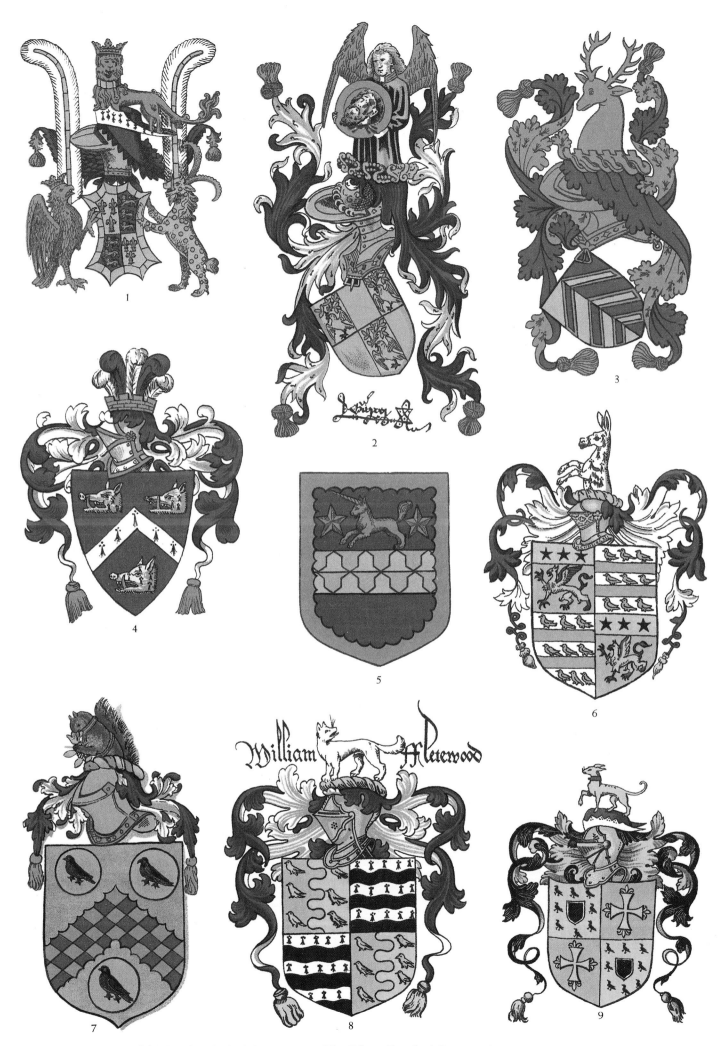

1. John Beaufort, Earl of Somerset. 2. The Tallow Chandlers' Company, London. 3. Sir John Say. 4. John Wylkynton. 5. Rowland Phillipson. 6. George Avelin. 7. Thomas Fleetwood. 8. William Fleetwood. 9. Richard Brownlow.

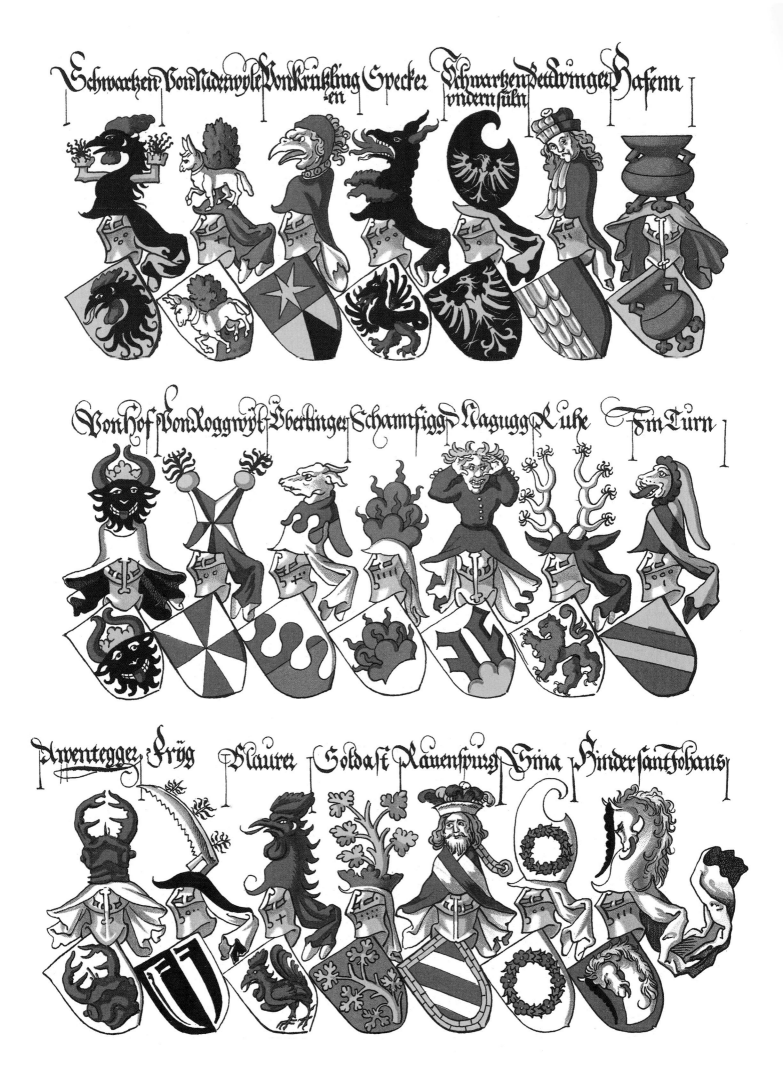

Arms of members of the *Geschlechtergesellschaft "zur Katze"* [Genealogical Society "at the Sign of the Cat"] (1547).

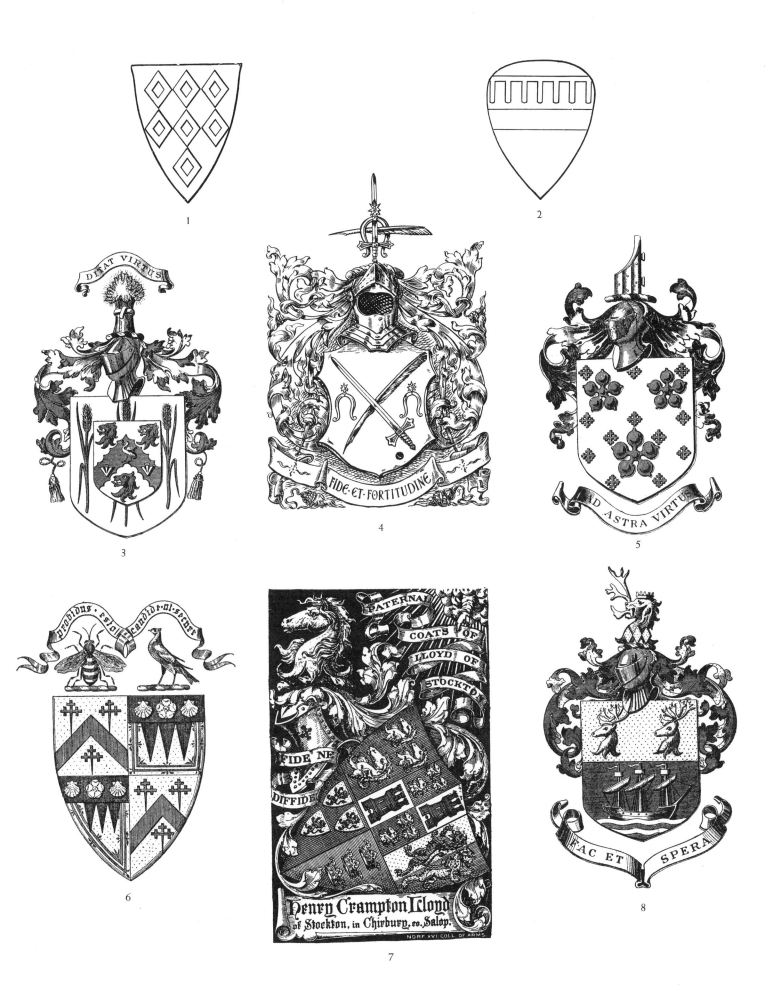

1. Roger de Quincy, Earl of Winchester. 2. Seiher de Quincy, Earl of Winchester. 3. George C. Cheape. 4. Sir John J. Grinlinton. 5. Philip Saltmarshe. 6. James Maxtone-Graham. 7. Henry C. Lloyd. 8. Frederick B. Fellows.

1

2

3

4

1. Duke Johann I of Cleves. **2.** Holzhausen. **3.** John Hamilton. **4.** The Bishop of Argyll.

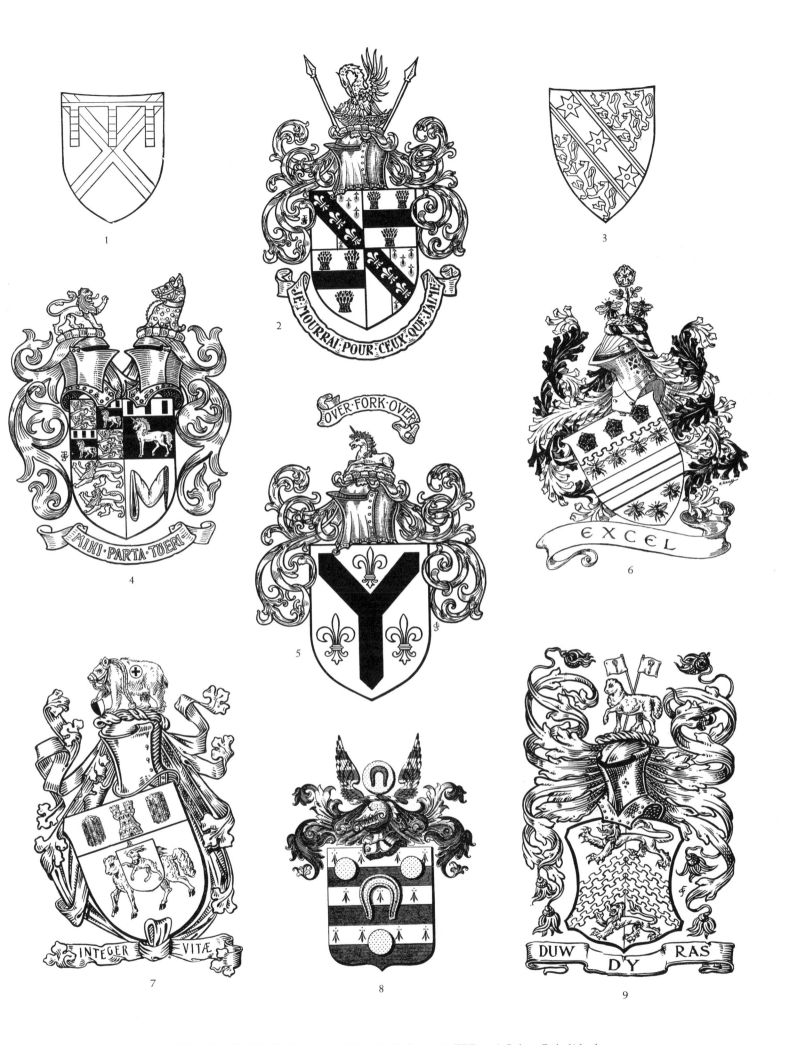

1. Richard Nevill, Earl of Salisbury. 2. Henry J. Coulson. 3. William de Bohun, Earl of Northampton. 4. Hamon Le Strange. 5. Henry H. Cunninghame. 6. Stuart M. Samuel. 7. William L. Christie. 8. G. W. Marshall. 9. William D. Davies.

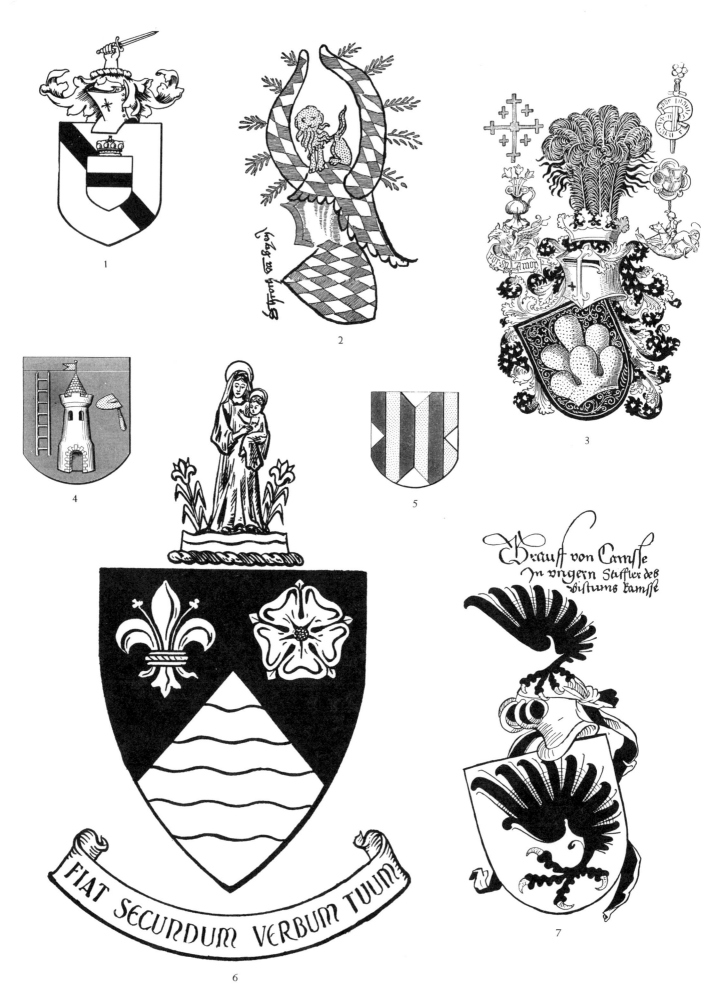

1. Conjoined arms. 2. The Duke of Bavaria. 3. Conrad Grünenberg. 4. The Tilers, Tours.
5. The Joiners, Péronne. 6. The Borough of Marylebone. 7. Count von Canisse.

FIAT SECUNDUM VERBUM TUUM

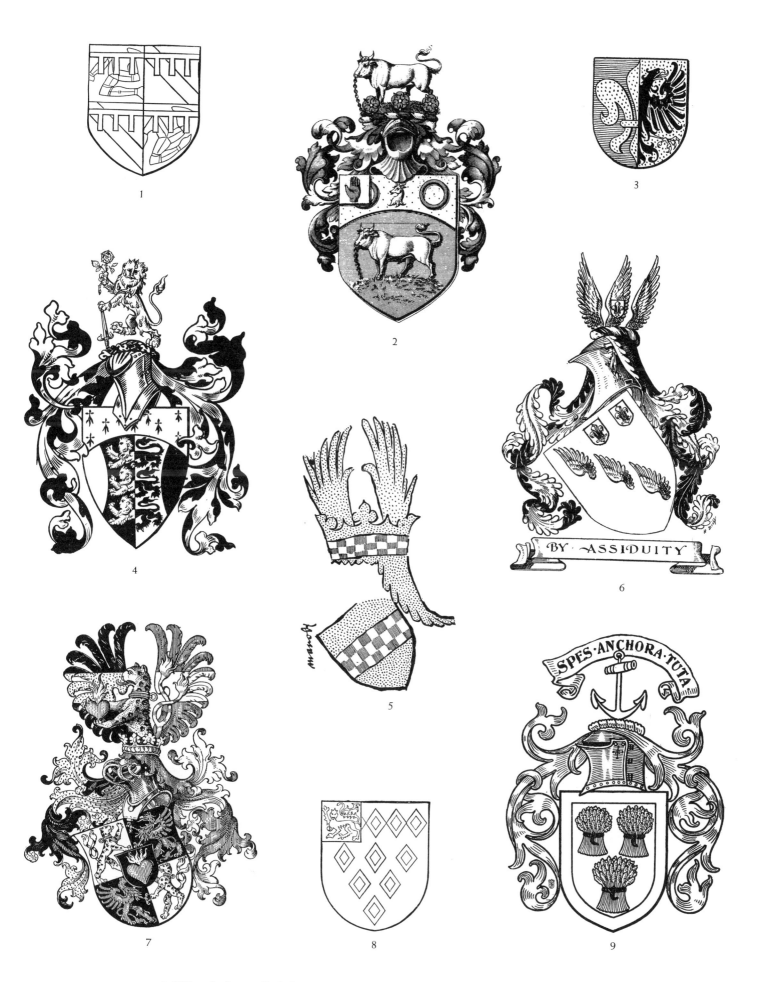

1. William Le Scrope, Earl of Wiltes. 2. Sir James Blyth. 3. Loschau. 4. Radford 5. Count von der Mark. 6. Robert N. Byass. 7. Schöllingen. 8. Louis de Bruges, Earl of Winchester. 9. James Dunsmure.

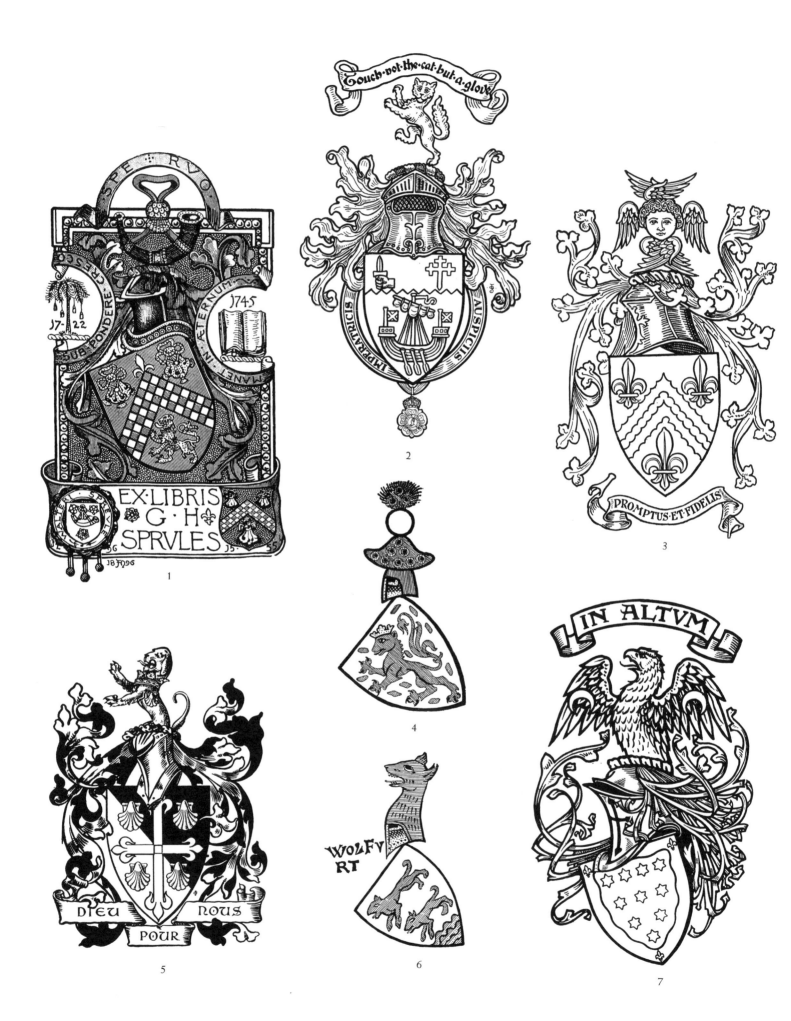

1. George H. Sprules (bookplate). 2. Sir Arthur Macpherson. 3. Mitchell-Carruthers. 4. Geroldseck. 5. William D. Fletcher. 6. Wolfurt. 7. Charles H. Alston.

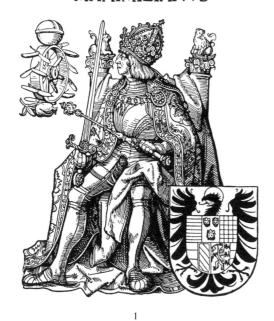

·MAXIMILIANVS·

1

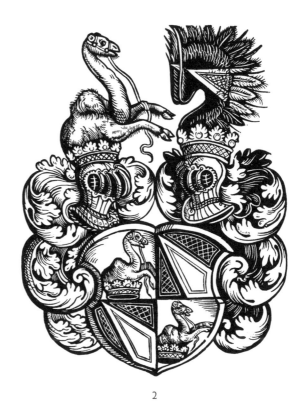

2

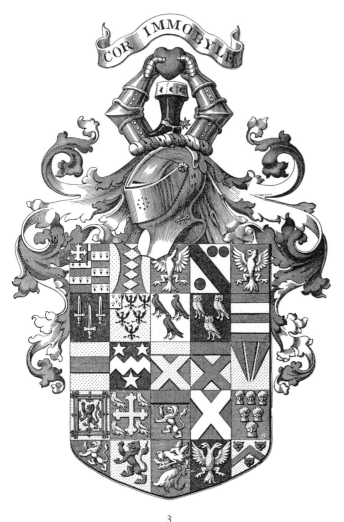

COR IMMOBYLE

3

4

1. Maximilian I, Holy Roman Emperor. 2. The Barons von Pögel. 3. Thomas Hussey. 4. The Prince of Anhalt.

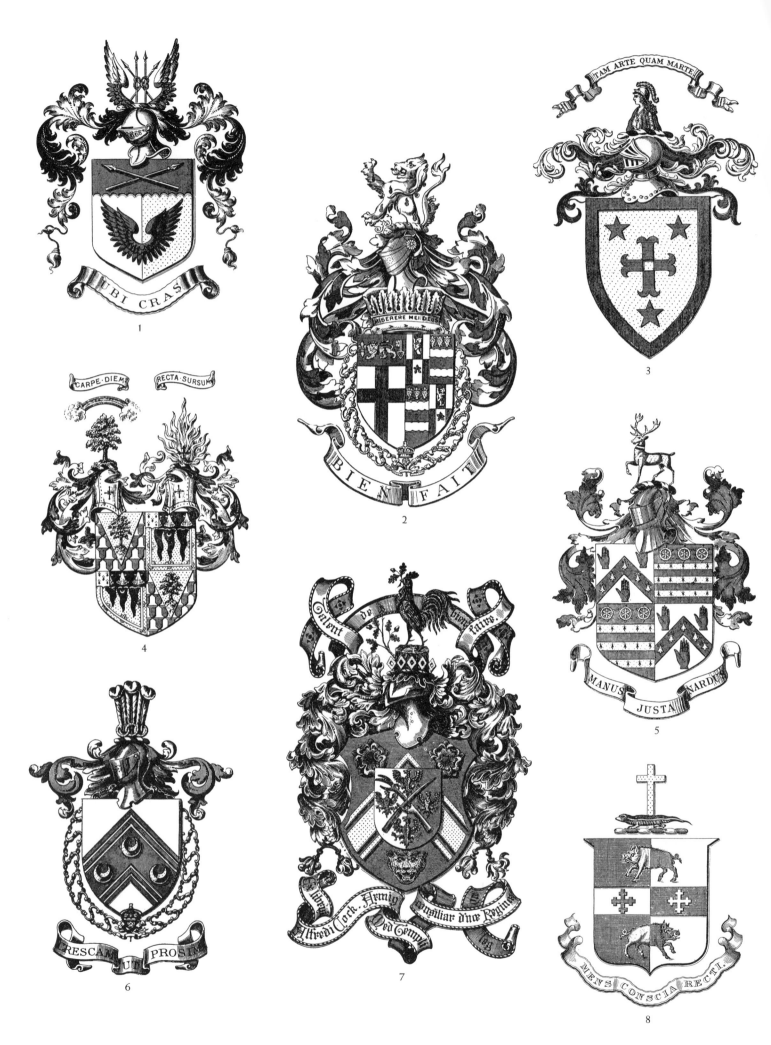

1. William B. Cloete. 2. William H. Weldon. 3. William J. Mylne. 4. John A. Graham-Wigan. 5. Edmund A. Maynard. 6. Charles H. Athill. 7. Alfred Cock. 8. Arthur O. Sillifant.

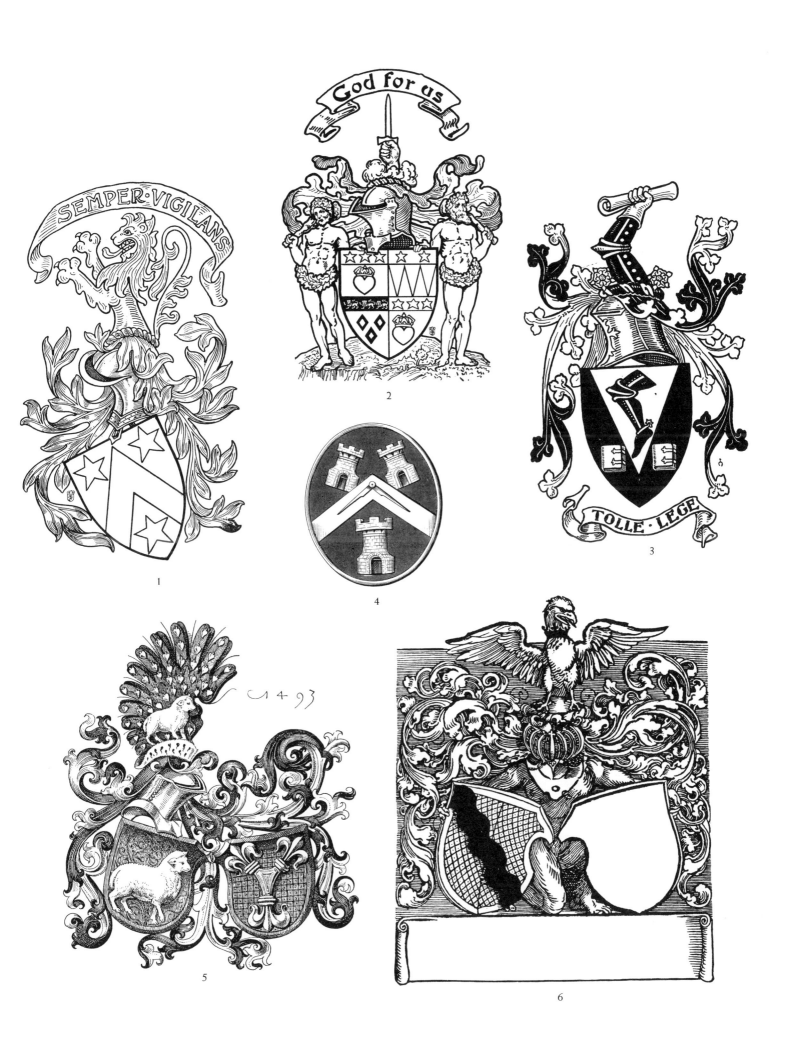

1. Walter H. Wilson. 2. John W. Douglass. 3. William Legg. 4. A seventeenth-century MS roll. 5. Löffelholz-Stromer. 6. Michael Behaim.

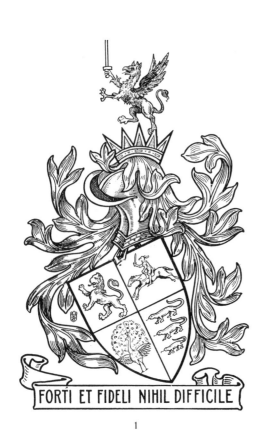

FORTI ET FIDELI NIHIL DIFFICILE

1

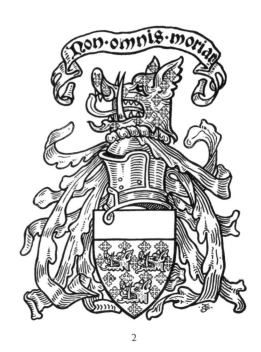

Non·omnis·moriar

2

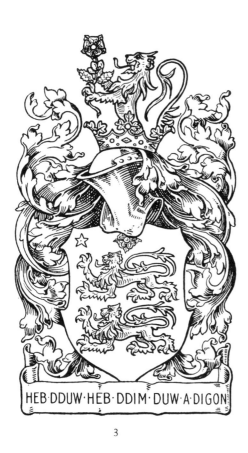

HEB·DDUW·HEB·DDIM·DUW·A·DIGON

3

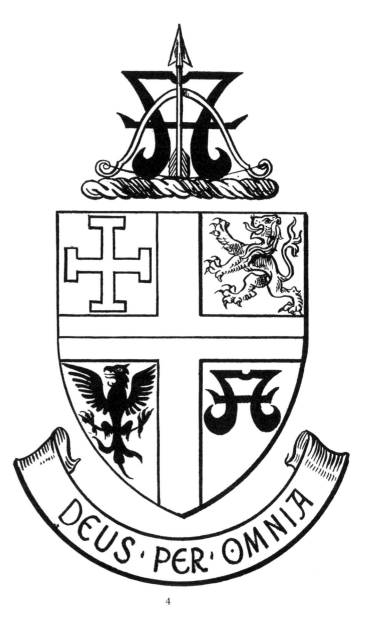

DEUS·PER·OMNIA

4

1. Stephen M. Lanigan-O'Keefe. 2. Joseph R. Heaven. 3. Michael J. Hughes. 4. The Borough of Islington.

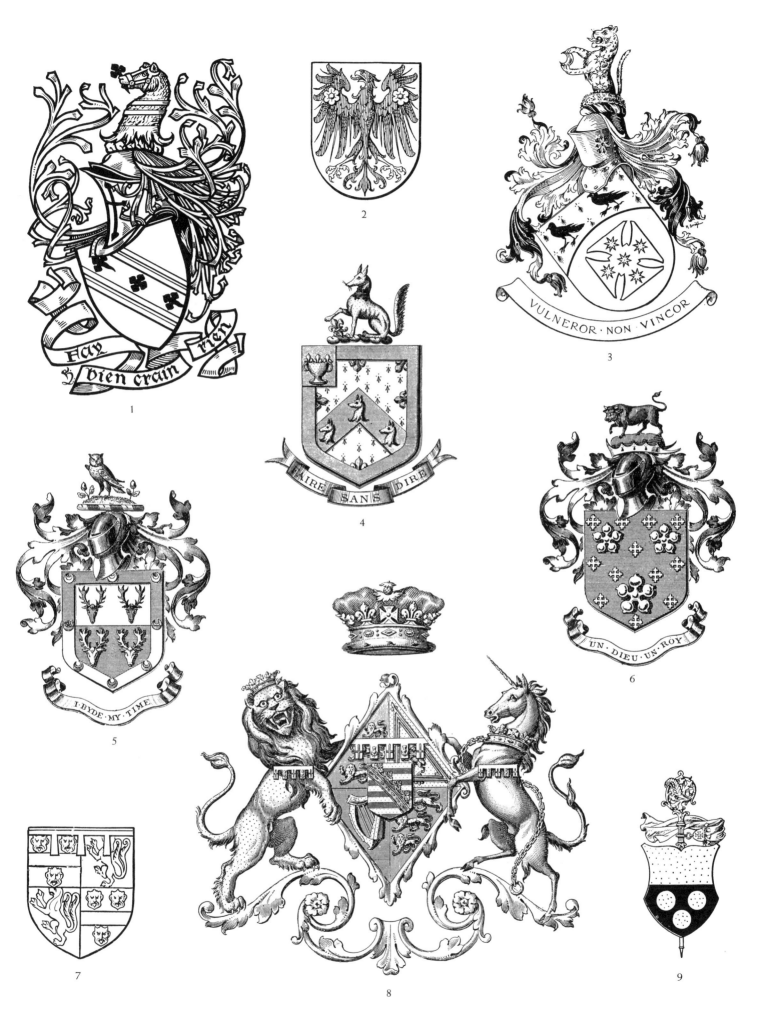

1. Arthur C. Benson. 2. The Town of Tangermünde. 3. Cuthbert B. Vickers. 4. Fox. 5. Everard W. Barton. 6. D'Arcy. 7. John de la Pole, Earl of Lincoln. 8. Princess Louise of Wales, Duchess of Fife. 9. An abbess.

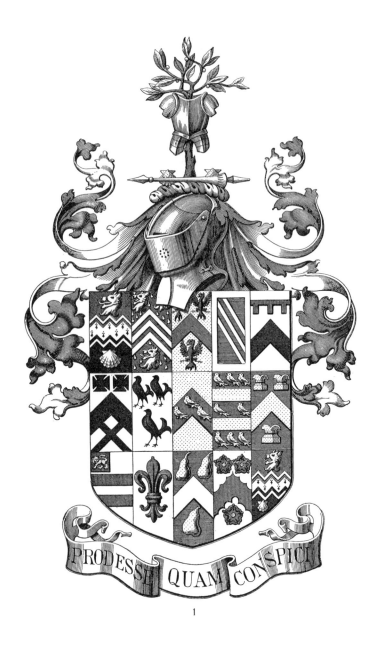

1

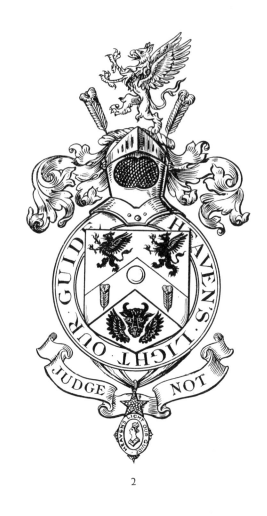

2

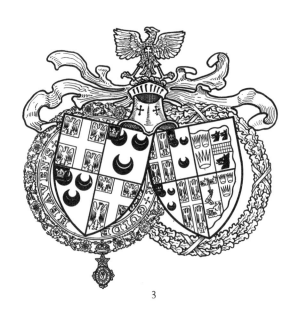

3

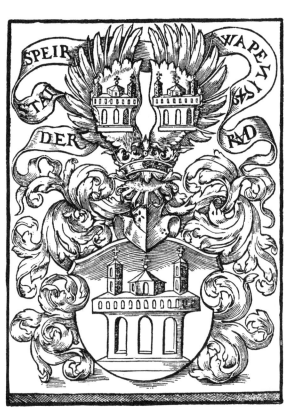

4

1. Benjamin E. Somers. **2.** Sir Lepel Griffin. **3.** Sir Richard Strachey. **4.** The City of Speyer.

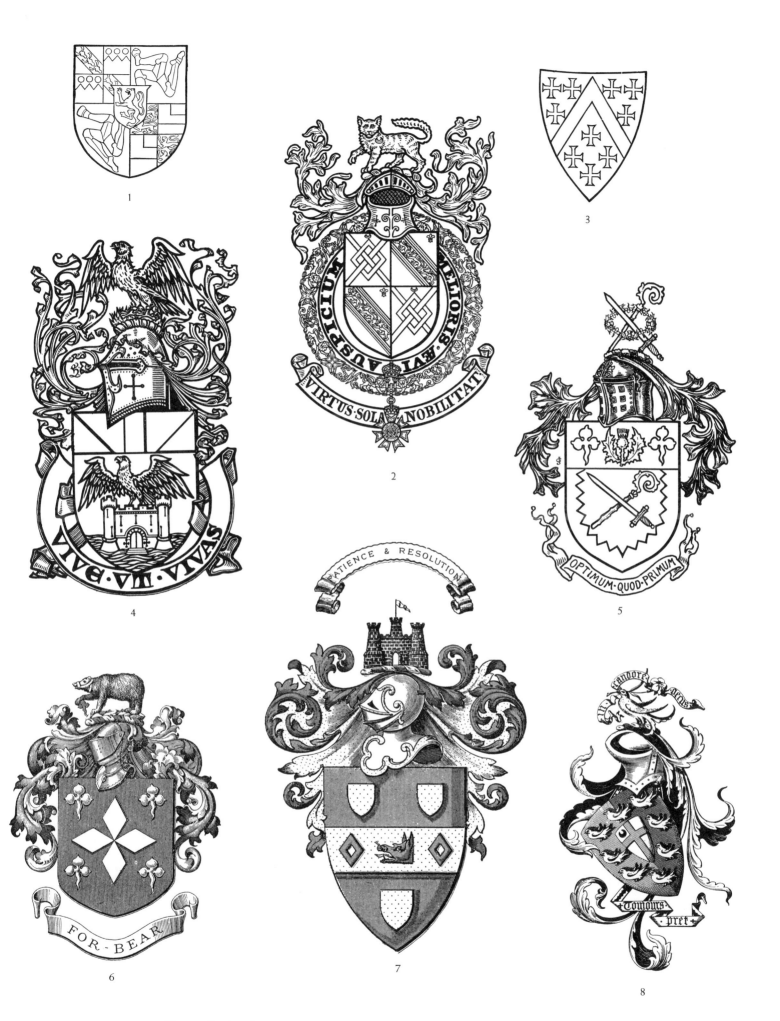

1. Thomas Stanley, Earl of Derby. 2. Sir Henry Blake. 3. Thomas, Lord Berkeley of Berkeley.
4. Louis M. Lanyon. 5. George E. Kirk. 6. Robert Barnes. 7. James M. Mutter. 8. Edward
M. Chadwick.

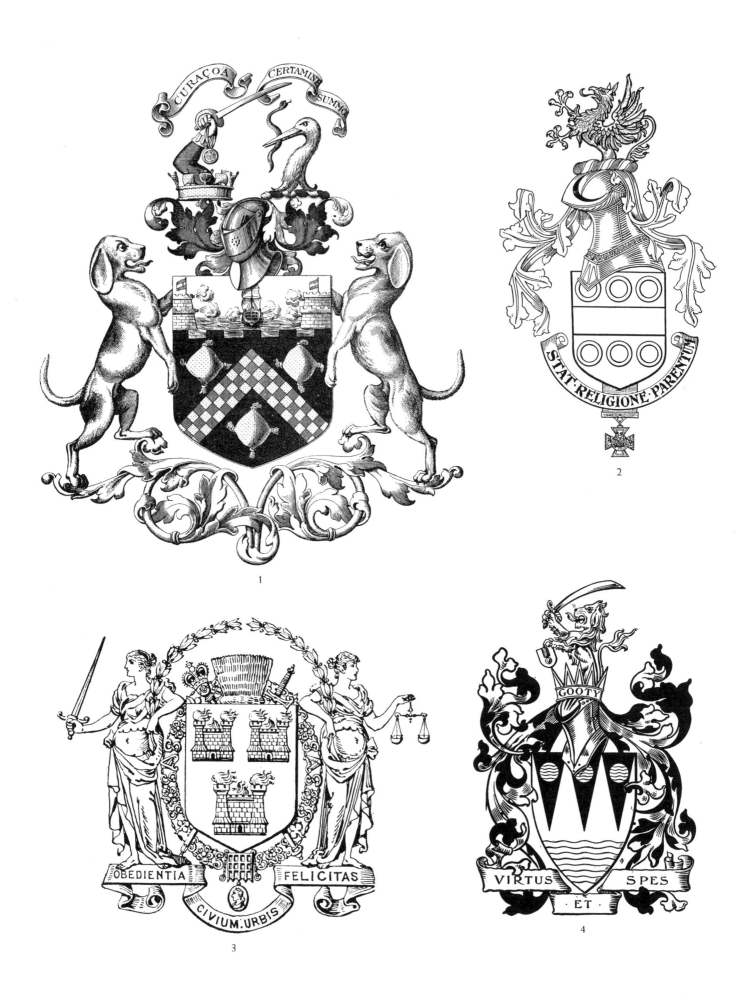

1. Charles T. Brisbane. 2. Charles D. Lucas. 3. The City. of Dublin. 4. Robert T. Caldwell.

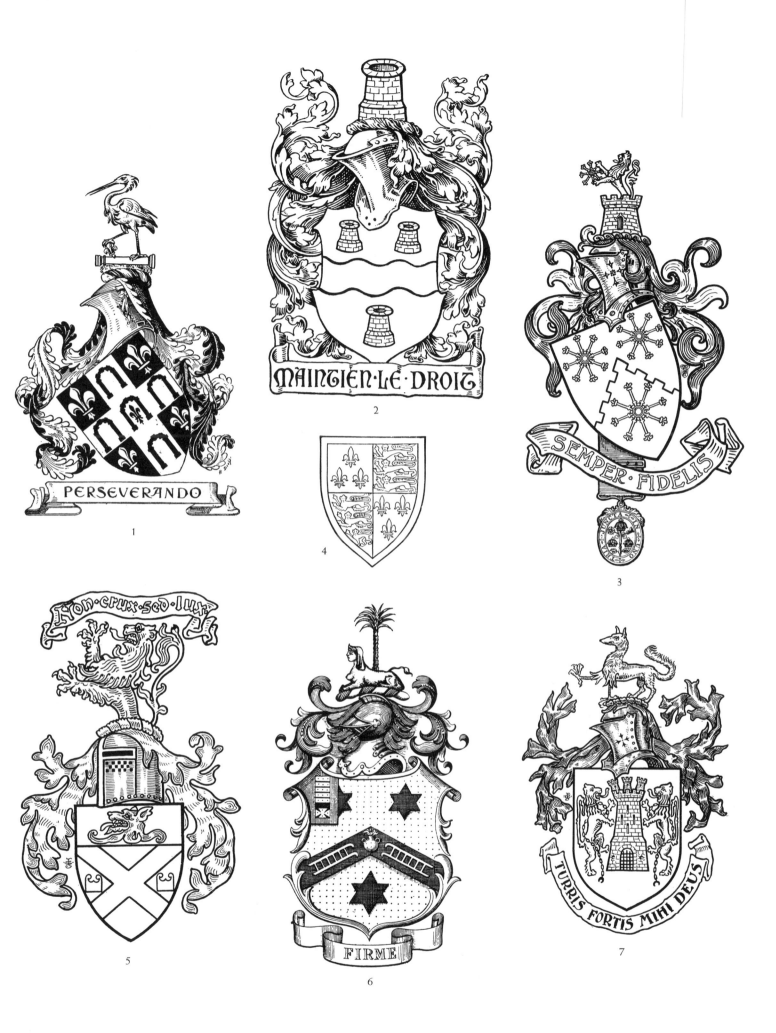

MAINTIEN·LE·DROIT

PERSEVERANDO

SEMPER·FIDELIS

Non·crux·sed·lux

FIRME

TURRIS FORTIS MIHI DEUS

1

2

3

4

5

6

7

1. Herbert D. Banks. 2. Hodsoll. 3. Robert H. Boyce. 4. John de Beaufort, Earl of Somerset.
5. William G. Black. 6. William S. D'Urban. 7. Edward F. Kelly.

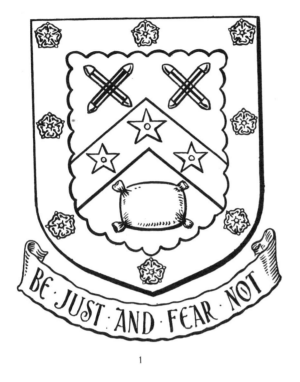

1

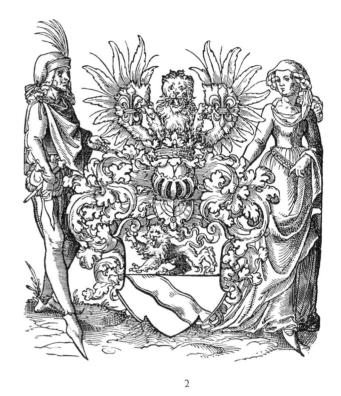

2

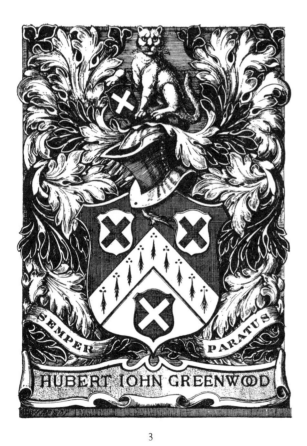

3

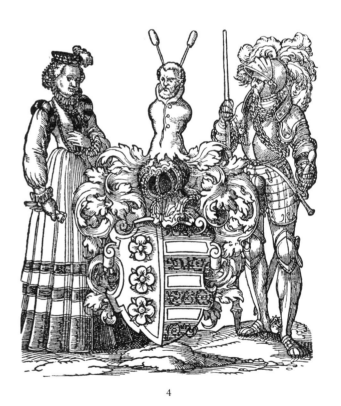

4

1. The Town of Pudsey.　2. Martorf.　3. Hubert J. Greenwood.　4. Hessberg.

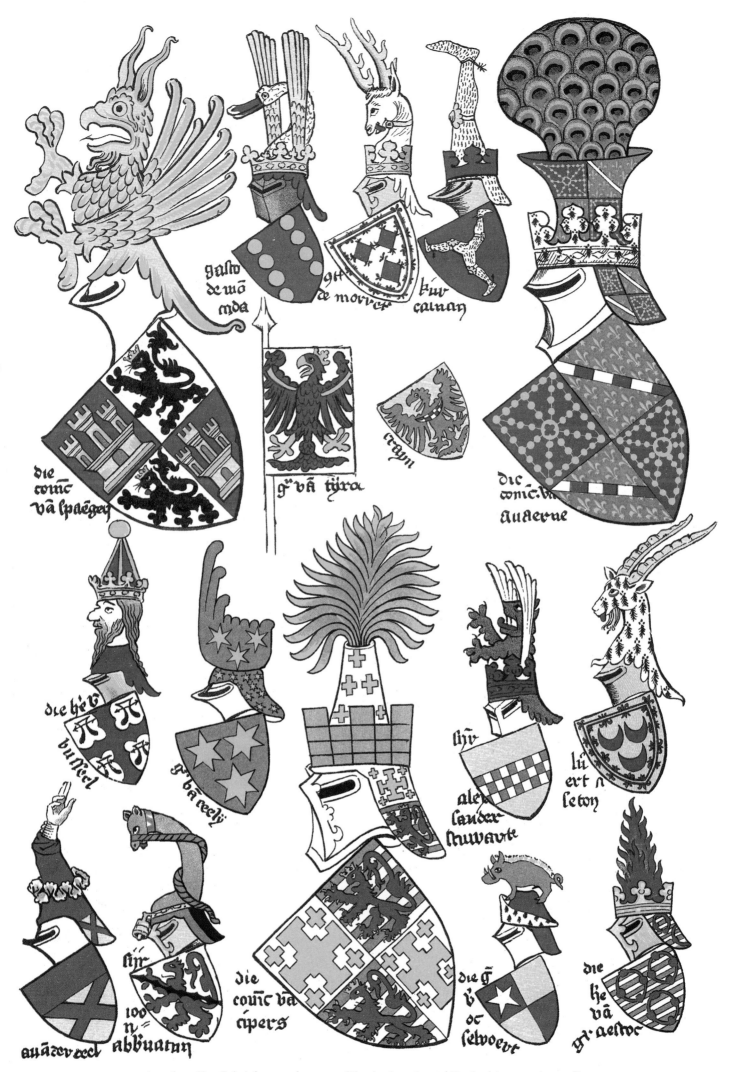

Arms from Von Gelre's fourteenth-century *Wapenboeck, ou Armorial* [Book of Arms, or Armorial].

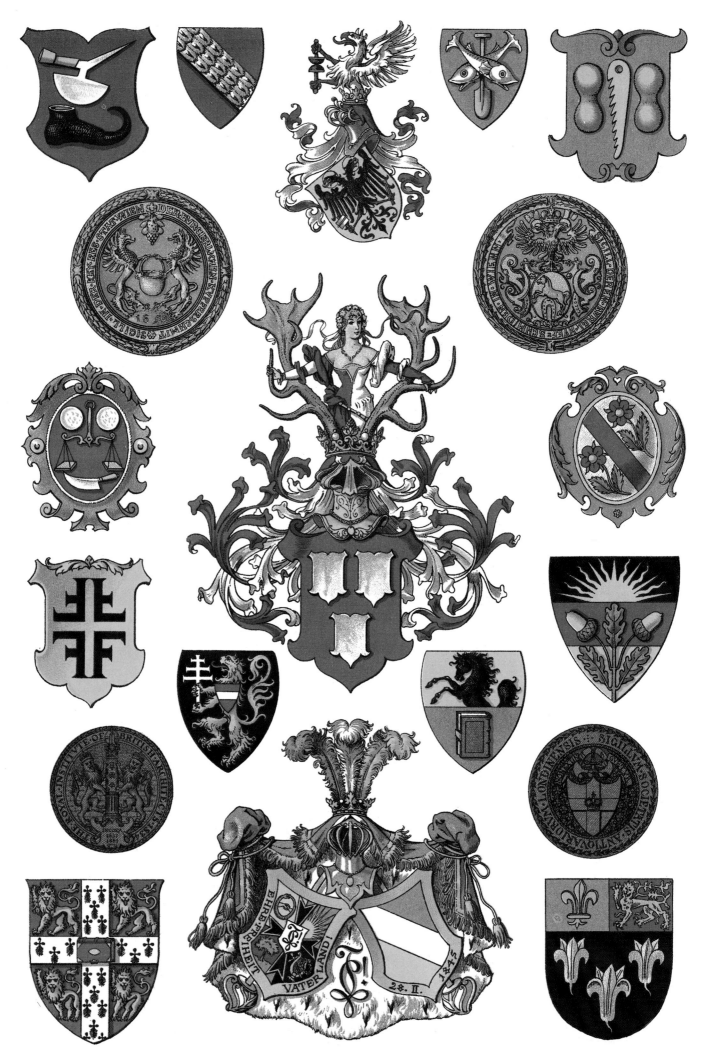

Arms of guilds, societies and corporations, etc.

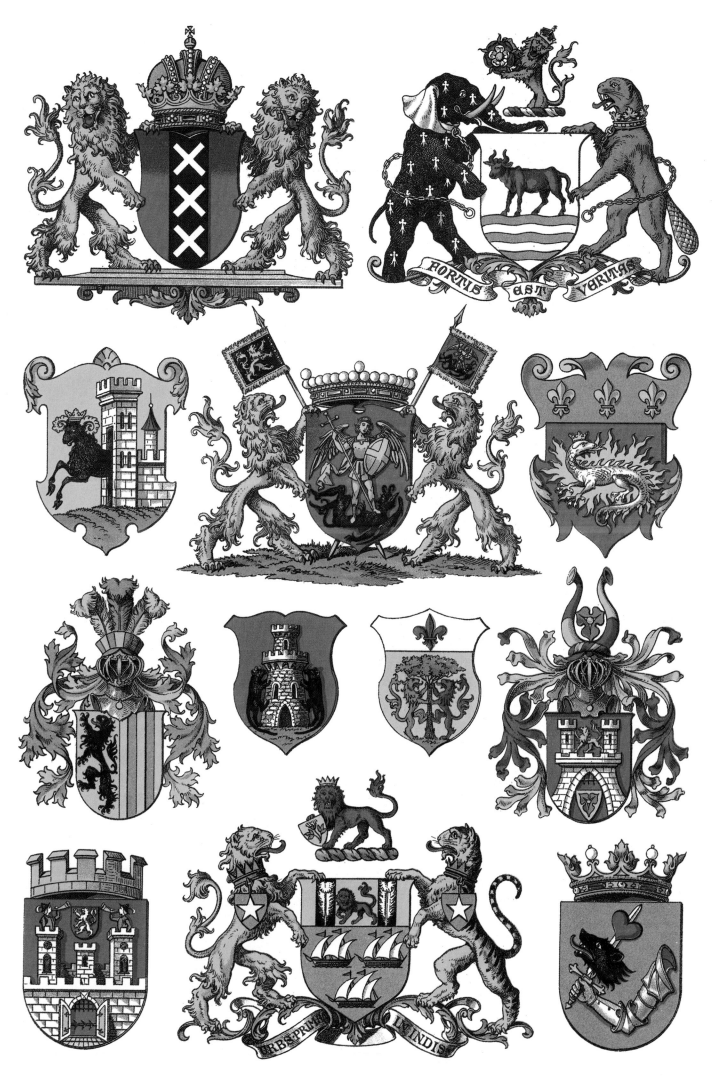

Arms of towns and cities.

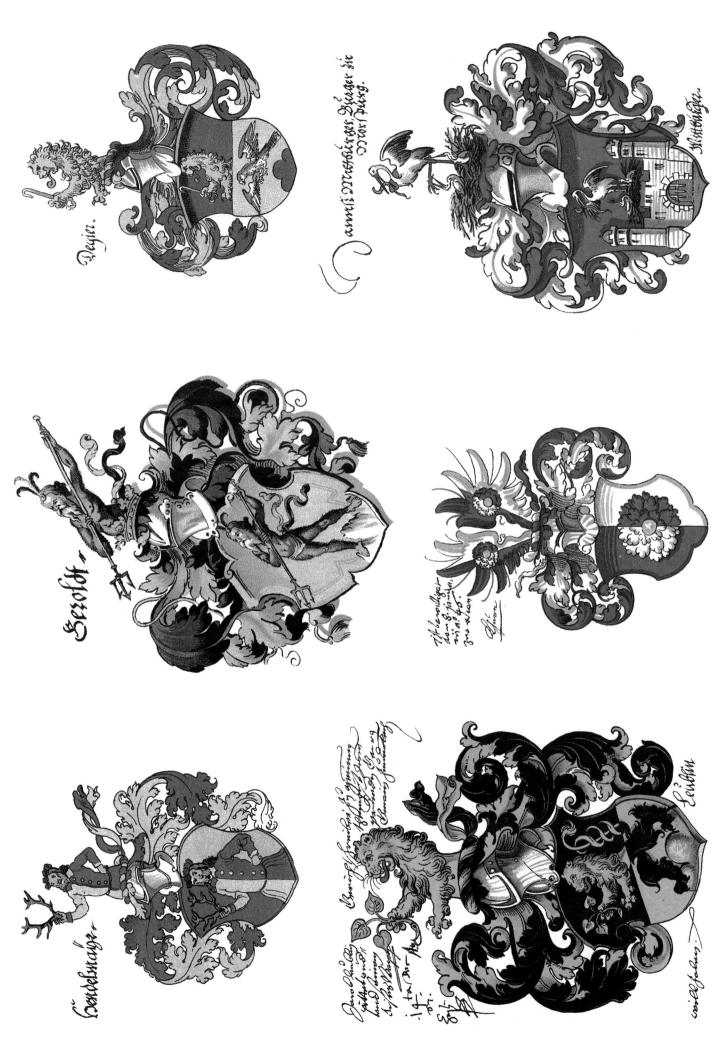

Sixteenth-century arms from the *Wappenbuch I* [Book of Arms, Vol. I].

Von siben und zwaintzigsten herren des landes

Von dem zwelften fürsten aigen ersten hertzogen zuo ostereich

Von zwen und zwaintzigisten herren des landes

Graff von bononia wappen und sinas gemachels

Zum fünfftzig und andern regierenden fürsten

Von acht und hiertzigsten herren des landes

Arms from Conrad Grünenberg's *Oesterreichische Chronik* [Austrian Chronicle] (1452–1484).

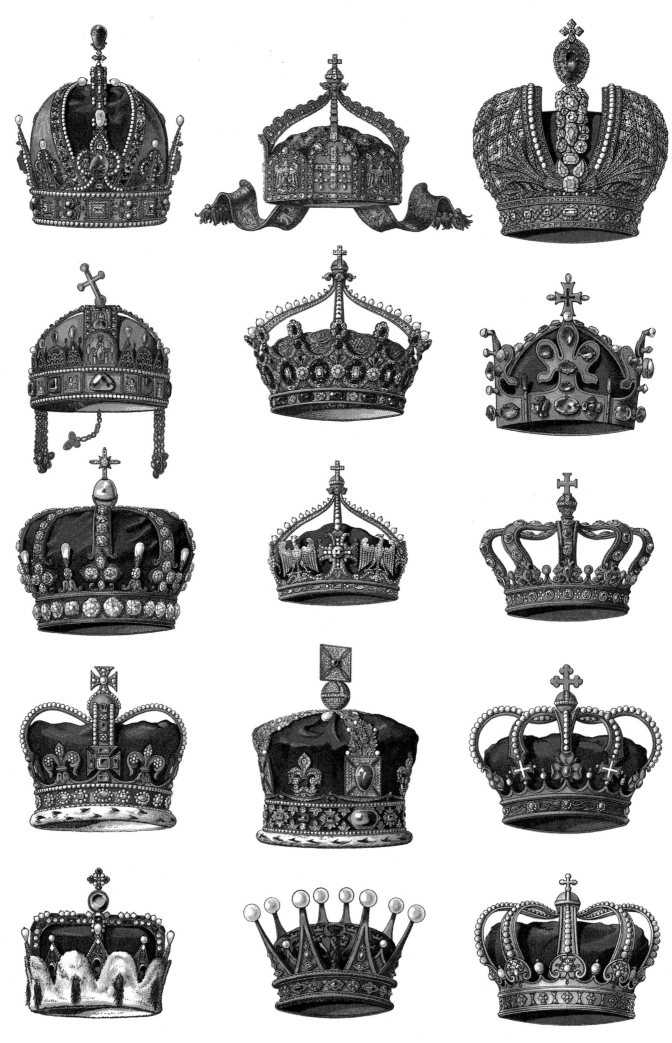

Royal and imperial crowns.

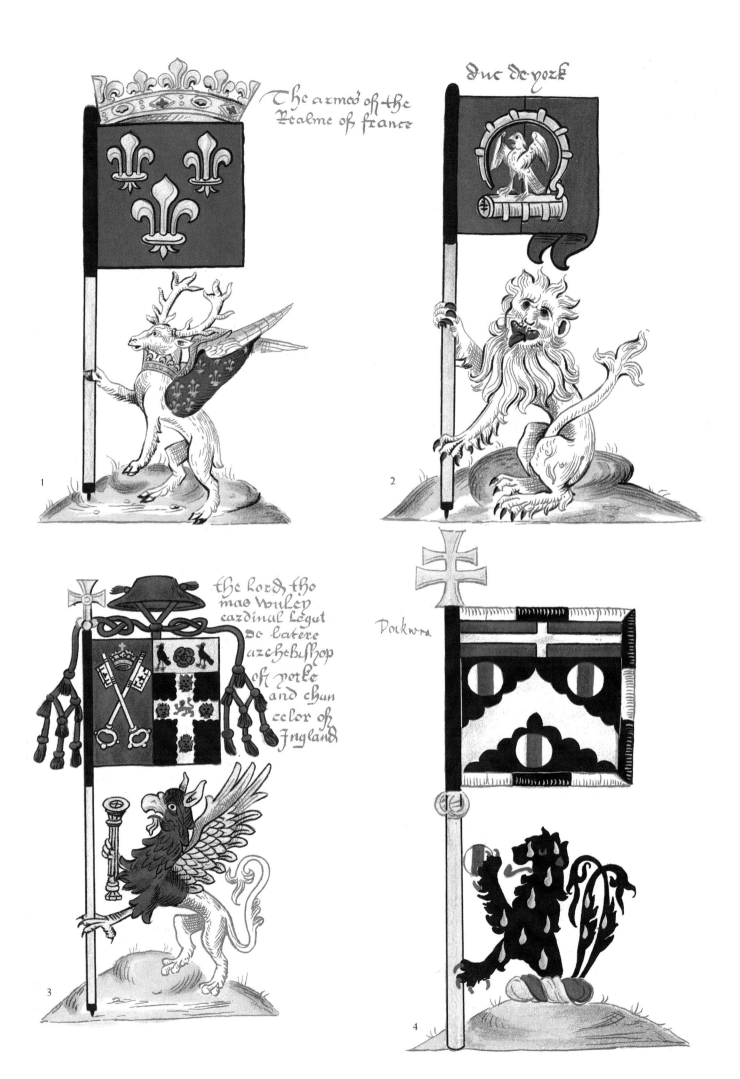

The armes off the Realme off france

Duc de york

the lord tho
mas wulsey
cardinal Legat
De latere
archebisshop
off yorke
and chan
celor off
Jngland

Dockwra

Banners of: **1**. France. **2**. Edward, Duke of York. **3**. Cardinal Wolsey. **4**. Sir Thomas Dockwra.

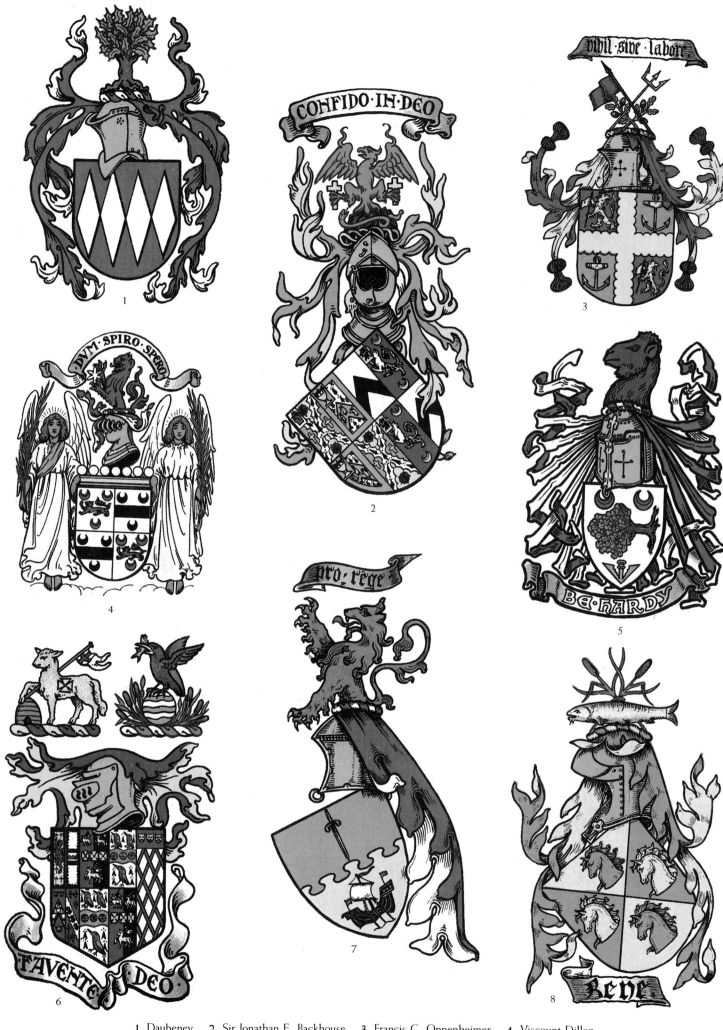

1. Daubeney. 2. Sir Jonathan E. Backhouse. 3. Francis C. Oppenheimer. 4. Viscount Dillon.
5. Henry W. Dauglish. 6. E. R. Fisher-Rowe. 7. John W. Macfie. 8. James Binney.

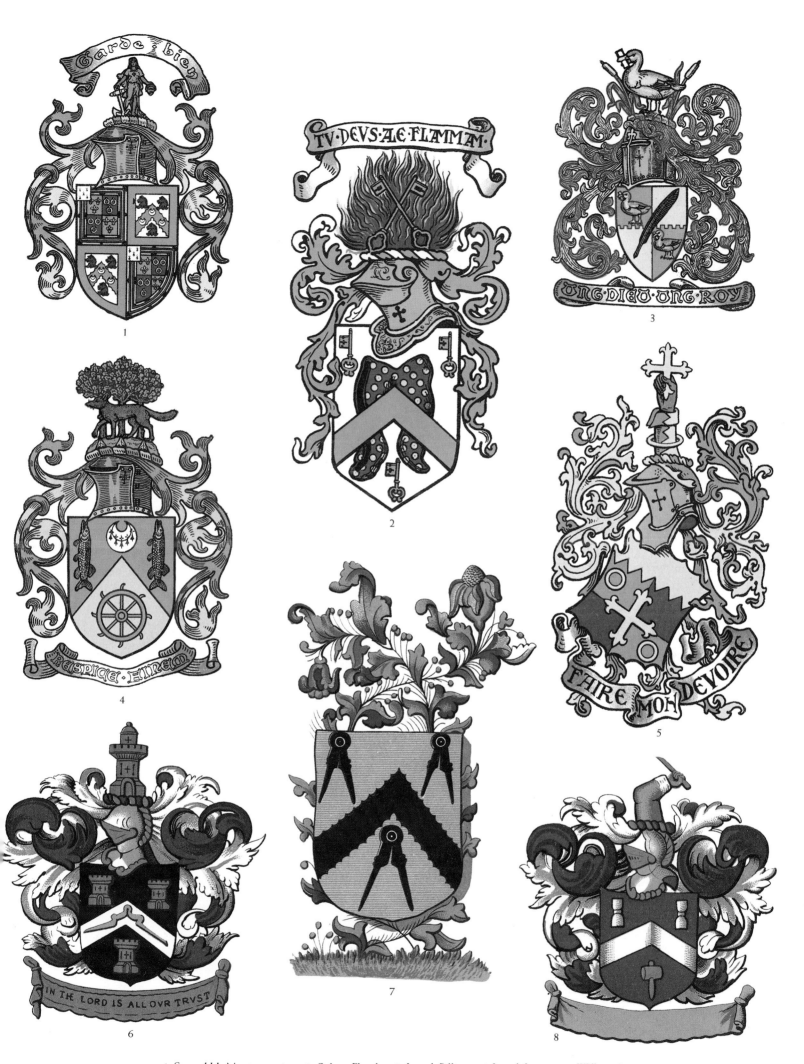

1. Samuel H. Montgomerie. 2. Sidney Flavel. 3. Joseph Billiat. 4. Joseph Lucas. 5. William A.
l'Anson. 6. A Masonic lodge. 7. The Carpenters' Company, London. 8. A marblers' company.

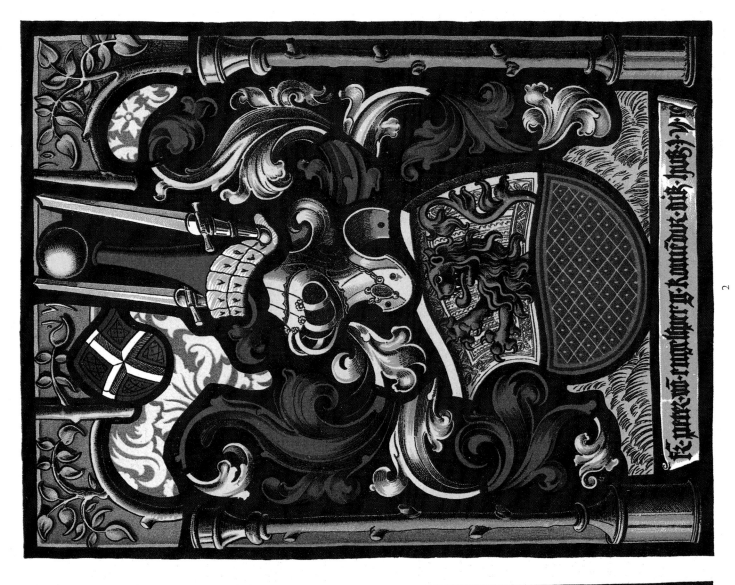

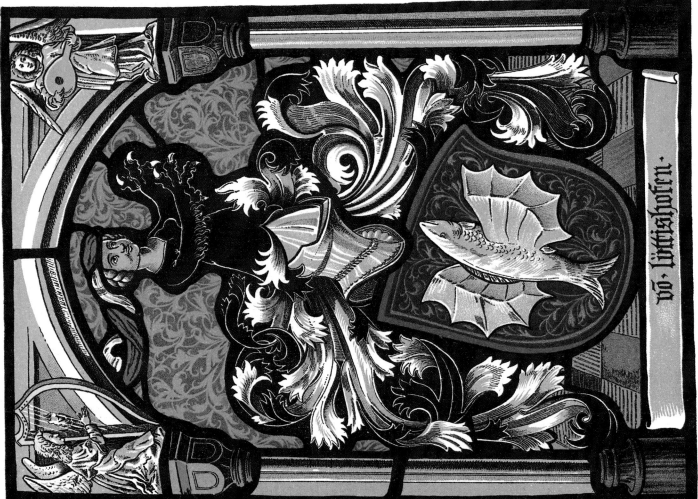

K · pxx · vö · engelsberg · Kumtur · vō · Hall

2

vō · Lüttishofen ·

1

1. Von Lüttishofen (heraldic window). 2. Peter von Engelsberg (heraldic window).

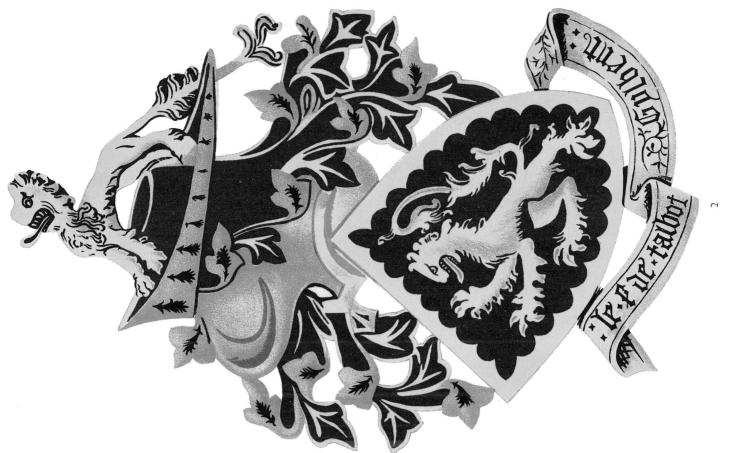

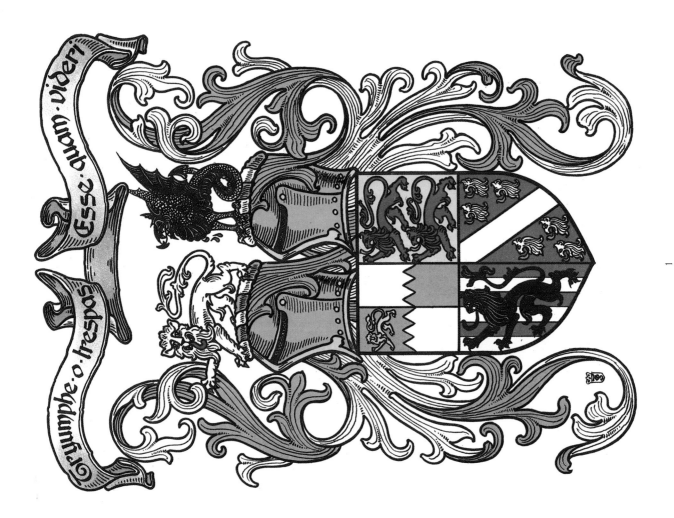

1. Croft. 2. Sir Gilbert Talbot.

117

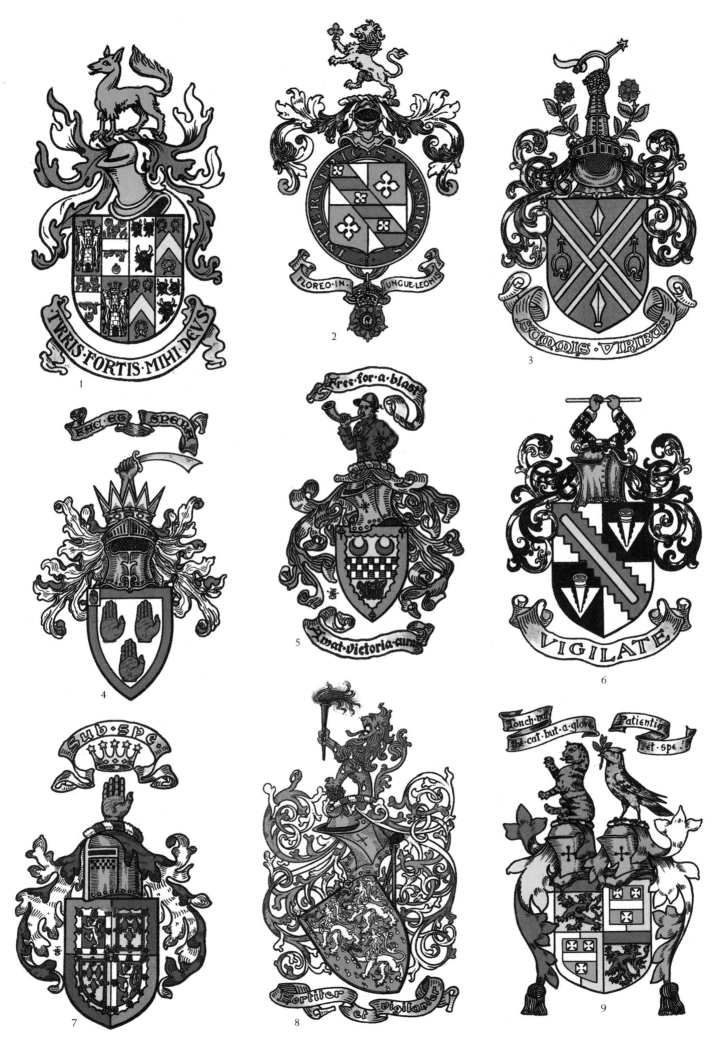

1. Arthur D. Kelly. 2. Sir Henry S. King. 3. Sir Henry Harben. 4. Sir Kenneth J. Matheson. 5. Robert Mildmay. 6. Llewellyn W. Longstaff. 7. John A. Dunbar-Dunbar. 8. Edward T. Tyson. 9. Peter Duguid-M'Combie.

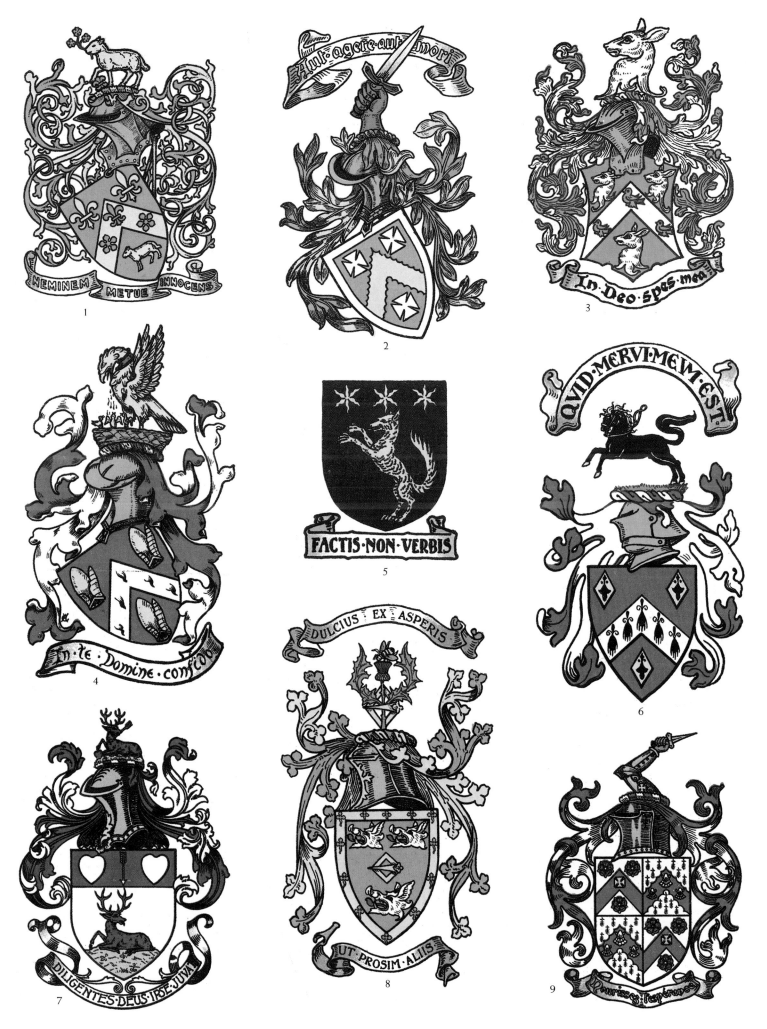

1. John Platt. 2. Charles H. Barclay. 3. Gerald M. Conran. 4. W. H. Wayne. 5. Henry
Rimington-Wilson. 6. Robert S. Stone. 7. John T. Harthill. 8. George B. Ferguson. 9. James
G. White.

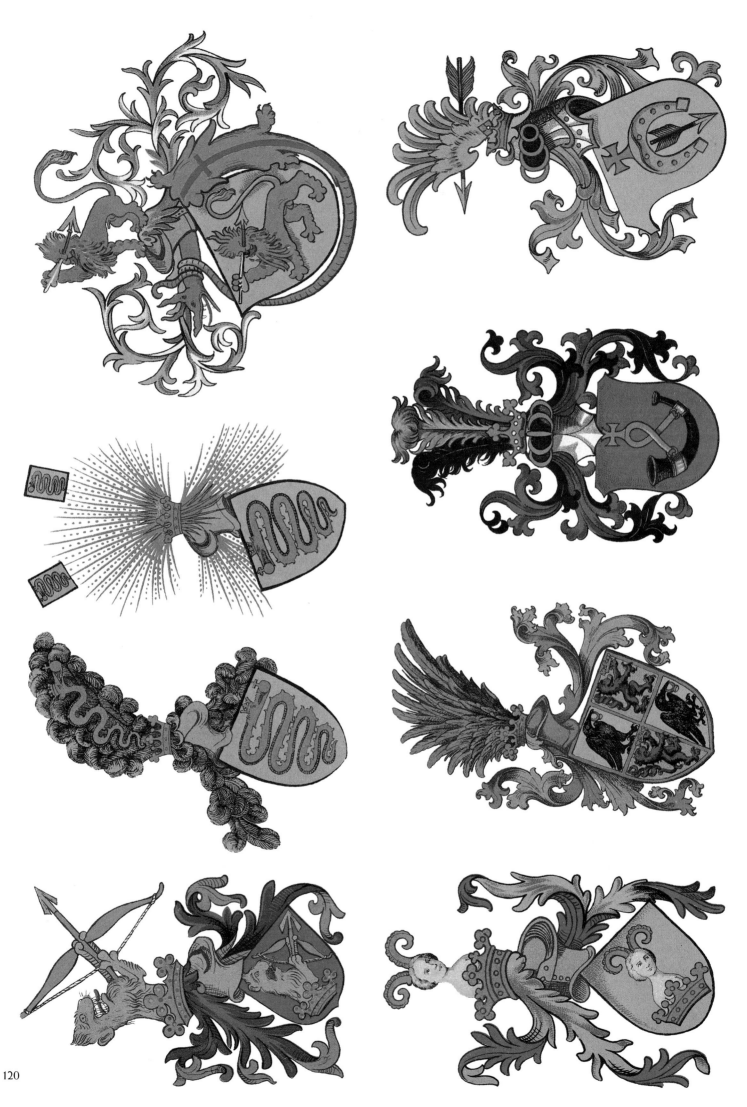

Hungarian and Polish arms.

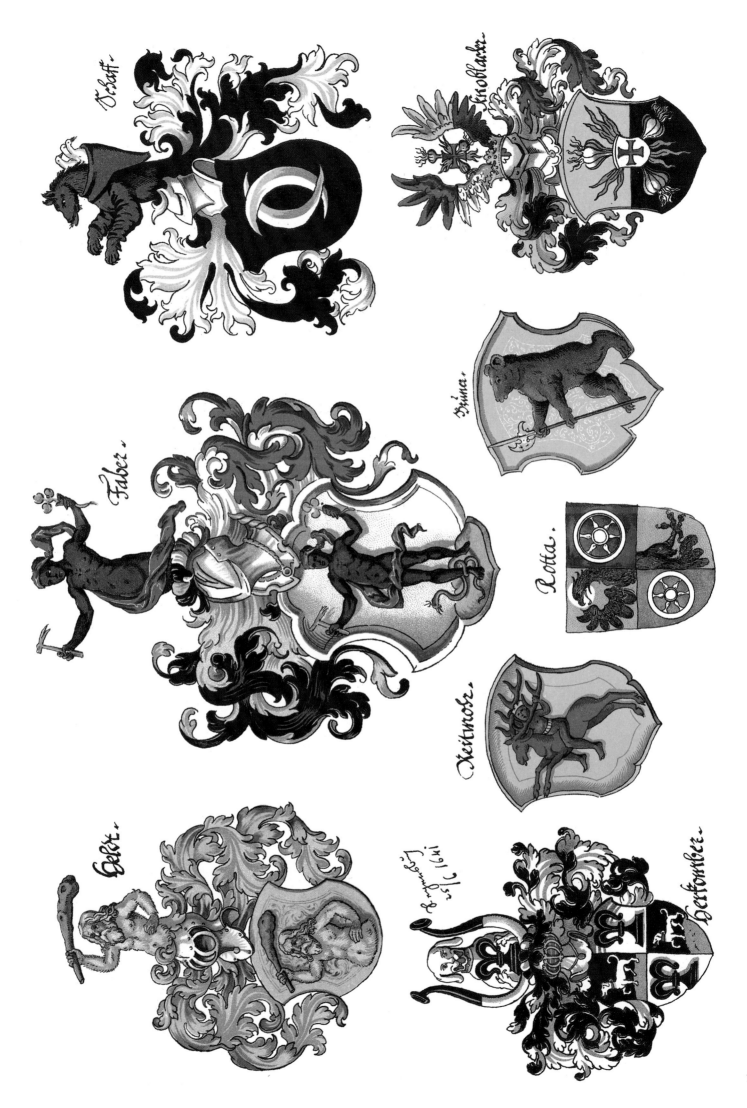

Sixteenth- and seventeenth-century arms from the *Wappenbuch II* [Book of Arms, Vol. II].

121

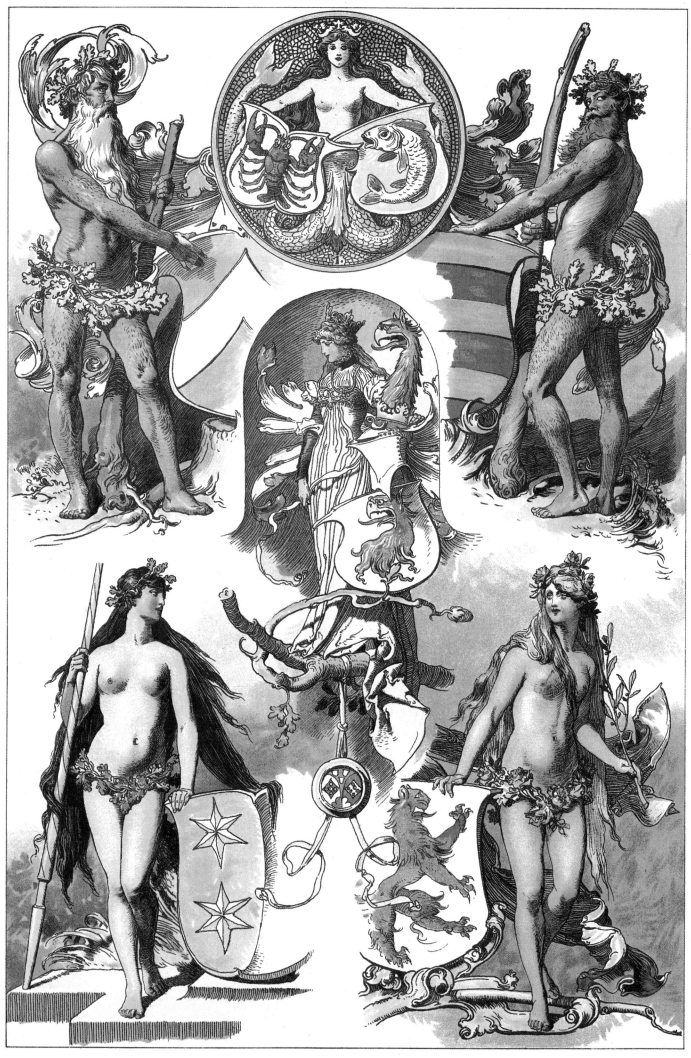

Human figures as supporters.

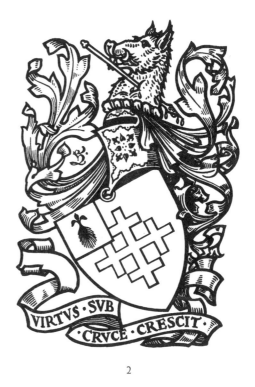

VIRTVS · SVB CRVCE · CRESCIT ·

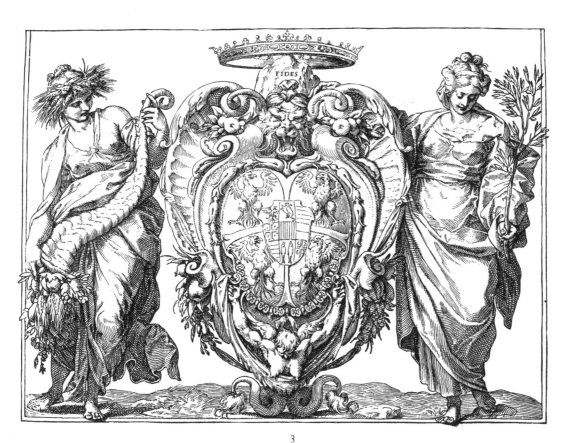

1. Von Heringen. 2. William P. Bury. 3. The Duchy of Mantua.

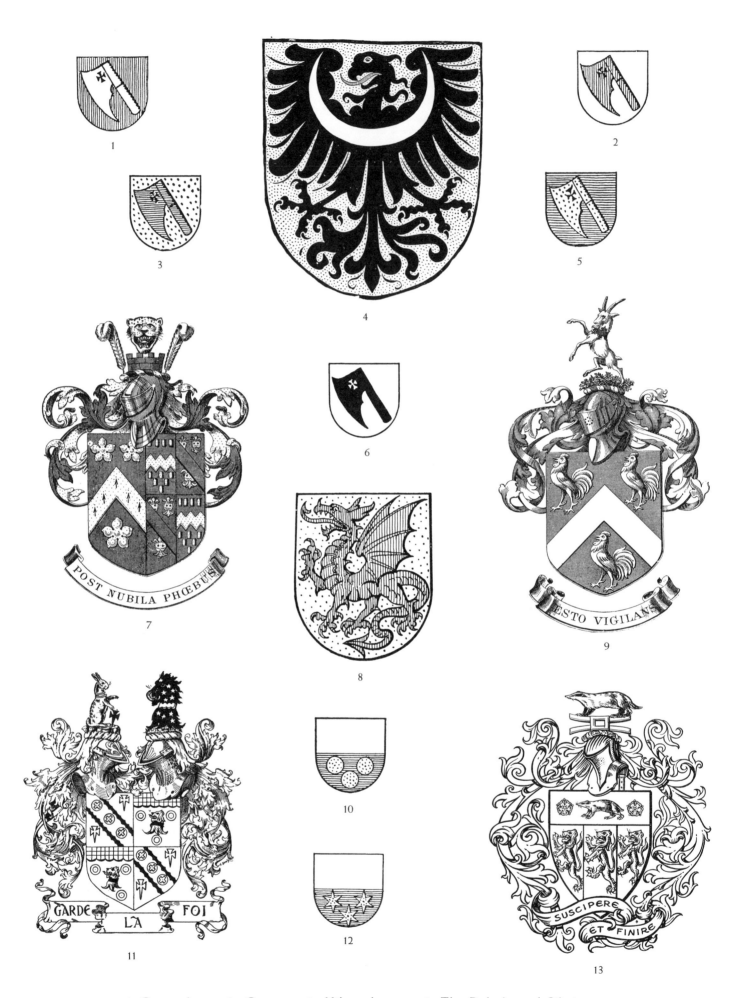

1. Cammerberg. 2. Cammer. 3. Hilgertshauser. 4. The Dukedom of Silesia.
5. Massenhauser. 6. Parteneck. 7. Alfred H. Tarleton. 8. An heraldic dragon.
9. Lloyd. 10. The City of Freiburg. 11. Edward J. Whittington-Ince. 12. The City of Freiberg.
13. Andrew R. Motion.

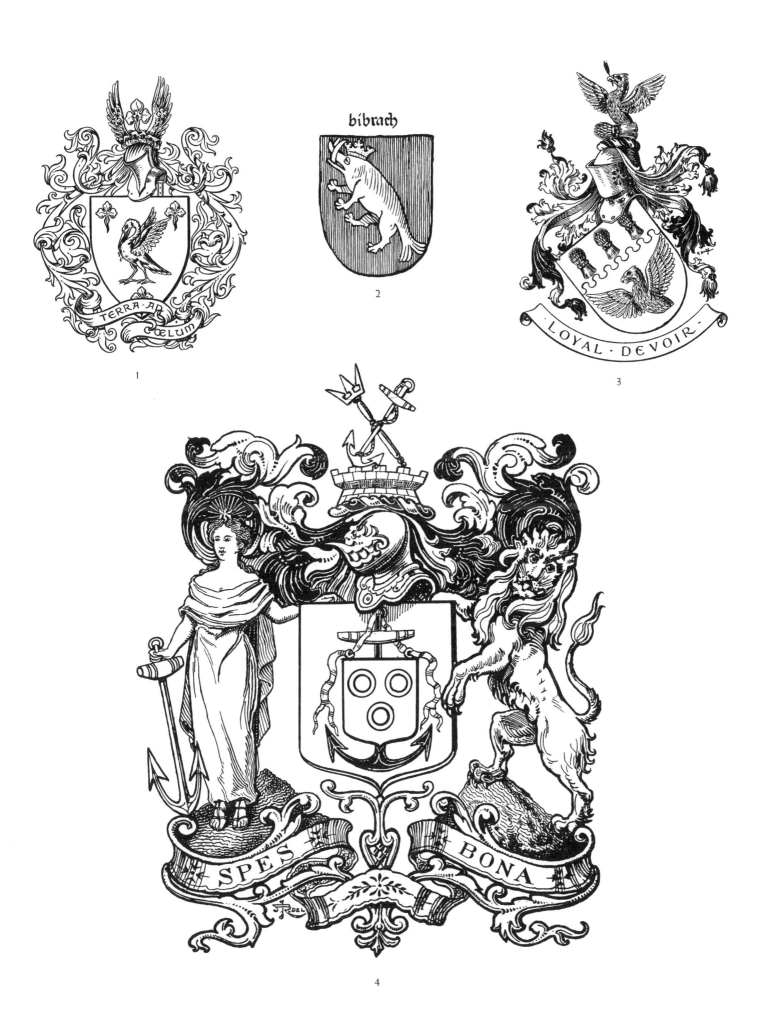

bibrach

TERRA AP OELUM

LOYAL · DEVOIR ·

SPES BONA

1. Edmund Frost. 2. The City of Biberach. 3. John H. Cartland 4. The City of Cape Town.

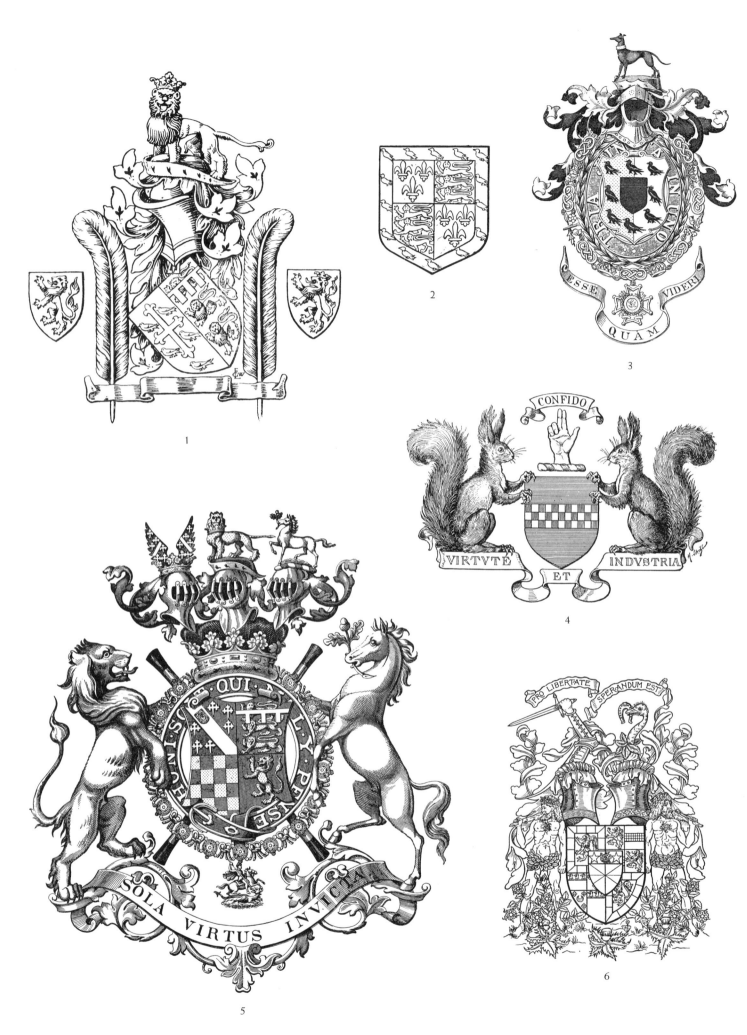

1. Thomas de Mowbray, Duke of Norfolk. 2. Jasper Tudor, Duke of Bedford. 3. Sir Charles H. Brownlow. 4. The Burgh of Kilmarnock. 5. The Duke of Norfolk. 6. Hugh R. Wallace.

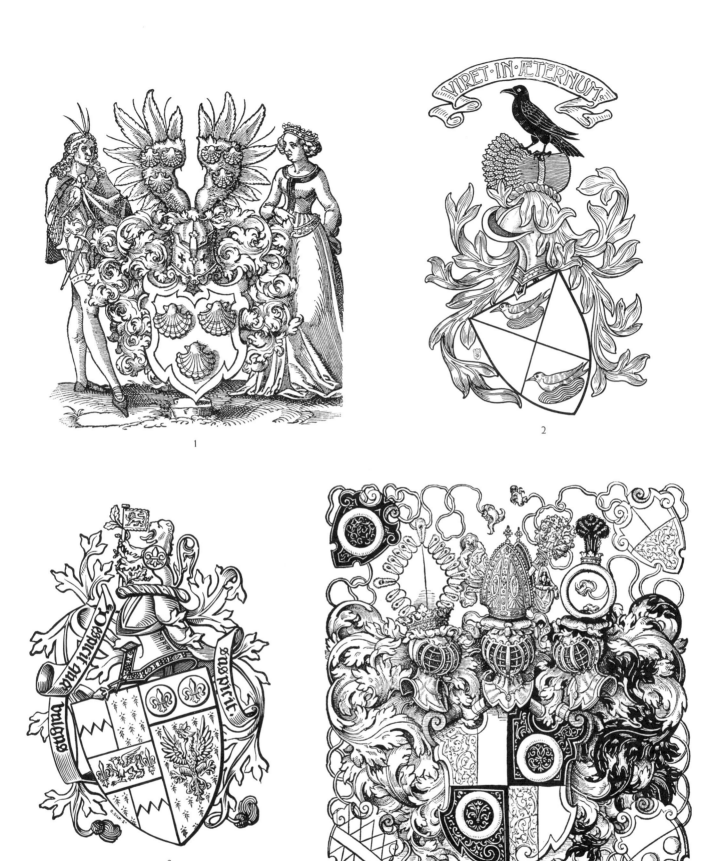

1. Stallburger. 2. Harry Holmes-Tarn. 3. John P. Rylands. 4. Johann Egenolph von Knöringen,
Bishop of Augsburg.

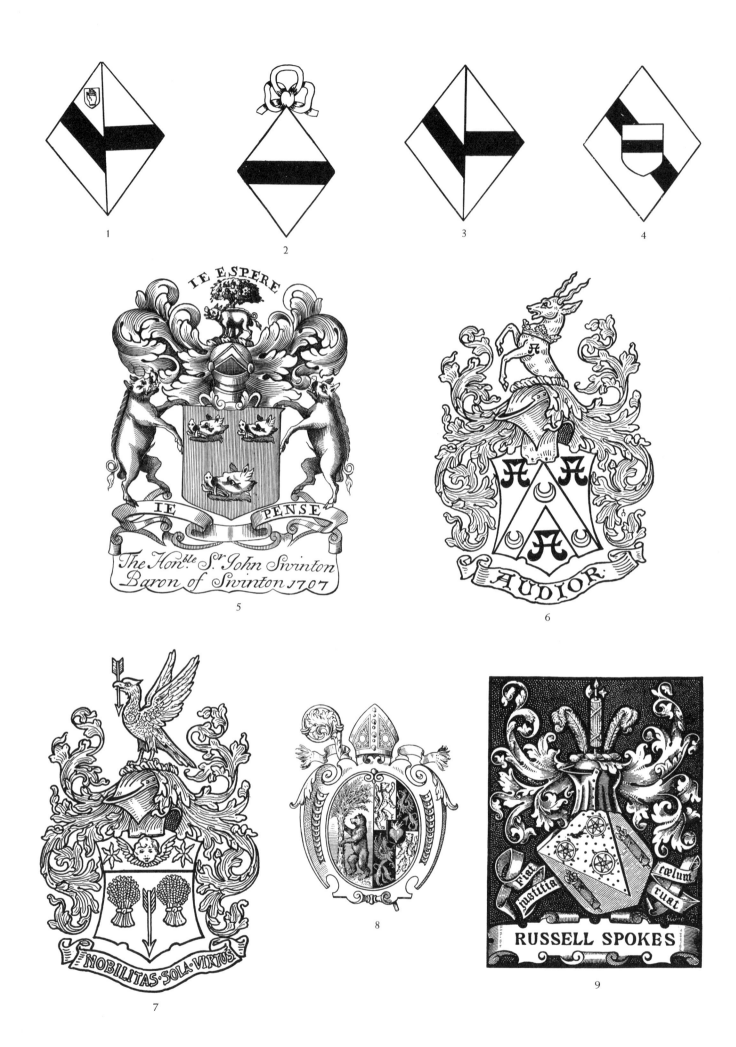

1. Conjoined arms. 2. An unmarried woman. 3 & 4. Conjoined arms. 5. Sir John Swinton of that Ilk (bookplate). 6. Samuel T. Heard. 7. Arthur T. Thackeray. 8. LEFT: The Abbey of Pernegg; RIGHT: Abbot Franz of Pernegg. 9. Russell Spokes (bookplate).

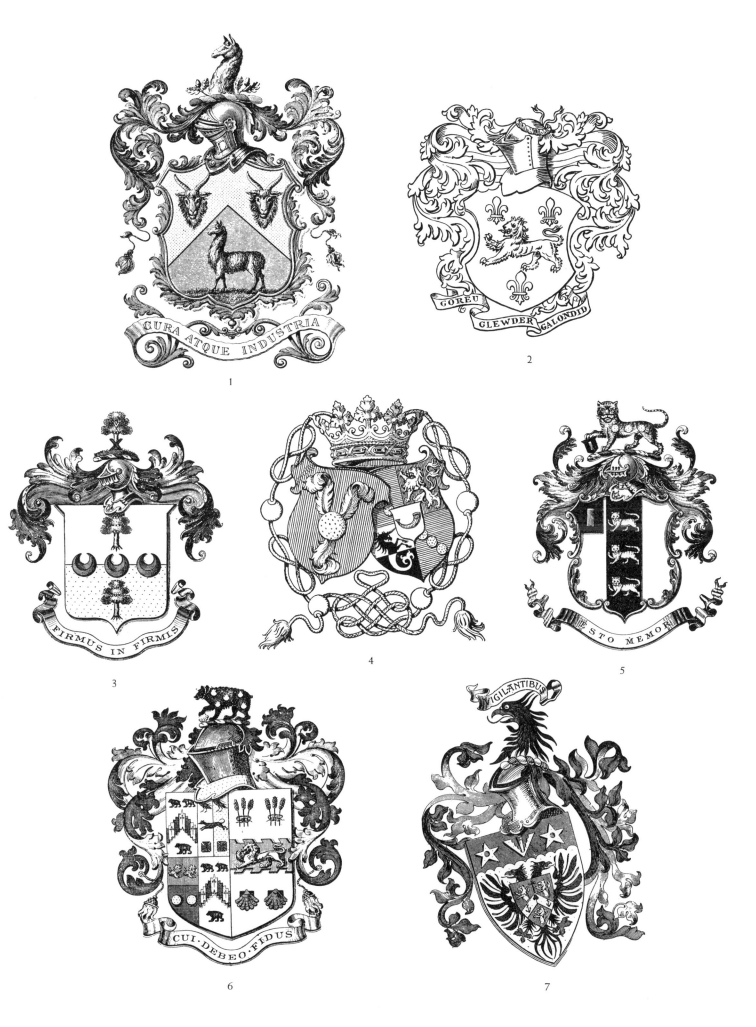

1. William H. Benn. 2. David C. Lloyd-Owen. 3. Ernest F. Kilpin. 4. LEFT: Franz Anton, Count von Harrach; RIGHT: Antoine, Countess of Falkenhain. 5. Joseph A. Keates. 6. Francis Layland-Barratt. 7. Robert S. Aitchison.

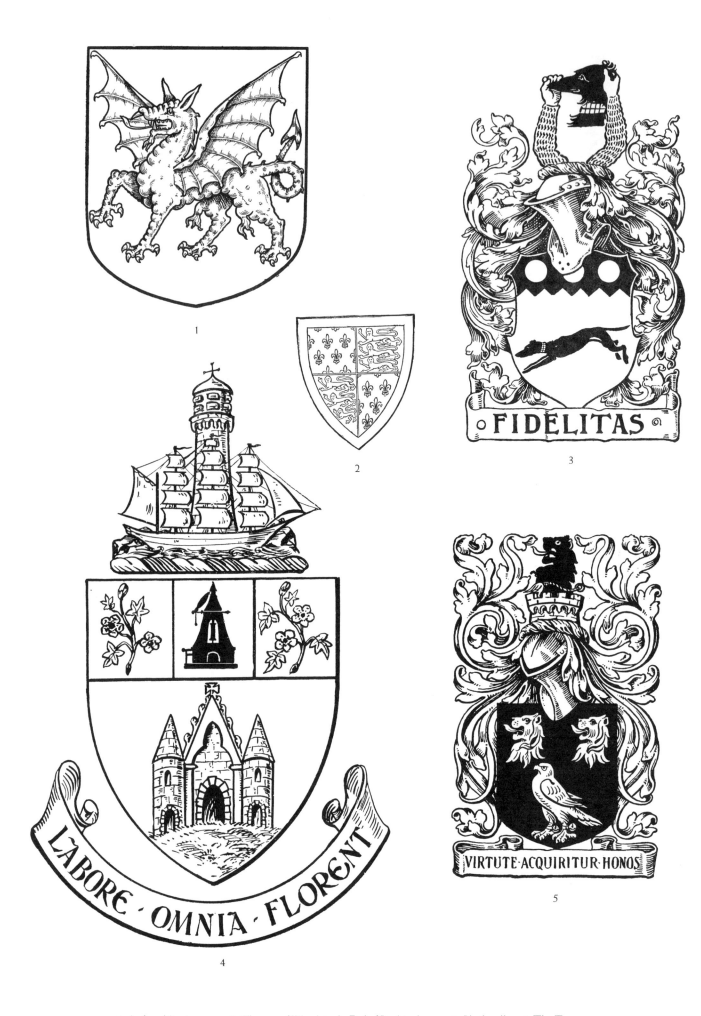

1. An heraldic dragon. 2. Thomas of Woodstock, Earl of Buckingham. 3. Blackwall. 4. The Town of Eccles. 5. Utrick A. Ritson.

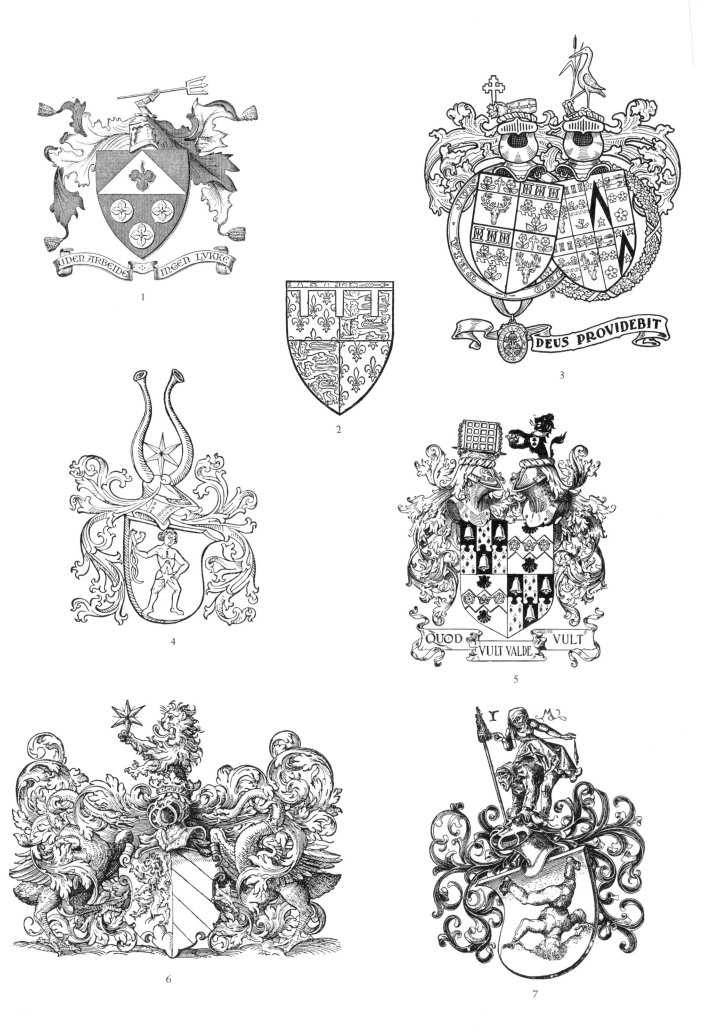

1. John L. Dreyer. 2. Edward the Black Prince. 3. Sir Robert T. White-Thomson. 4. Erhard Ratdolt. 5. Henry R. Porter. 6. Nikolaus Reussner. 7. Arms engraved by Israel van Meckenem.

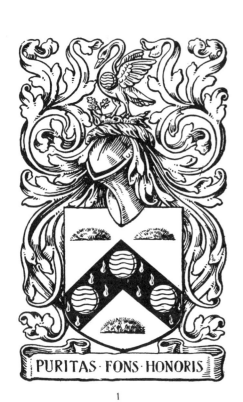

PURITAS · FONS · HONORIS

1

2

3

PERGE · SED · CAUTE

4

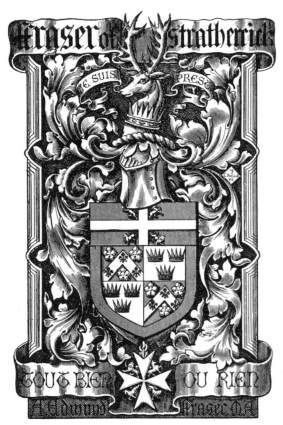

5

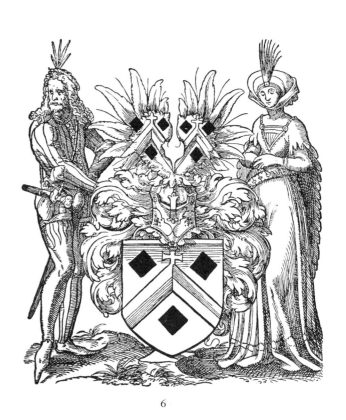

6

1. Arthur H. Sykes. 2. Monesse. 3. John de Holand, Duke of Exeter. 4. Joseph
Lees. 5. Alexander E. Fraser. 6. Neuenhaus.

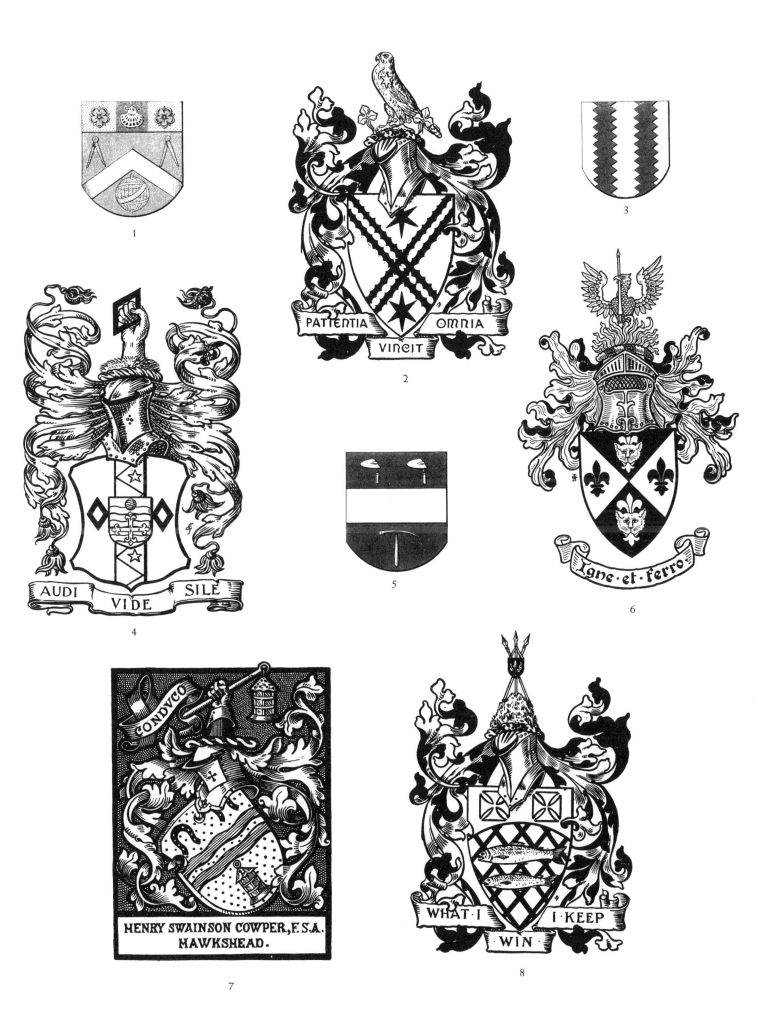

1. The Joiners, London. 2. Charles Scarisbrick. 3. The Joiners, Amiens. 4. Philip
F. Tillard. 5. The Tilers, La Rochelle. 6. Sir Alfred Hickman. 7. Henry S. Cowper (book-
plate). 8. George P. Winlaw.

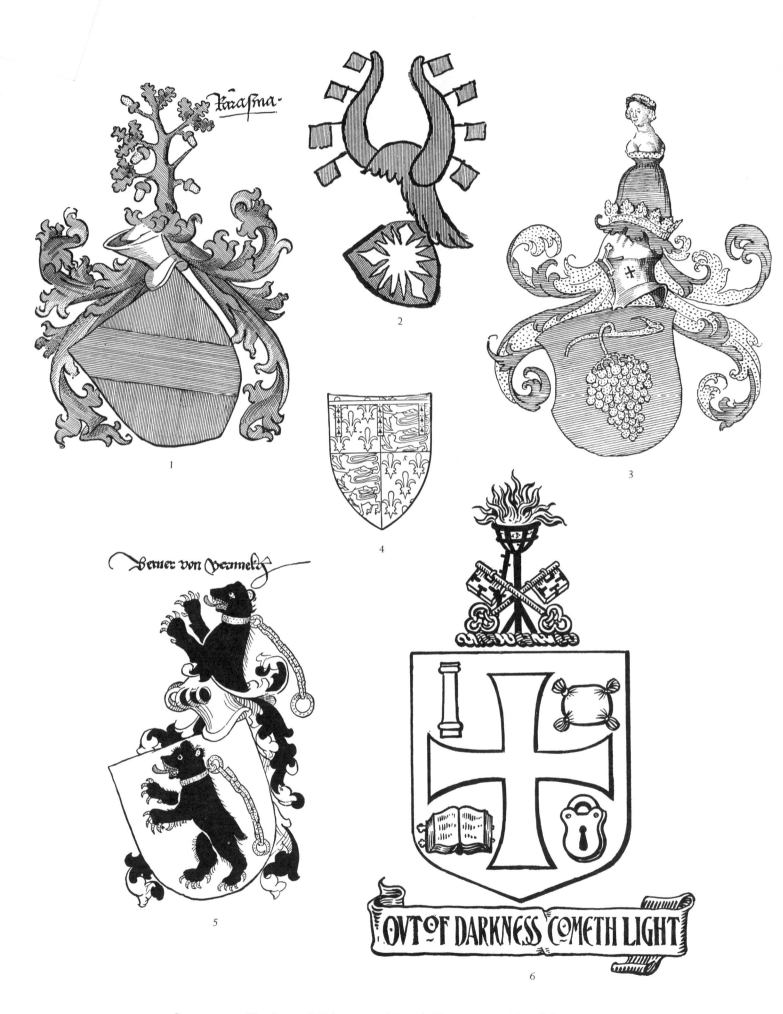

1. Rattasma.　2. The Count of Holstein.　3. Heinrich Trautwein.　4. John of Gaunt, Duke of Lancaster.　5. Berner von Berneck.　6. The Borough of Wolverhampton.

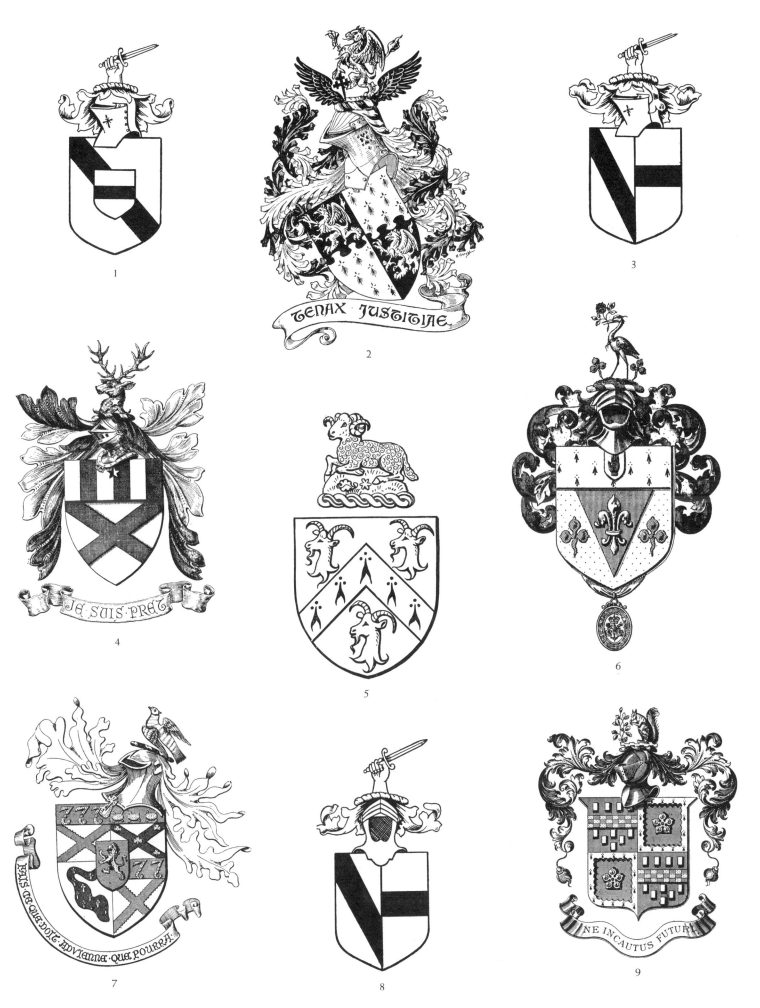

1. Conjoined arms.　2. George J. Marples.　3. Conjoined arms.　4. Theodore Maxwell.　5. William F. Marwood.　6. Sir David Gamble.　7. Henry C. Tweedy.　8. Conjoined arms.　9. William B. Lee.

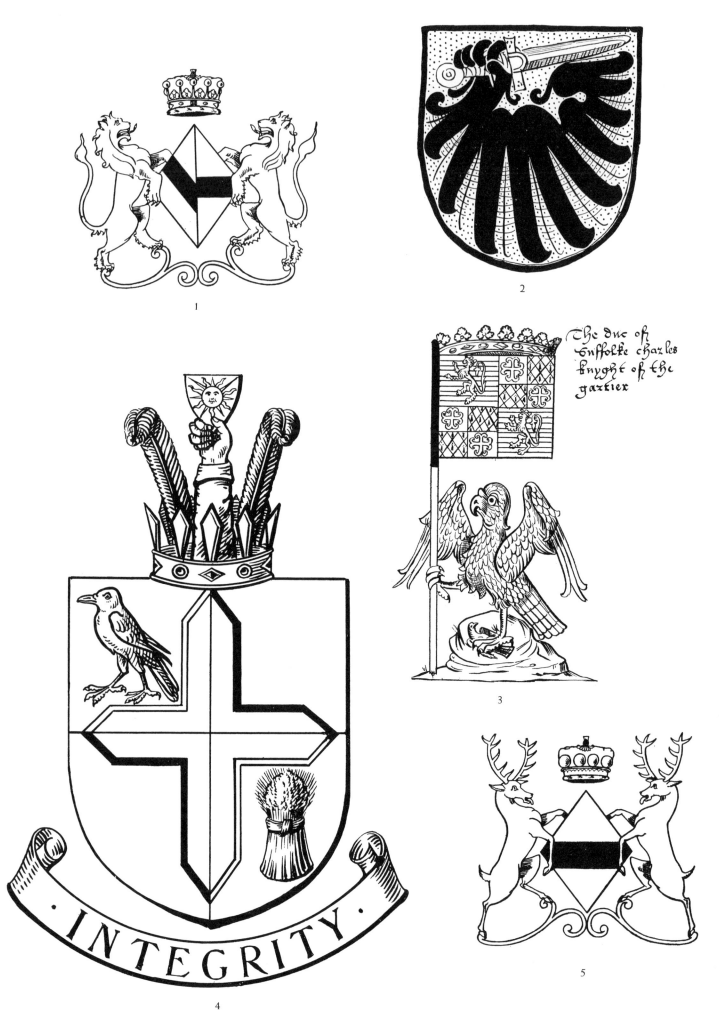

The duc of
Suffolke charles
knyght of the
garter

1. Conjoined arms. 2. The Duke of Calabria. 3. Sir Charles Brandon, Duke of Suffolk (banner).
4. The Town of Dukinfield. 5. A peeress.

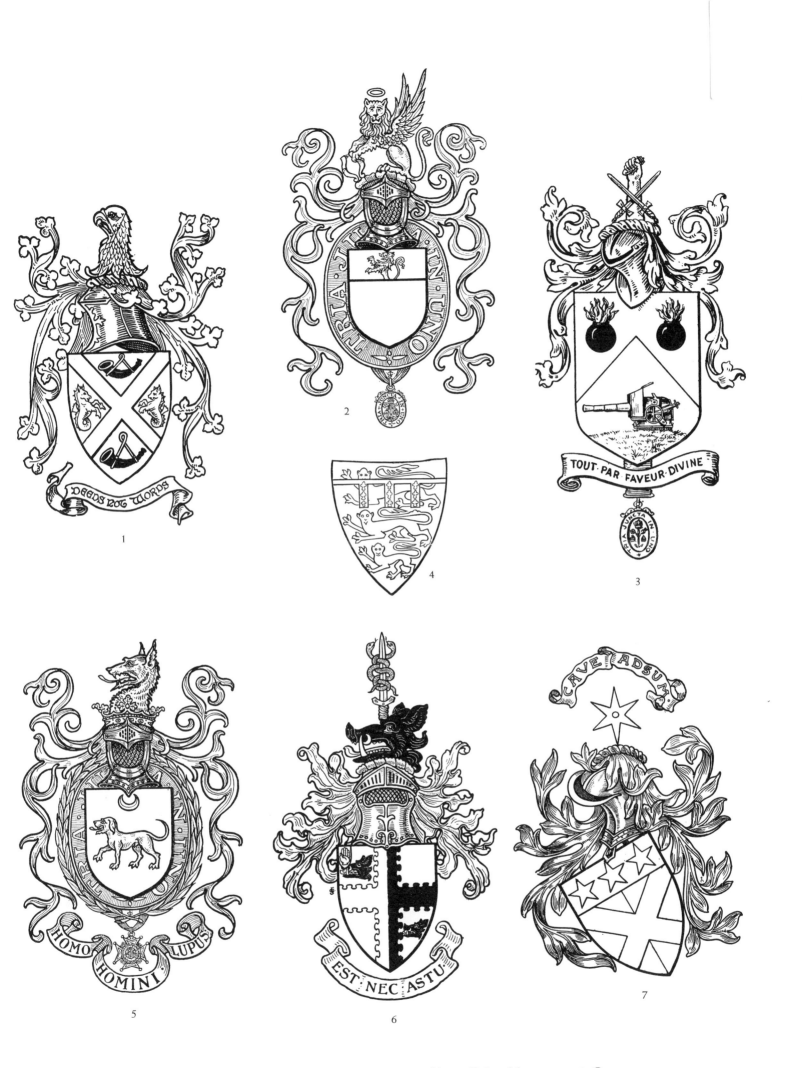

1. Pirrie. 2. Markham. 3. Joseph Vavasseur. 4. Henry, Duke of Lancaster. 5. George
B. Wolseley. 6. Sir Thomas Brooke. 7. David J. Jardine.

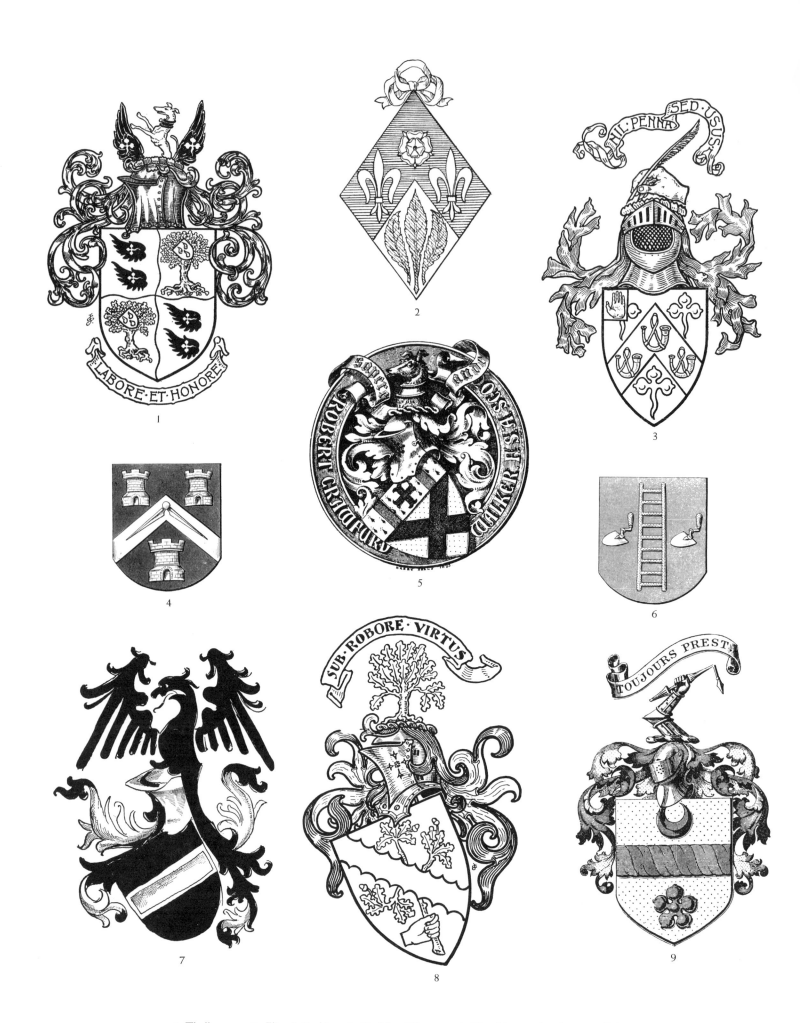

1. Thellusson.　2. Elise J. Foulds.　3. Sir John Gilmour.　4. The Masons, London.　5. Robert
C. Walker (bookplate).　6. The Tilers, Paris.　7. Imaginary Austrian arms.　8. Thomas
S. Aikman.　9. James Carmichael.

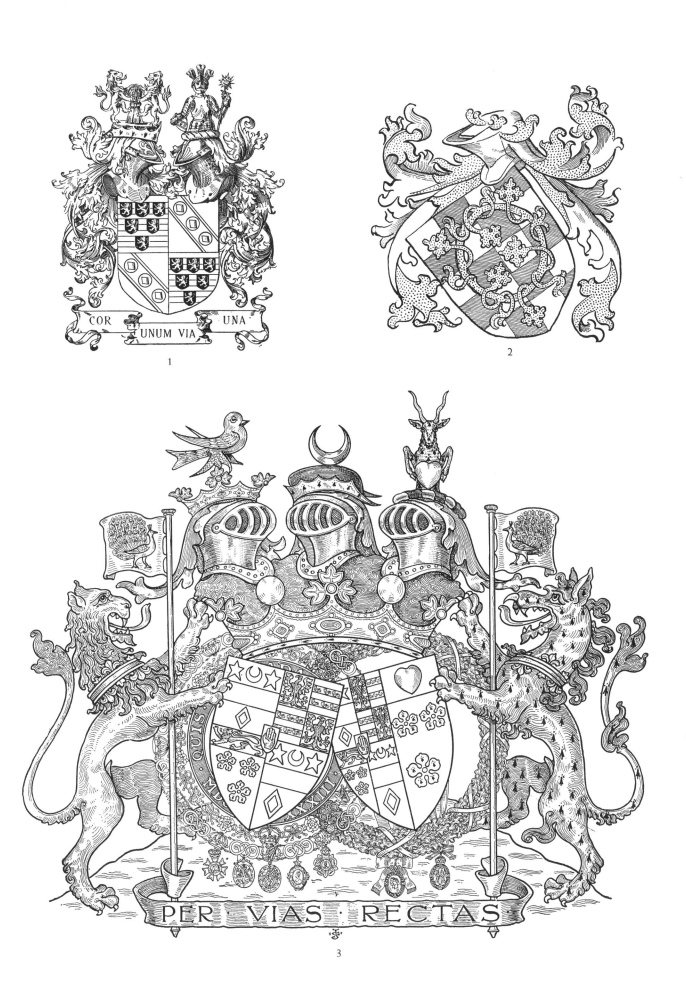

1. Lord John P. Joicey-Cecil. 2. Imaginary Austrian arms. 3. Hamilton-Temple-Blackwood, Marquess of Dufferin and Ava.

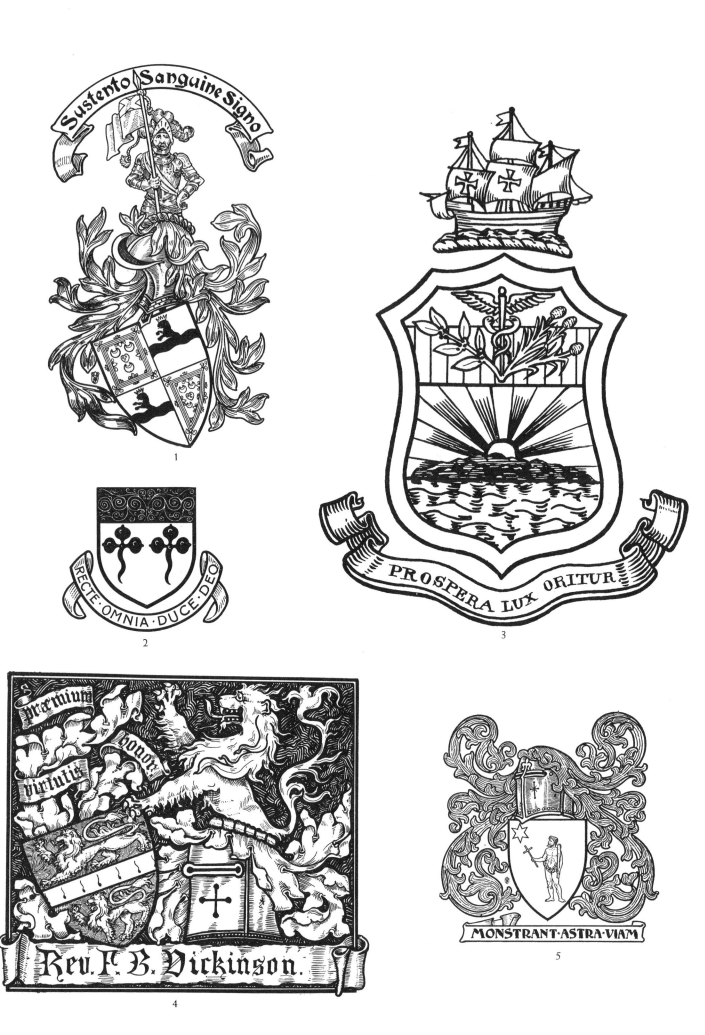

1. Alexander D. Seton.　2. Rodd.　3. Puerto Rico.　4. F. B. Dickinson (bookplate).　5. John Oswald.

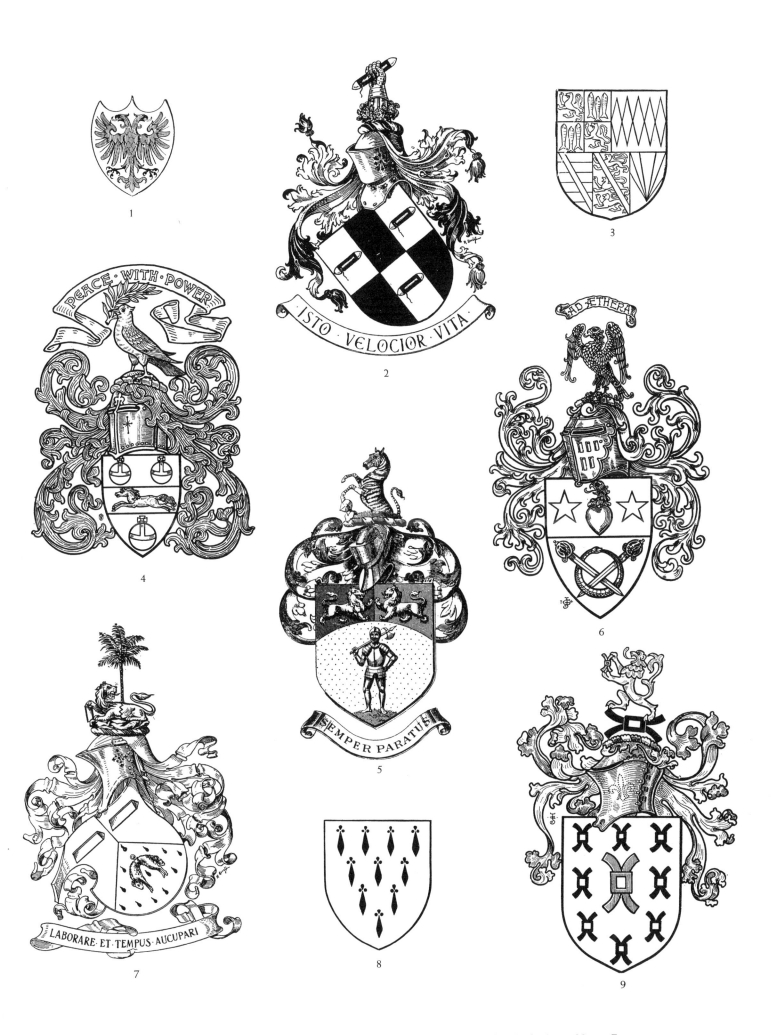

1. John Milton. 2. Frank Shuttleworth. 3. Henry A. Percy, Earl of Northumberland. 4. Horace E. Moss. 5. John C. Kemsley. 6. John Falconer. 7. Benjamin M. Woollan. 8. John de Montfort, Duke of Brittany and Earl of Richmond. 9. Samuel M. Milne.

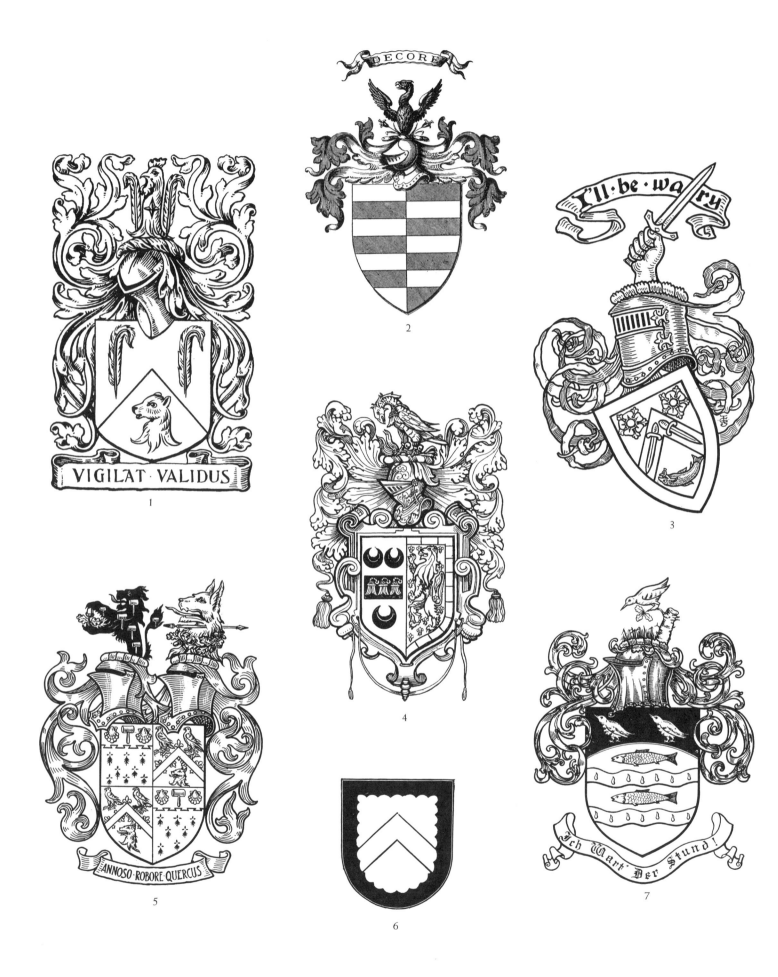

1. Arthur J. Galpin. 2. Hugh Ballingall. 3. John Finlay. 4. Ambrose Lee. 5. Henry W. Worsley-
Taylor. 6. Humphrey Stafford, Earl of Devonshire. 7. Johann G. Langhans.

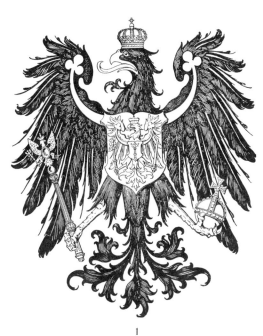

1

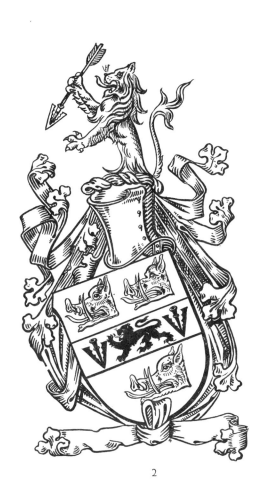

2

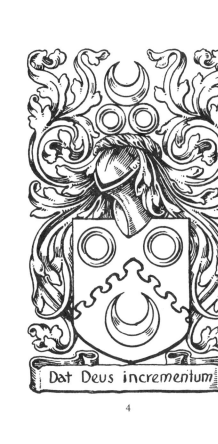

4

3

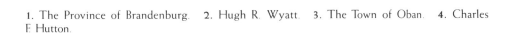

1. The Province of Brandenburg.　2. Hugh R. Wyatt.　3. The Town of Oban.　4. Charles
F. Hutton.

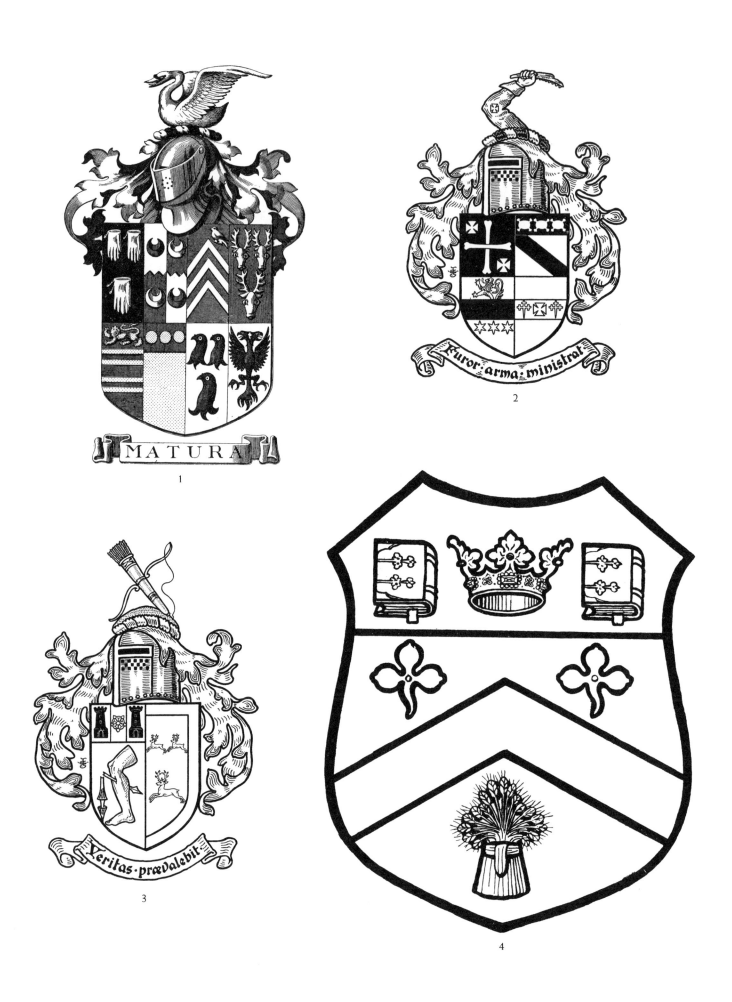

1. Briane B. Barttelot. 2. Montague C. Baines. 3. Edmund T. Bower. 4. Clifton College.

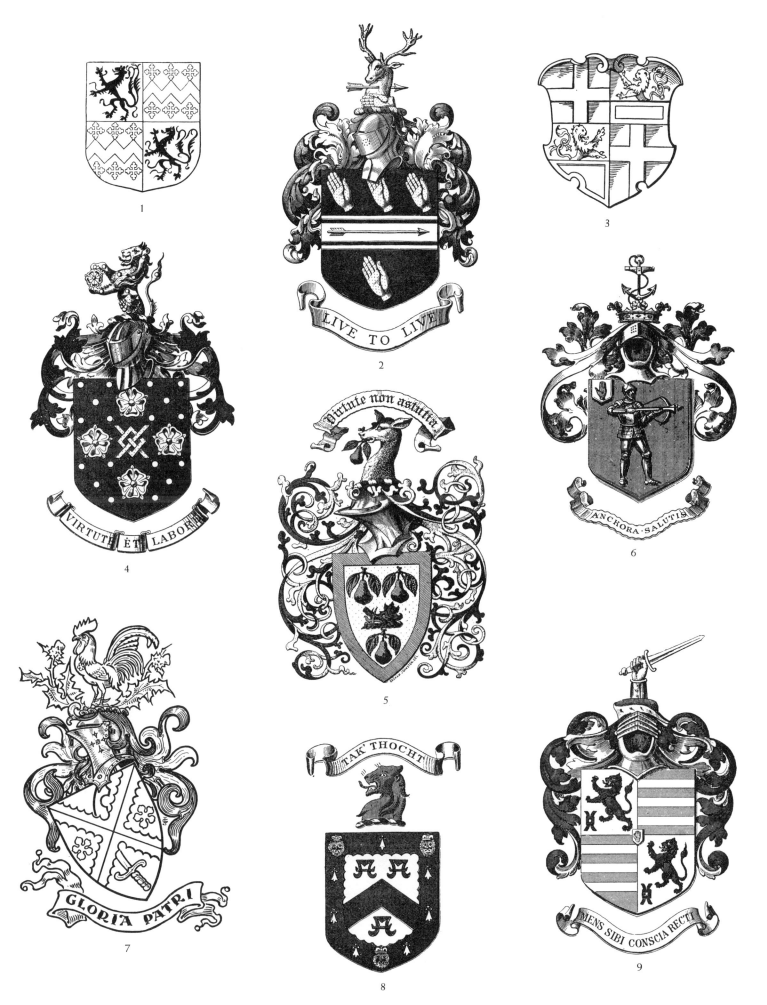

1. John de Welles, Viscount de Welles. 2. Thomas Bate. 3. Von Eltz. 4. Frederick Platt. 5. Gordon Pirie. 6. Sir Bryan O'Loghlen. 7. Thomas R. Dewar. 8. James O. Fairlie. 9. Sir Claude Champion de Crespigny.

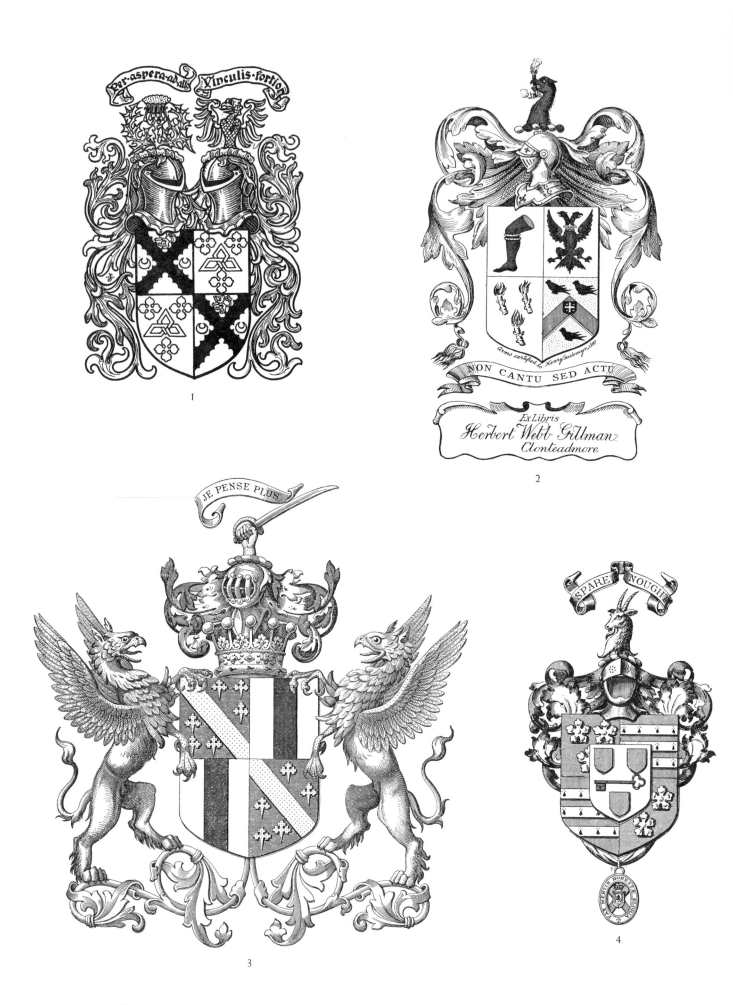

1. David A. Vipont. 2. Herbert F. Webb Gillman (bookplate). 3. Goodeve-Erskine, Earl of Mar. 4. Sir Hector M. Hay.

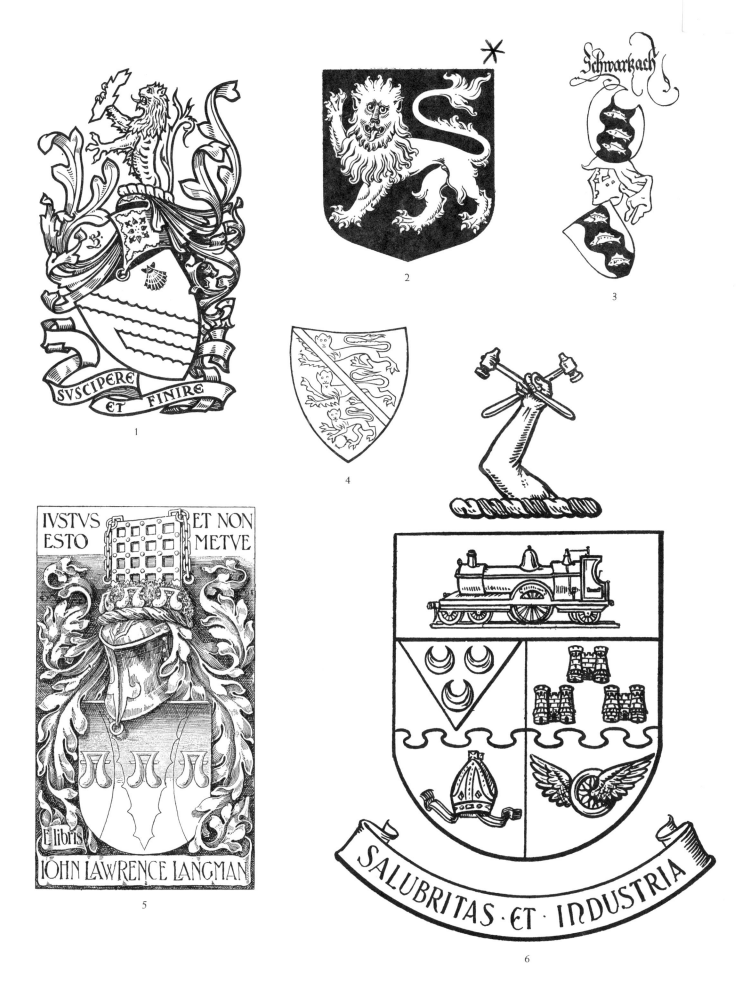

1. Wagstaff. 2. A lion passant guardant. 3. Michael von Schwarzach. 4. Henry of Lancaster. 5. John L. Langman (bookplate). 6. The Borough of Swindon.

1

2

3

4

1. Fenton. **2.** Hunter-Weston. **3.** Ross-of-Bladensburg. **4.** Nicolson.

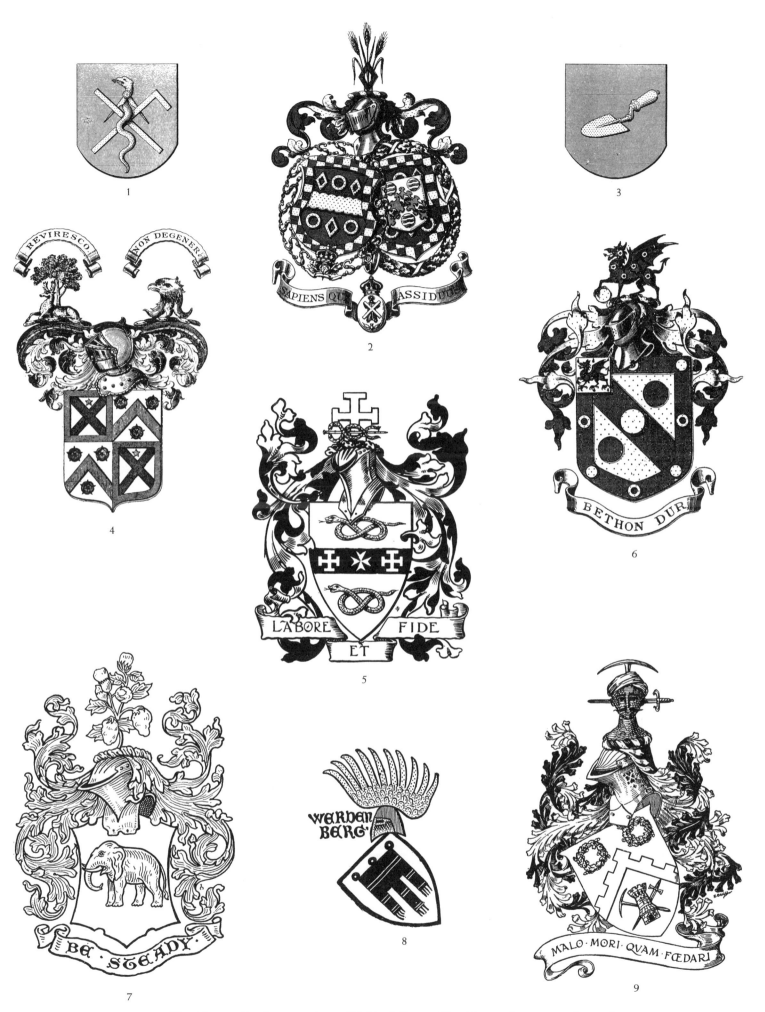

1. The Masons, Beaulieu. 2. James W. Mitchell. 3. The Masons, Saumur. 4. James A.
Wedderburn-Maxwell. 5. Thomas Chaplin. 6. William H. Sloggett. 7. Samuel
Butcher. 8. Werdenberg. 9. Francis I. Richarde-Seaver.

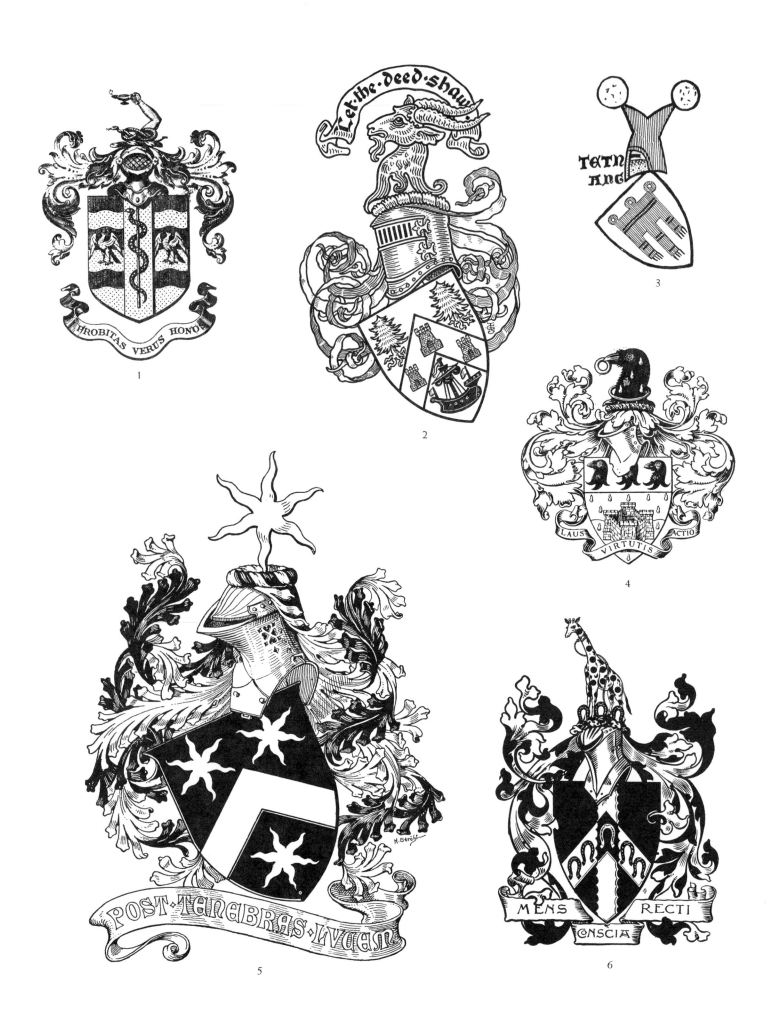

1. Sir William B. Dalby. 2. John Fleming. 3. Tettnang. 4. Arthur P. Rawson. 5. Henry
J. Langdale. 6. Fred Crisp.

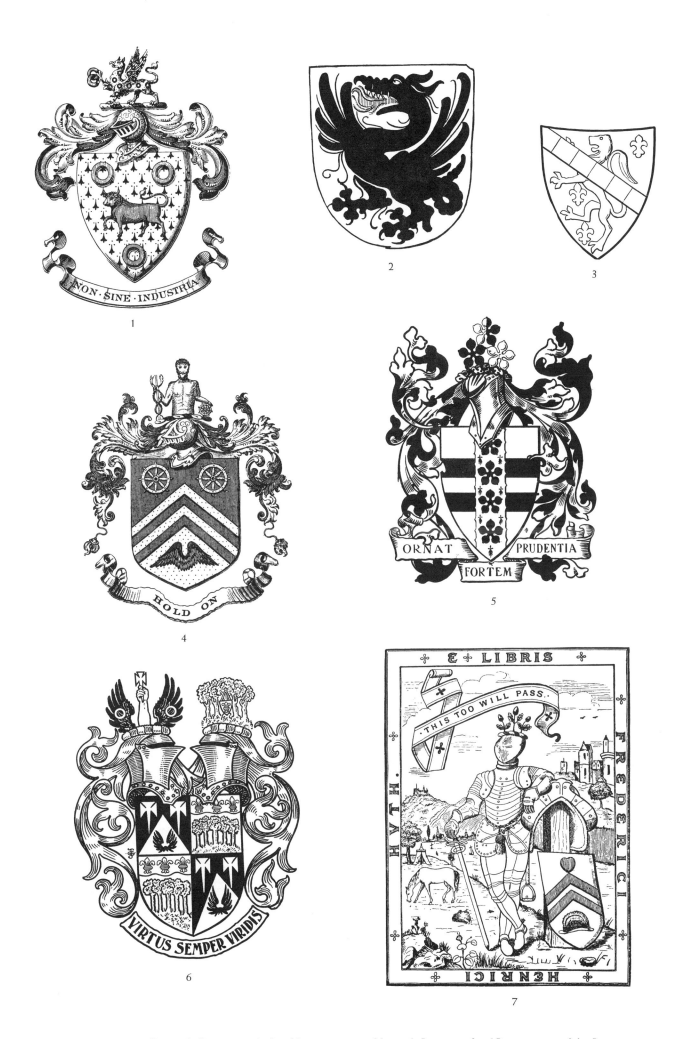

1. Francis A. Bevan. 2. An heraldic wyvern. 3. Henry de Beaumont, Lord Beaumont. 4. John B. Willans. 5. William J. Lancaster. 6. Charles H. France-Hayhurst. 7. Frederick H. Huth (bookplate).

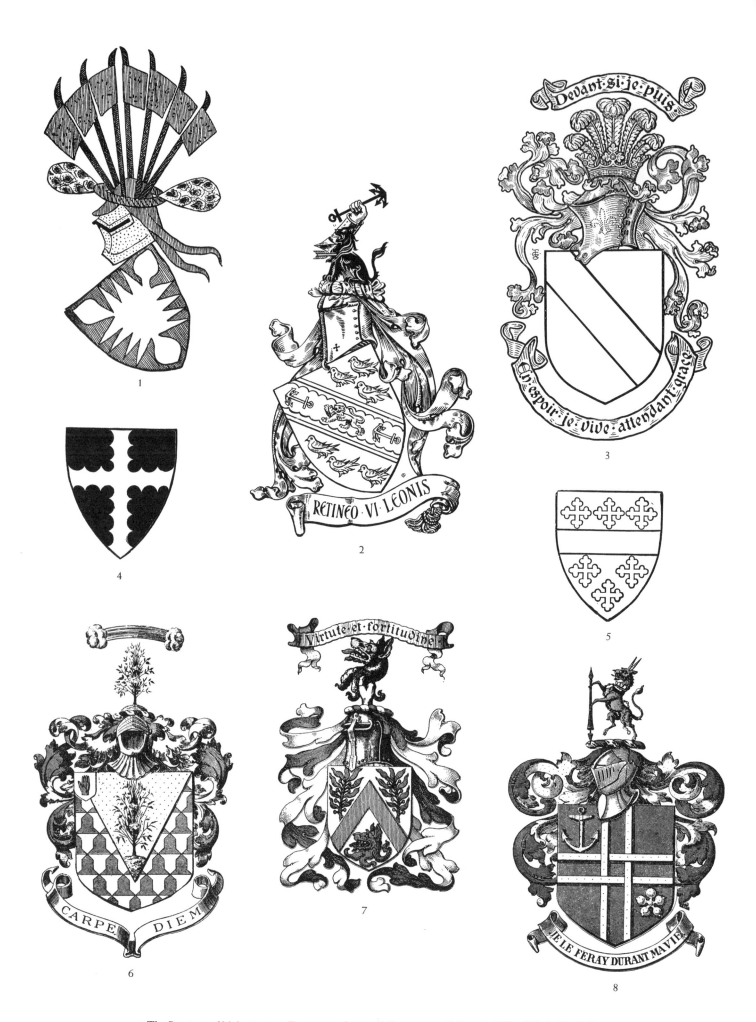

1. The Province of Holstein. 2. Tonge. 3. Simon C. Scrope. 4. Robert de Ufford, Earl of Suffolk.
5. Thomas Beauchamp, Earl of Warwick. 6. Wigan. 7. George A. Cooper.
8. John Moresby.

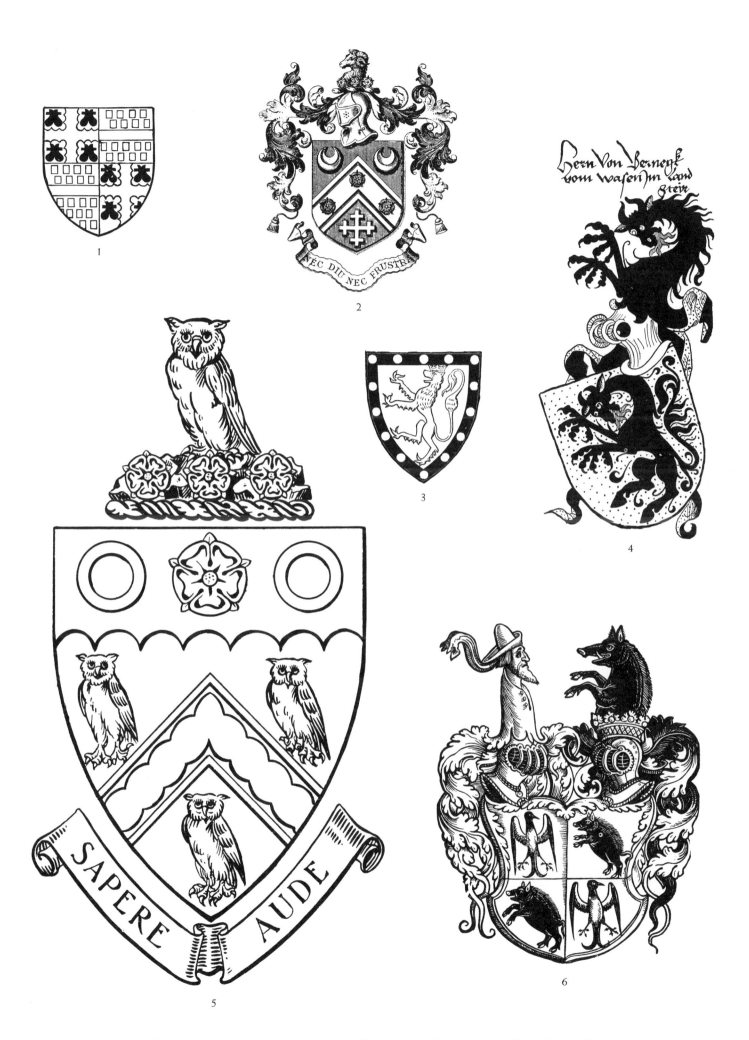

NEC DIU NEC FRUSTRA

Hern Von Berneck vom Wasen jm land Steir

SAPERE AUDE

1. Henry Bourchier, Earl of Essex. 2. Lees Knowles. 3. Edmund, Earl of Cornwall. 4. Von Berneck. 5. The Borough of Oldham. 6. The Barons von Rindscheit.

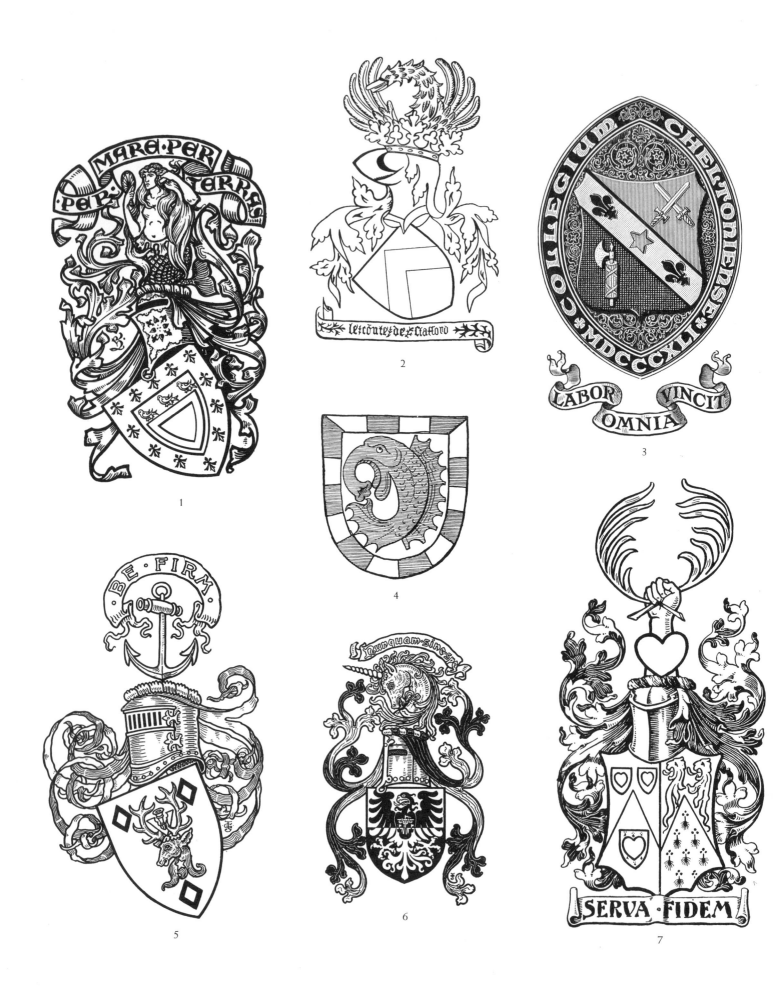

1. Andrew Rutherford. 2. Humphrey Stafford, Earl of Stafford. 3. Cheltenham College (book-plate). 4. Count von Dälffin. 5. James M. Coats. 6. Iain Ramsey. 7. Frederick C. Corfield.